LIVES OF THE ARTISTS

LIVES OF THE ARTISTS

Lives *of* *the* Artists

Calvin Tomkins

A John Macrae Book/Holt Paperback

Henry Holt and Company • New York

Henry Holt and Company, LLC
Publishers since 1866
175 Fifth Avenue
New York, New York 10010
www.henryholt.com

Henry Holt® and ⓅⓅ® are registered trademarks
of Henry Holt and Company, LLC.

Distributed in Canada by H. B. Fenn and Company Ltd.

Library of Congress Cataloging-in-Publication Data

Tomkins, Calvin, 1925–
 Lives of the artists / Calvin Tomkins.—1st ed.
 p. cm.
 "A John Macrae book."
 Includes index.
 ISBN 978-0-8050-9144-1
 1. Artists—Biography—History and criticism. 2. Art, Modern—
20th century. I. Title.
 N6489.T66 2008
 700.92—dc22 2008013121

Henry Holt books are available for special promotions and
premiums. For details contact: Director, Special Markets.

Printed in the United States of America

D 10 9 8 7 6 5

Once again, for Dodie

CONTENTS

PREFACE

Making art is both harder and easier than it used to be. The radical changes in art and society that were set in motion during the early years of the twentieth century gave rise to a new kind of artist, whose first obligation was to invent or discover a new self. Tradition, skill, rigorous training, formal knowledge: All the old requirements fell away or became optional. Art, it seemed, could be whatever artists decided it was, and there were no restrictions on the new methods and materials—from video and verbal constructs to raw nature and urban detritus—that they could use. The limitless freedom of the modern artist has been an unending burden. If art can be anything, where do you begin?

For the ten contemporary artists discussed in this book, art has been, among other things, an approach to the problem of living. (The profiles were all published in *The New Yorker* during the last decade, and are reprinted here, with a few minor

changes and updatings, as sightings of lives in midstream, open to future developments.) Common denominators are notably absent. Richard Serra, our greatest living sculptor, freely acknowledges his early debt to the work of Jasper Johns, our most extravagantly admired painter, but the two men are so different in temperament, sensibility, and ego management that it would be hard to imagine them having a useful conversation. Jeff Koons and Damien Hirst, the reigning masters of a deliberately outrageous, media-centered art that feeds off the corrupting influences of entertainment, celebrity, and late-capitalist glut, have both, in mid-career, settled into the unlikely roles of devoted husbands and fathers. Conversely, Cindy Sherman shuns the spotlight at all cost, but thrives as a virtuoso performer in a theater of her ever-shifting selves, and Maurizio Cattelan, an escape artist with a taste for anonymity, scours the world for serious jokes that pinpoint our social and philosophical dilemmas.

Julian Schnabel's star waxed and waned in sync with the overheated art market of the 1980s; since then he has doubled himself, holding on to his claims as a neo-expressionist painter while forging a second career as an award-winning film director. James Turrell has spent his long career transforming an extinct volcanic crater into an observatory for the phenomenological aspects of light. Matthew Barney's obsessive, myth-haunted films grow out of his sculptures, whose materials have included Vaseline, tapioca, his own body, the Boise football stadium, the Chrysler Building, the Isle of Man, and a great many of his fellow creatures, living and dead. John Currin decided to rejuvenate the art of figurative painting by rediscovering traditional skills that proved to be, in his hands, perfectly viable after all. If these artists have anything in common, it is not apparent in their work.

I once heard a clueless young painter express scorn for a more successful one by saying that he "doesn't even know what art is." Does anyone? Marcel Duchamp, the most influential artist of the last hundred years, nailed down this useful enigma in 1913, when he began selecting and signing common, machine-made objects (a bottle-drying rack, a snow shovel), thus converting them into "readymade" works of art. The readymade, Duchamp said, was "a form of denying the possibility of defining art." Some people feel that much of what passes for art these days is just self-indulgence; posterity, that implacable judge, may decide they're right. In the meanwhile, contemporary art of every description basks in an unprecedented climate of acceptance. An avalanche of money from new and often unexpected sources—American hedge fund owners, Russian oligarchs, shadowy billionaires in Hong Kong or Shanghai or Abu Dhabi—has transformed the art market, and the top contemporary artists now command higher prices at auction than Impressionists or modern masters. The collapse that art professionals have been predicting for years may be inevitable, but the widespread stock market jitters of 2007 did not deter buyers from paying $19 million at auction for one of Damien Hirst's medicine cabinet sculptures, and just under $72 million for Andy Warhol's *Green Car Crash*. The art world, which used to be a community, is now part of the worldwide visual culture industry, which includes film, fashion, television, and advertising, and works overtime to trample down the boundaries that used to keep them separate.

All this makes life more complicated for the artist. The pressure to succeed in the marketplace, to establish a unique artistic "brand" or style, may clash with the need to accept failure in pursuit of a deeper vision. It takes a strong character to reconcile or ignore these tendencies, and this brings us back to the question

of self-invention. Formalist art critics used to say that the life of an artist was irrelevant to an understanding of his or her work. This may be so for certain critics, but ever since 1550, when Giorgio Vasari published the first edition of his *Lives of the Most Eminent Architects, Painters, and Sculptors of Italy* (the title I shamelessly swipe here), biography has informed our understanding of art. In my experience, the lives of contemporary artists are so integral to what they make that the two cannot be considered in isolation. If the work is interesting, the life probably is too.

Most contemporary art is not very interesting, of course, partly because there is so much of it. Ten thousand artists live in New York. For the ones you never hear about, unlimited freedom often translates into art that is relatively easy to do—slacker art, in the current phrase. For the others, making art is still one of the most demanding jobs on earth. Frank Stella, another contemporary master, recommends looking at the contemporary art world as an expanding pyramid. The base gets wider and wider, but there's still not much room at the top.

LIVES OF THE ARTISTS

DAMIEN HIRST

It took Damien Hirst less than five years to become the most famous living British artist. As early as 1992, *The Independent* ran a cartoon of Prime Minister John Major submerged horizontally in a glass tank, with an onlooker exclaiming, "Oh, God! It's disintegrating!" The reference, as the paper's readers were expected to know, was to the twenty-seven-year-old Hirst's tiger shark in formaldehyde, a real-life art work acquired the previous year by the advertising magnate Charles Saatchi. In London, Hirst is as well known as the rock stars he hangs out with, but fame has not yet singed him with its dragon breath. Now thirty-four, he is an open, friendly, humorous, quick-witted, dirty-minded, hard-drinking, and immensely likeable Yorkshireman whose tough, working-class features look as though they could turn belligerent at some point but never do.

Unlike most of the other young British artists of his generation (or YBAs, as the tabloids call them), Hirst has produced a

fairly diverse body of work. In addition to the shark piece, whose formal title is *The Physical Impossibility of Death in the Mind of Somebody Living,* he makes several different kinds of paintings on canvas: spot paintings, in which all the spots are the same size but each is a different color; spin paintings, made by dripping pigments on a canvas mounted on a turntable; and butterfly paintings, made by laying exotically colored (dead) butterflies on wet canvases painted a single, all-over bright hue. These works are intensely decorative and often quite beautiful, an effect that Hirst tries to neutralize with the titles he assigns them—names of pharmaceutical narcotics or stimulants in the case of the spot paintings, and, for the spin jobs, titles like *Beautiful, handsome, tasteless, thoughtless, amazing, spinning, cyclone good-in-bed painting* (1995), or *Beautiful, kiss my fucking ass painting* (1996).

Sculpture is what propelled Hirst to fame, however, and his three-dimensional forms often suggest a mating of Minimal art and Grand Guignol. In the 1970s, some formalist critics used to complain that Minimal art, by inviting the viewer to create a scenario from simple, machine-made sculptural forms, was too theatrical. The "theater" of Donald Judd or Dan Flavin, however, with its spare metal boxes or fluorescent-light tubes, looks pretty tame next to Damien Hirst's *A Thousand Years,* a vitrine containing a rotting cow's head, live maggots that hatch into flies, and an Insect-O-Cutor to zap the flies, or his 1992 *She Wanted to Find the Most Perfect Form of Flying,* a large steel-and-glass enclosure whose walls and floor are drenched with what looks like blood and whose contents include a spotless white lab coat on a hanger, a blood-spattered chair, and a three-legged table on which, amid some bloody debris, a live goldfish swims serenely in a round bowl. The scenario here is up to you, of

course, but Hirst has suggested that it deals with sexuality, which "always turns into murder for some reason."

Actually, sex and violence do not figure prominently in Hirst's oeuvre. His main sculptural fixation over the last decade has been with death—or, rather, with the impossibility of death in the mind of someone who, like Hirst himself, is infatuated with life. "Death is an unacceptable idea," Hirst has said, "so the only way to deal with it is to be detached or amused." His medicine cabinets—works in which surgical instruments or prescription drugs are neatly aligned on the shelves of ordinary glass-fronted cabinets—can be seen as supercool metaphors for the human body and its losing struggle against disease and decay. (They also refer, according to Hirst, to "the fact that people believe in medicine but don't believe in art, without questioning either.") His shark in formaldehyde, which at first glance looks alive and very deadly; his cow and calf, chainsawed in half vertically, the halves presented side by side in adjoining glass cases (*Mother and Child Divided*); his pristine white lamb (whole) floating in formaldehyde so that its hooves don't quite touch the bottom of the tank (*Away from the Flock*)—these images, which could have been merely shocking, or morbid, or sentimental, or disgusting, manage somehow, maybe because of the distancing effect of their minimalist steel-and-glass containers, to engage our attention on other levels, not excluding the visceral, populist level that Hirst himself often has in mind. "A lot of people think art's weird and stupid," he told me. "I want to get to those people, get them to come in and go 'Arrrgh!'" Whether or not his work is merely sensational, as some critics maintain—providing shock for the sake of shock—his sculptures are hard to forget, and the best of them are carried off, like Andy Warhol's iconic works, with the panache of a master showman.

And, anyway, Hirst wants to know, "What the hell's wrong with sensational?"

ONE EVENING LAST JUNE, Hirst said to me, "I think art has always been interested in extreme things. Death is frightening. If you don't think about it, then it's going to get the better of you. I'm just trying to say, 'Look, how about this?' "

We were sitting in the kitchen of Hirst's three-hundred-year-old farmhouse, in Devon, at the time, finishing a very good dinner cooked by Hirst (whom nobody can be around for ten minutes without calling Damien), after a two-hour train trip from London followed by a forty-five-minute taxi ride from the station. Connor, Damien's four-year-old son, was playing happily and a bit noisily on his father's lap. Maia Norman, Damien's companion and Connor's mother, would arrive around midnight: She was driving one of their Range Rovers down from London, where they had spent the last few days. It had, as usual, been a hectic interlude. Damien had put in some time at his business office, conferring with his associates, Hugh Allan and Jude Tyrrell, about current projects and activities. These included Milly, a millennium fireworks rocket engineered and designed by Damien, to be manufactured by a Chinese firm and sold in department stores for £29 apiece; *Beagle 2,* the British space probe, which was planning to use a small Damien Hirst spot painting as a "test card" for instrumental calibrations during the European Space Agency's mission to Mars, in 2003; and a television documentary on the history of meat, for which Damien had been asked to be the narrator.

Of more immediate concern was a lunch for two hundred invited guests to celebrate the first anniversary of Pharmacy, the Notting Hill restaurant whose concept and décor were by Hirst.

Damien had also checked on the progress of his ten assistants at two London studios, and he had done a great deal of convivial drinking and snooker-playing at the Groucho Club, the popular Soho hangout for media, entertainment, and art world luminaries, where the sort of drunken antics that Damien and his mates fancy are not only tolerated but tacitly encouraged.

Damien, on his last night in town, had arranged a dinner party at Pharmacy for Matta, the eighty-seven-year-old Surrealist painter, whom he had just met the previous evening. Damien had not gone to bed at all that night but had moved on from Pharmacy to the Groucho and several other drinking clubs with Maia and Mary Brennan, his mother, who lives in a cottage adjoining their Devon house and helps look after Connor, and who doesn't at all mind staying up late when she comes to London. After dropping Mary and Maia off around three A.M., at a houseboat on the Thames which is now their London living quarters, Damien had continued on his own, God knows where. By the time he showed up for the anniversary lunch at Pharmacy, around two the next afternoon, he looked pretty wasted—unshaved, clothes rumpled, eyes half shut. He had a few drinks, sambucas and Ricard pastis. (Damien likes to mix things up, alcoholically.) He wasn't being coherent, but this didn't interfere with the carnival of affection that surrounded him the minute he arrived—friends and near friends coming over to hug him, friends' children pulling on his arm and spilling his drink, rock musicians shouting at him across the big, bright room, whose high-style décor includes several butterfly paintings, a large plastic sculpture representing an atomic structure, colorful wallpaper reproducing pharmaceutical compounds from a drug encyclopedia, and, on the stairs, dangling human skeletons and four huge pharmacist's jars filled with colored liquids. During the next

three hours, as Damien continued to order, spill, and consume various alcoholic beverages, I was surprised to note that he became progressively more alert and articulate. We were scheduled to catch a six o'clock train to Devon from Paddington Station. Long after I had given up hope that this might happen, at about five forty-five, Damien rounded up Connor and Mary Brennan, went outside in the rain, found a taxi, and got us all to Paddington with three minutes to spare. As he walked to the train platform, carrying an exhausted Connor on his shoulders and holding his nice, cheery mum by the hand, he looked like the sort of family man you could really depend on.

DAMIEN HIRST NEVER knew his own father. Growing up in the working-class town of Leeds, in the north of England, he got on well enough with his stepfather, a car salesman named Hirst, who had married his mother when Damien was a year old, but the marriage collapsed after twelve years and two more children, and Damien's mother (who reverted to her maiden name) concedes that by then she had lost control of Damien—"which says more about him than about me," she adds. He had a few brushes with the police as a youngster, "a little stealing, minor stuff," according to Hugh Allan, who also grew up in Leeds. "We were raised on punk music and punk culture. Damien played guitar in a band, and my brother played bass."

After getting out of school, Damien hung around for a year or so, not knowing what to do with himself, until it occurred to him to go to art school. He had always liked to draw. He took the foundation course at Jacob Kramer College, an art school in Leeds. After that, he applied to two professional art schools—St. Martin's, in London, and Cardiff College, in Wales—and was turned down by both of them. At loose ends again, he got a

doctor friend to let him sit in on his anatomy course at the morgue; Damien did life drawings of the corpses. "That's when I got interested in things being more real," he said. There is a horrendous snapshot of a grinning Damien in the morgue, cheek to cheek with the severed head of an elderly cadaver. In 1983, when he was eighteen, he moved to London, where he got a construction job. He painted in his spare time—turgid, heavily impastoed canvases in the Abstract Expressionist manner—until curiosity nudged him into collage. "There was an old guy named Mr. Barnes, who lived in the building next to mine and collected junk," Damien told me. "After not seeing him for a while, a friend of mine and I got worried about him, so we went in through the back of the building. Upstairs, we found two rooms with about sixty years of this guy's life in there—magazines, pajamas, two hundred empty toothpaste tubes, an incredible amount of worthless stuff." Mr. Barnes never came back. The building manager was throwing everything out, so Damien began moving it into his flat. "That's what I made all my early collages out of—his stuff," he recalled. "I kind of turned into him."

Damien's mother told him he'd never get into a professional art school if he just "stuck rubbish on boards," but in 1985 his collages got him accepted at Goldsmiths' College, which turned out to be the perfect place. Goldsmiths', in southeast London, was anti-establishment, anti-authoritarian, and anti-hierarchical. There were no departmental divisions, and no formal teaching as such. Each student was assigned a studio and a tutor, and periodically there was a seminar where everyone's work was criticized by fellow students and several tutors. Michael Craig-Martin, an Irish-born, American-raised artist who began teaching there in 1973, believes that Goldsmiths' emergence in the last decade as the main incubator of new British art stems in part from the

profound social changes brought about in England by Margaret Thatcher. As Craig-Martin sees it, "England as a society is almost unrecognizable today, compared to twenty years ago. There used to be a sense of vulgarity about seeking success or money overtly—the English preferred to lose gracefully than to win vulgarly. But today they're as aggressive and outspoken and vulgar as they were in the eighteenth century, and Damien is part of that."

Although Craig-Martin was not one of Damien Hirst's tutors at Goldsmiths', he noticed Damien soon enough. "I remember going to an opening at Anthony d'Offay's gallery and finding that the person who served me champagne was Damien," he said. "He'd got himself a part-time stockroom job there, which was really unusual—a first-year student going right to the top place." At the end of his second year at Goldsmiths', Damien took the lead in putting together the exhibition that would largely define his own generation of artists. Year-end shows by students at the college were annual events, but this was something new. Visiting his girlfriend in the Docklands area south of the Thames, Hirst had noticed an abandoned warehouse, found out who owned it, got permission to occupy the premises for a month that summer, and wangled a loan from the London Docklands Development Corporation. Hirst and his fellow students spent several weeks cleaning the place, which was ankle deep in pigeon droppings. The show was a group effort, but Damien chose the sixteen artists—first-, second-, and third-year students, and a few who had already graduated—raised the money for a catalogue, and got Ian Jeffrey, the head of the Goldsmiths' art history department, to write the catalogue essay. "The whole thing," according to Craig-Martin, "was a perfect mirror image of a professional exhibition."

"Freeze," as they decided to call it (as in "freeze-frame"), opened on August 6, 1988, and word spread quickly through the London art community that something was up. Hirst got Norman Rosenthal, the Royal Academy's director of exhibitions, to see the show by picking him up in a taxi and taking him there. The work on view in that huge, empty space did not reflect any common style, nor did the students seem to be breaking new ground aesthetically; several of the more striking pieces, in fact, clearly showed the influence of the American artists who the year before had exhibited in "New York Art Now," at the Saatchi Gallery, on Boundary Road. What struck most viewers, though, was the brash, all-out, try-anything ambition and energy of the Goldsmiths' students, the sense of youthful high spirits and bursting confidence. There were a lot of paintings in the show, and some conceptual pieces made from throwaway materials, and a couple of real shockers, like Mat Collishaw's photographic light box showing an enlarged close-up of a bullet wound in a man's skull. Among the weaker works, it was generally agreed, were Damien Hirst's collages.

At this point, a number of people assumed that Hirst was going to become an art dealer or a museum curator rather than an artist. He had a sharp eye, obviously, and a terrific talent for promoting other people's work. Rachel Whiteread, a graduate of the Slade School of Fine Art, who wasn't in the "Freeze" show, remembered with amazement how Damien used to bring Norman Rosenthal and other art world power brokers to her studio to see the work she'd done. (Whiteread would soon win renown comparable to Hirst's for her ghostlike casts of common domestic objects such as chairs, bathtubs, a living room, and eventually a whole house in East London.) She had met Damien in a pub three years before the "Freeze" show, and they had liked

each other on sight. "I told him how cheeky and arrogant he was," she recalled, "because he was trying to take over the world even then—and he hadn't made anything!" Damien did want to take over the world, but he was serious about being an artist. "Freeze" continued, with two extensions, through September 29, and new artists and new work were added each time. For the third version, Damien invented his first spot paintings. He did them directly on one wall—uniform colored circles lined up in a grid pattern. The spot paintings would become Hirst's logo, the antidote to his death-and-decay pieces; since no two spots were exactly the same color, the paintings were free of harmony, color balance, or any other aesthetic devices, and they all seemed to project a happy, eye-catching glow, like advertisements. "They are what they are," as Hirst once said. "Perfectly dumb paintings which feel absolutely right."

Several of the "Freeze" artists gained commercial recognition before Hirst did. A couple of London dealers bought works by Hirst from a warehouse group show called "Gambler," which Damien helped organize in 1990, a year after he got out of Goldsmiths', but nobody offered him a solo show. Anthony d'Offay, his former employer, sent him to the Cologne Art Fair to look for new talent; he wanted Damien to start a small, cutting-edge gallery, which he would fund. When Damien asked him for some money to make a sculpture he was thinking about (it was the fly piece), d'Offay said he could have it if he agreed to do the gallery. Damien got his back up over that, and said no. It was around this time that he met Jay Jopling.

Although they were nearly the same age and had grown up within twenty miles of each other in Yorkshire, Hirst and Jopling came from vastly different backgrounds. Jopling's father had been a Cabinet minister (for agriculture) in the Thatcher government.

Jay went to Eton and Oxford, where he read art history, and in 1990, just down from the university, he was brokering art deals, trying to put together enough money so that he could work with young artists. He was already working with Marc Quinn, who had achieved some renown with a self-portrait sculpture cast in eight pints of his own blood. Jopling met Damien at a gallery opening, and then was seated next to him at a dinner afterward. "We ended up going on to a bar together and talking for hours," Jopling told me. "I'll never forget Damien saying, 'What do you like most about life?' 'I don't know,' I said. 'What do you like?' And he looked at me with those burning eyes and said, 'Everything.'"

The next evening, Jopling came to Hirst's place—a council flat in Brixton—and saw drawings and plans for a whole galaxy of things that Hirst didn't have the money to make: steel-and-glass vitrine pieces and cabinet pieces and "natural history" pieces, one of which was a tank containing a huge shark in formaldehyde. "These were all drawn in detail, by hand and on a computer which a friend of his had access to," Jopling told me. "I was totally excited. I told him that what money I had I wanted to invest in realizing these works."

With Jopling's still somewhat limited funds, Hirst made *Isolated Elements Swimming in the Same Direction for the Purpose of Understanding,* a large glass-fronted cabinet with thirty-eight compartments, each of which contained, preserved in formaldehyde, a different species of fish from the Billingsgate Fish Market. He borrowed money from friends to produce *A Thousand Years,* the fly piece with the rotting cow's head, which he showed, along with some of his early medicine cabinets, in the 1990 "Gambler" exhibition. The key event in Hirst's early career was the purchase of *A Thousand Years,* in 1991, by Charles Saatchi.

Widely admired internationally for his keen eye and his daring tactics, and also for the museum-quality exhibitions he put on at a gallery that he had established in 1985, in a former paint factory in St. John's Wood, Saatchi had often been criticized for selling off at large profits works he had acquired for next to nothing. (When he unloaded three paintings by the Italian artist Sandro Chia, the rumor spread that he had sold twenty-eight, and destroyed Chia's market in the process. To this day, Chia is known mainly as the artist whom Saatchi dumped.) Saatchi had a new incentive to sell: Having shown little interest in British art until then, he was infatuated by the "Freeze" generation. He had gone to "Freeze" several times, and now he was buying Gary Hume, Marc Quinn, Jenny Saville, Damien Hirst, and several other YBAs. When Saatchi bought *A Thousand Years,* the art world took notice. Soon after that, he bought the second version of *Isolated Elements Swimming in the Same Direction for the Purpose of Understanding.* (The first version, with the fish swimming in the opposite direction, had gone to Damien's friend the novelist Danny Moynihan.) Saatchi also put up something like £60,000 for Hirst to make his shark sculpture.

Damien had originally wanted to do a painting of a shark, but had then decided that the shark had to be more real than that. "I like the idea of a thing to describe a feeling," he said once, and the feeling he had in mind was sheer terror. He wanted to use a great white shark, of course, and he was astonished to discover that they had become a protected species. A tiger shark would have to do. "I had an Australian surfer friend," he said, "and we got out the atlas and went round the map of Australia, marking where the sharks were. He told me to write to all the main towns, saying 'Shark Wanted,' and I did, and the fucking phone never stopped ringing. I'd put Jay Jopling's number on the no-

tice. After three weeks, we found this guy named Vic Hyslop, who had a shark museum, and he gave us a quote: six thousand pounds for a tiger shark." When the fourteen-foot monster arrived, frozen, Damien and Hugh Allan spent two weeks injecting formaldehyde into the carcass in his Brixton studio, sloshing around in a huge tank in dry suits and face masks (to keep from being asphyxiated by formaldehyde fumes). "Those were the days when I did everything myself," Damien recalled.

Shark and viewers met for the first time in 1992, at the Saatchi Gallery, in a group show of "Young British Artists." Larry Gagosian, the New York superdealer, saw it there and immediately telephoned Saatchi. Gagosian wanted to buy the shark and bring it to New York, but Jay Jopling and Saatchi had other plans. Hirst and Jopling were a team, even though Jopling didn't have a gallery yet (he would eventually open White Cube, a small but highly influential gallery on Duke Street), and even though Hirst had stolen Jopling's girlfriend, Maia Norman, a dazzling blond American who grew up in California and was an avid surfer before she moved to London and became a jewelry designer. Things were a little tense after Damien moved in with Maia, but then Jay married Sam Taylor-Wood, a photographer and filmmaker who was one of the rising YBAs, and everyone stayed friends. Maia and Damien were a real match, two strong and independent personalities with no need to control or compete with each other. Maia "is like an alien to me," Damien told me. "She inhabits a world I didn't know existed."

The YBAs were a competitive but remarkably cohesive group. They drank together, slept together, promoted one another's work, and welcomed talented newcomers. "Freeze"-type group shows, organized by artists, proliferated in temporary spaces around London. Damien curated several of them. "People in the

art world got after me and said, 'You've got to decide whether you're an artist or a curator,'" he told me, "and I kept saying 'Why?' If you go out and buy objects and arrange them in a sculpture, why can't you do it with art works? It's all art to me." Although he'd had very few solo shows, Damien was already becoming famous. The shark, the first dead-animal sculptures, the animal-rights protesters who fervently demonstrated against them, and his own bumptious, cocky personality made him seem like the driving force behind the whole YBA phenomenon, which, in fact, with backstage help from Jopling and Saatchi, he was. In 1992, Hirst was short-listed for the Turner Prize, the country's most prestigious award for artists under fifty. He didn't win it that year, but three years later he did.

The British seem to tolerate innovation in film, fashion, and music, but in this century they have consistently resisted and ridiculed it in the visual arts. Now, however, for the first time that anybody can remember, stories about young British artists began turning up on page 3 or even page 1 of the London newspapers. When a self-styled artist poured black ink into Hirst's lamb in formaldehyde (*Away from the Flock*), at the Serpentine Gallery in 1994, the papers all played it big; they reacted even more gleefully in 1995, when Hirst's first solo show at the Gagosian Gallery in New York was canceled because the New York City Department of Health took issue with the sanitary arrangements for the main art work, a glass case in which cows were supposed to simulate copulation by means of a hydraulic apparatus.

Hirst's Gagosian show took place in the spring of 1996. Instead of copulating cows, the main work, entitled *Some Comfort Gained from the Acceptance of the Inherent Lies in Everything,* consisted

of two cows chainsawed into segments, from head to tail, and displayed consecutively in tall, formaldehyde-filled steel-and-glass cases aligned so that viewers could walk between them and see their truncated innards. There was also a pig sculpture, with the pig sliced in half vertically and similarly displayed, except that one of the glass cases moved back and forth on a track, so that the pig alternately departed from and rejoined its other half. In addition, there were some very large spin paintings and spot paintings, a beach ball floating on a column of air, and a mock ashtray eight feet in diameter containing several weeks' worth of real cigarette butts from the Groucho Club. The show was an art world event, which quite a few New York art types decided not to be impressed by. You kept hearing that vitrines had been done by Jeff Koons, who submerged basketballs in fish tanks in the 1980s, and that the spot paintings were too much like Gerhard Richter's color charts. Art generally comes from other art, though, and did so long before "appropriation" became a style. To me, Hirst's exhibition made everything else in New York look a little dingy. I found myself grinning a lot, and not worrying whether the stuff was really any good.

Slicing up cows and pigs from the abattoir might horrify the animal rights lobby, but Hirst's concepts were so over the top, so full of gross-out humor, and yet so coolly executed, that the effect was hilarious rather than morbid. The work had the same qualities of cheekiness and professionalism that made it almost impossible to dislike Hirst personally. In that crowd of ambitious, highly competitive British artists, he seemed to have no enemies. Everybody mentioned his generous impulses—his urge to support the work of his friends and to buy it himself, now that he could afford to—and his irrepressible energy and

high spirits. "You never switch off, do you?" Hugh Allan once marveled. "No, never," said Damien. He was not only the leader and standard-bearer of young British art but also its court jester, buying everybody drinks and telling jokes and dropping his pants in public. ("He's always had his willy out at every opportunity," according to Rachel Whiteread.)

There were a few people who thought he was pushing too hard. In 1996, Damien made a couple of not-great videos, and he directed a short feature film, *Hanging Around,* starring his actor friend Keith Allan, which his friends agreed was wooden and inchoate. David Sylvester, the dean of the London art critics, who had agreed to write about Hirst for a monograph on his work, decided not to after seeing *Hanging Around.* He was "appalled," he told the publisher, "by its mediocrity, banality, self-indulgence and lack of self-criticism." At this point, Damien's life seemed to be spinning out of control, what with the drinking and the drugs and the all-night parties at the Metropolitan Hotel, where he and Maia often stayed. What brought him up short was, first, becoming a father, and, second, his 1997 solo show of new work at the Bruno Bischofberger Gallery, in Zurich. He hadn't had enough time to get ready for the show; he was working on some sculptures until and after they were installed, and he felt humiliated by the results. "There was something wrong with every piece in that show," he told me ruefully.

Hirst changed his life after that. He pretty much cut out the drugs, and he stopped exhibiting for a couple of years. He hired an accountant to straighten out his affairs (it was Frank Dunphy, a legendary theatrical accountant who once represented most of the circus clowns in London), and he set up an office in Bloomsbury,

run by Hugh Allan and Jude Tyrrell, which they decided, whimsically, to call Science, because it would deal with Hirst's extra-art activities, while Jay Jopling would take care of the art side. Just before Connor was born, in 1995, moreover, Damien and Maia had bought the house in Devon, near the sea. "Maia said if we were going to live in the country, it had to be in a place where she could surf," Damien told me. "I didn't really want a house, but I fell totally in love with this one the minute I saw it."

These days, they spend more time in Devon than in London. Damien recently acquired the sculptor Lynn Chadwick's very large studio in Gloucester, about an hour and a half northeast of his Devon house, where he plans to do most of his work in the future. At the moment, he is doing no real art work in Devon. During the last three years, in fact, he has gone through periods of thinking he might give up art altogether. "I thought that if I put the energy that goes into art into Maia and Connor," he said, "I'd have a much better life, and I'd be more true to them and more true to art, in a way. But then Maia said something that really surprised me. She said, 'I hope you realize that I need you to be an artist.' It wasn't just her loving me and putting up with my being an artist. She needed me to be an artist. 'Hi, honey, I'm home—I've given up art for you.' And it's 'Goodbye.' Does that make any sense?" As Maia recalled it, she made that remark around the time he was getting into the restaurant business with Pharmacy. "He's far more interesting to live with when he's thinking about new aspects of life through art," she explained. "I wouldn't ever want him to channel his energy into something else."

On my last night in London, I had dinner with Damien at Mirabelle, a fashionable restaurant in the heart of Mayfair. He had brought along his friend Alex James, the bass player for Blur,

which is one of the top rock groups in England. Tall, laconic, and laid-back, James is probably as famous as Hirst, or more so if you're a teenager. They both looked fairly respectable, in T-shirts under dark jackets. One reason Damien had brought Alex along, I sensed, was that he'd had enough of being interviewed.

Damien was in terrific form, revved up, full of mischief. He had just settled a running feud with Marco Pierre White, the chef, over some art works in Quo Vadis, one of White's many London restaurants. Damien had lent the works—by himself and by other artists in his private collection. The restaurant was closed for renovations, and the works had been returned to Damien, but there were two spot paintings on mirrors near the bar which White had said were not being returned. Damien had been much annoyed, earlier, to read a newspaper story in which White bad-mouthed his art and said that he was making his own spot paintings on weekends. (White, who also grew up in Leeds, is famously belligerent.) Damien had told Hugh Allan to go over to Quo Vadis and smash the spot-painted mirrors with a hammer. Frank Dunphy and others intervened, though, and the crisis blew over. (The spots were cleaned off the mirrors.) Marco Pierre White, in fact, was treating us to dinner at Mirabelle, which he also owns. Damien instructed Alex to order a very expensive red wine.

At dinner, Damien said he was thinking about doing a chicken in formaldehyde, in an unlimited edition. "A prepared chicken," he said. "It will look just like the kind you get in supermarkets, all trussed up. We'll sell it at Sainsbury's. I'm interested in mass market." He and Frank Dunphy have set up a company to sell unlimited Hirst art editions. "It's called Other Criteria," Damien told me, "after a book by Leo Steinberg."

Edging closer to interview mode, I asked him whether he had an ideal viewer in mind. "Yes," he shot back. "Saturn devouring his children." Served me right, I thought.

Main course done, Damien and Alex ordered sambucas and made "sambuca vapor lockers," which involved lighting the liquor, clamping a palm over the glass to form a vacuum, and sucking out the fumes. A man and a woman at the next table watched with interest, so Damien ordered sambucas for them, too, and clamped his hand over the woman's glass for her when she couldn't get it right.

After dessert, the headwaiter suggested that we take coffee in the bar, because our table was needed. Damien seemed agreeable, but in the bar he dropped his pants; he stood up in the middle of the room (which was rather dark), and let them fall to the ground and then pulled them up. It didn't seem to me that anyone noticed—perfect timing, or British sangfroid.

In the taxi, later, Damien had the driver stop so he could get some cash at a money machine across the street. He moved in close behind a well-dressed man who was doing the same thing, and growled, "Give me your money." The man jumped, whirled around, and started laughing. Back in the cab, Damien and Alex sang, and Damien told bawdy jokes. "Fame is hard to deal with," Damien said at one point, "but I have my mates who are more famous than me." He got out his cell phone and called people: Maia in Devon, Jay Jopling ("Hello, darling, I love you"). He took us to his houseboat at Cheyne Walk, and peed off the bow, while the taxi waited. Then he and Alex were off again, to a meeting with Marco Pierre White at Quo Vadis, and I asked to be dropped off at my hotel. Just before leaving them, I think I heard him say, "Art, love, and God—they're dumb words, and

probably the dumbest is art. I don't know what it is, art. But I believe in it, so far."

September 20, 1999

Since this was written, Hirst and his art have moved in opposite directions. He and Maia have two more sons, Cassius and Cyrus, and family life in Devon occupies most of their time. Pharmacy (the restaurant) is defunct. Hirst has sworn off strong drink, and severed relations with Charles Saatchi. His work, meanwhile, has become the leading brand in the wildly expanding contemporary art market. In 2007, one of his medicine cabinet sculptures set an auction record ($19.2 million) for work by a living artist, and two months later his For the Love of God, *a human skull encrusted with 8,601 diamonds, was sold to a private investment group for what was reported to be more than $100 million. Hirst announced that the work would go on tour for two years, appearing at major museums throughout the world, and then be sold for a lot more. Neither life nor death shows any signs of letting him down.*

CINDY SHERMAN

People are often amazed that someone as nice as Cindy Sherman could be a major artist. By nice, I mean friendly, modest, warm, considerate, and even-tempered—qualities that we do not usually associate with artistic ego, and which might seem antithetical to the disturbing and phenomenally influential work that this artist has produced over the last twenty-three years. Since the early 1980s, when her now famous series of "Untitled Film Stills" caught the art world's attention, Sherman's photography-based art has presented us with deformed, disfigured, or demented people; still-lifes of spilled food and vomit; wicked parodies of Old Master paintings; grotesque, part-human monsters; medical mannequins arranged in pornographic poses; and, more recently, hideously distorted masks and mutilated dolls. These and other manifestations of Sherman's singular talent have brought her virtually universal praise. Her name figured prominently on most end-of-the-millennium lists of the century's

leading artists. (*ARTnews* placed her, along with Jasper Johns and Bruce Naumann, among the top ten now living.) One of the "Untitled Film Stills," which originally sold for $50 apiece, brought $200,500 at Christie's last spring, and the photographs in her current show, which opened at the Gagosian Gallery in Los Angeles in March, were all sold before the opening, at $30,000 each. None of this seems to have left a dent in Sherman's unassuming, unpretentious personality, or kept her from being the nicest girl on any block.

All right, she's forty-six, well past girlhood, but the fact is that both men and women tend to see her this way. "Cindy is such a girl," her old friend Brooke Alderson said recently. "When we talk, it's usually about something like finding the right lipstick at Kmart." When I asked Sherman about the violent images in her most recent New York show—the scarred and mutilated dolls—she agreed that they were pretty violent, and went on to say that, "as everybody knows," she had recently gone through a painful divorce, and there was probably some anger being acted out in them. Nobody ever sees that anger acted out anywhere else. She could be a poster girl for T. S. Eliot's dictum that the more perfect the artist, the greater the separation between the individual who suffers and the mind that creates.

Sherman was married for nearly fifteen years to the French-born video artist Michel Auder, who is ten years older than she is but not nearly as well known. She dealt with the strains that her growing fame placed on their marriage by shunning the spotlight so rigorously that her New York dealers (and friends) Helene Winer and Janelle Reiring, whose gallery, Metro Pictures, has represented her since the start of her career, assumed that she took no pleasure in the trappings of her success. "I really had

thought she didn't enjoy it, and that she chose to lead this incredibly quiet life away from the art world," Reiring told me. "But it wasn't that at all. It's amazing how she's been able to change her life around." She goes out more, to dinners and art world openings. She's found a house in Sag Harbor to supplement her SoHo loft. She keeps in shape by kickboxing at a gym twice a week, and she has even been linked romantically, if briefly, with Steve Martin, who escorted her to the Venice Biennale last May and to the opening of the "Sensation" show at the Brooklyn Museum last October. Experiencing celebrity on Martin's level was "a little scary" to Sherman, who is rarely recognized in public. They have remained friends, and Martin was the co-host (with Larry Gagosian) of a dinner for her at Mr. Chow's, in Beverly Hills, after her opening.

For the Gagosian show, Sherman reverted to a device she had often used in the past: taking her own face and body as jumping-off points for large-scale photographs of fictional characters. There were twelve of them this time, and in Sherman's mind they were all Hollywood types, women who had some connection, however peripheral, with the film industry. A big, busty, too-blond number in a white dress, sporting an extreme (obviously fake) diamond ring and turquoise eyeshadow, was described to me by Sherman as "some collector's wife, maybe, or a mogul's wife." (First wife, that is.) Another, even more heavily made-up creature, with glitter in her flyaway blond wig, was "an ex–bit player, who's still thinking about the Hollywood lifestyle." There were former Valley Girls who had spent too much time in the sun; a New Age guru with long silver-blue fingernails, Indian beads, and a serene half smile; and a tattooed "biker chick," as Cindy referred to her, who had "started out looking closer to Cher, but then I sort of roughened her around

the edges." It was a little odd, walking around the empty gallery with the artist—this was the day before the opening, when the show had just been installed—looking at portraits for which she had posed but in which she was not present. Sherman herself is slim, casual, and unaggressive. Her hair these days is short and blond. (It changes color periodically.) Her makeup is minimal. At the gallery that morning, she had on jeans and a red-and-white T-shirt, but she informed me that she had bought a dark-blue Prada dress for the opening, and had just had her nails done at Frédéric Fekkai, courtesy of the Gagosian Gallery. Her rental car was a red Jaguar—Hertz was offering a special on it, she said, giggling. In her relaxed, low-key way, Sherman is great fun to be around. This is not something that could be said of the women whose pictures lined the walls.

AT THE OPENING the next night, which was hugely crowded, a woman in a fur stole asked me what I thought of the pictures. I mumbled something, which neither of us could hear above the din. "I've been looking at her work for a long time," the woman said, in a firm and measured tone, "and these are the most disturbing things I've seen yet. There is no empathy in them, none at all. Every woman I've talked to here feels the same way." I asked if she meant that the pictures were cruel, and she said yes, emphatically. I could see her point. Several of Sherman's Hollywood types projected a kind of desperation that went beyond parody. They weren't losers, exactly, but you couldn't help seeing how hard they worked to hang on to things—youth, glamour, hope. Although the women might appear shallow, with their silicone implants and their gaudy makeup, their stories ran deep, and this, of course, is what has made Sherman's

work so powerful and so influential. She has reclaimed the oldest trick in the book, storytelling, and given it new life in visual art. An amazing number of younger artists have followed her lead; the galleries are full of what has come to be called setup photography, in which complex and often highly enigmatic scenarios are plotted, constructed, and photographed, and much of the newer painting and sculpture on view these days has a strong narrative content. Nobody's stories, however, are more gripping than Sherman's, or more merciless. Although her Hollywood portraits didn't strike me as cruel, I had the sense, whenever I glimpsed one of their real-life counterparts circulating in the opening night crowd, that to some people they could be very upsetting.

At the dinner immediately following, in Mr. Chow's dynastic, Art Deco palace, I never even saw Sherman. She had disappeared in the cloud of stars and potentates: Robin Williams, Jacqueline Bisset, David Hockney, LL Cool J, Chloë Sevigny, Cheryl Tiegs, Ahmet Ertegun, Eli Broad, Mike Leigh, Elle Macpherson, among many others. Several people I talked with, including Steve Martin, thought it was interesting that Sherman had come full circle, so to speak, with photographs that had to do, in one way or another, with the movie business. Sherman herself once talked to an interviewer about the stereotype of a girl who dreams all her life of being a movie star, and either succeeds or fails. "I was more interested in the types of characters that fail," she had said. And now here she was, a star in her own right, celebrated yet virtually anonymous. Dinner guests who didn't know her kept asking which one was Cindy.

She left town two days later, a few hours before the Academy Awards ceremony. "I was just as happy not to go to that," she

told me. "It would have seemed a little pretentious, and I was pretty stressed out from the opening."

GROWING UP IN suburban Long Island, in the 1950s and 1960s, Cindy Sherman watched a lot of movies on television. *Million Dollar Movie* played the same film five nights running, and she'd watch all five showings. She watched horror films, and classics, and occasionally an art film on PBS; she vividly remembers seeing Chris Marker's *La Jetée,* a post-nuclear-holocaust story done almost entirely in still images and voice-over. Cindy was born in Glen Ridge, New Jersey, but when she was three her family moved to Huntington Beach, Long Island, where her father worked as an engineer for Grumman Aircraft and her mother taught in the public schools. She had what she remembers as a normal, happy childhood. "The summers were great," she told me. "We could just take a towel and walk to the beach, ten minutes away down a wind-ey little road." Cindy—her given name was Cynthia, but nobody called her that—was the youngest of five children, two of whom had grown up and moved out by the time she came along. (She was nineteen years younger than Bob, the eldest.) Her brothers and her sister remember that Cindy spent a lot of time alone in her room, and that she loved to play dress-up. She had a trunk full of old clothes, some of them inherited from her grandmother, with which she could transform herself into a little old lady or a witch or a monster; she never seemed to want to be a ballerina or a glamour girl. Cindy didn't have a problem with the way she looked out of costume; it was just that she really enjoyed becoming someone else. Because she was the baby of the family, she was probably spared some of the difficulties that the others had gone through with Charles Sherman, their father, whom they all seem to have disliked in varying degrees.

Cindy once described her father to Peter Schjeldahl as a "creep," an insensitive and self-absorbed man who "would criticize with hate." Their mother, she added, "was always shielding him from the world and us from him." Cindy's brothers and sister went on to have families and productive lives, all except Frank, who committed suicide when he was twenty-seven. Frank, who never settled on a career, had moved back into his parents' house while Cindy was still in school, and during the last year of his life the two of them were very close.

Another thing her siblings remember is that Cindy was always drawing. Even while she watched TV, she would be working on a school art project or making skillful likenesses of people or objects. She got her best grades in art, and, since her family couldn't afford private-college tuition, she chose the State University College at Buffalo, whose art department offered a bachelor of fine arts degree.

Sherman entered college in the fall of 1972. She did very well in drawing and painting—she could copy anything with great precision—but the basic BFA curriculum required her to take a photography course, and she flunked that, not having mastered the technical aspects. Obliged to take the course again as a sophomore, she had a different instructor, a young woman named Barbara Jo Revelle, one of the few teachers at the college who were aware of Conceptual art and other contemporary trends. "She felt that to have an idea was what mattered," Sherman recalled, "and right away that made so much more sense to me." Sherman had recently met Robert Longo, a charismatic older student who knew a lot about modern and contemporary art. On one of their first dates, he took her to the Albright-Knox Art Gallery, a first-rate museum right across the street from the college, which she had never thought to visit on her own.

In the spring of her sophomore year, Sherman was living off campus with Longo, and worrying herself silly about her photography class's upcoming field trip. "Barbara Jo's class had a history of going out every spring to a local waterfall—not Niagara, just some idyllic spot—to get naked and take pictures," she said. "Me being the prude I was, and still am, I dreaded that so much! So I decided to confront the idea. I took a picture of myself just standing in a room of the apartment I shared with Robert, stark naked, like a deer in the headlights. After that, I did more pictures using my body, distorting it by weird angles. I guess that was the beginning of using myself." She passed the course this time, and soon afterward decided to change her major from painting to photography. Her adviser said she didn't seem very committed to either, and had her switched from a BFA- to a regular BA-degree program.

Robert Longo graduated in 1974, but he stayed on in Buffalo and, with his friend Charles Clough, started Hallwalls, a nonprofit exhibition space in a former Buffalo ice-making plant. (It was modeled on Artists Space in New York, and other "alternative" galleries that were springing up in the early 1970s.) Longo and Clough wangled grant funds to renovate the premises, and they invited artists whose work they admired to come and lecture or lead workshops; in the first year, visitors included Robert Irwin, Jonathan Borofsky, Vito Acconci, and Chris Burden. As Longo's girlfriend, Sherman struck Clough and the other artists and students who hung out at Hallwalls as a quiet, background presence but a presence nonetheless. Now and then, for exhibition openings or parties, she would turn up as someone else—Lucille Ball, on one memorable occasion, or a pregnant housewife, decked out in one of the clunky outfits she was always picking up at local thrift shops. She never tried to act out the character she had become, or

to call attention to herself; it was just the same quiet Cindy, playing dress-up. Eventually, encouraged by Longo, she began to photograph some of these people she could turn herself into. Linda Cathcart, a newly appointed curator at the Albright-Knox, put a fold-out book of her photographs—a series of head shots in which she transformed herself using makeup—in a regional group show there in 1975, along with work by Longo, Clough, and other Hallwalls artists. "The more Cindy's work accessed Cindy, the more it grew," Longo recalled. "Cindy's work was growing a lot faster than mine."

Sherman graduated that year and would have been happy to stay in Buffalo indefinitely, even though most of her artist friends said she should be in New York. The city scared her; as a kid, growing up less than an hour away, she had almost never gone there. Then, in 1977, she won a $3,000 grant from the National Endowment for the Arts. Longo had just been selected as one of five artists in an important show at Artists Space, and he decided it was time they made the break. "I've got the show," he said, "and you've got the money."

They moved that summer, subletting a loft on Fulton Street from the artist Troy Brauntuch. "Cindy had a real hard time for the first few months," Longo recalled. "She'd get dressed and put on her makeup, and then never leave the apartment." She was hired for an entry-level buyer's job at Macy's, but she quit after one day. Helene Winer came to the rescue at that point, by making her the receptionist at Artists Space. As the director there, Winer had visited Hallwalls, met Longo and Sherman and the others, and shown their work in New York. "I wanted Artists Space to be a place where artists felt comfortable, and right from the start everybody adored Cindy," she told me. Sherman worked there from 1977 to 1981. And there, too, she occasionally came

to work as someone else—a nurse in a white uniform, a 1950s secretary type—and everyone found that weird and funny, but she stopped doing it because, she said, she was afraid of losing her street identity, "which you really need in New York." One day in 1978, she brought in some eight-by-ten black-and-white photographs. It was the first work she had been able to do since leaving Buffalo, and it struck Winer and others as original and very exciting.

UNTITLED FILM STILL #7 (1978). A young woman in a white slip and white stockings stands in the open doorway of a cheap motel. She faces us directly, bending forward at the waist, holding a full martini glass by the rim as, with her left arm, she pushes back the curtains. Oversized dark glasses shield her eyes from the harsh sunlight raking one bare shoulder. Another woman (Sherman's friend Nancy Dwyer) sits in the sun to the left of the door, her face hidden by a straw hat. Vegas showgirls getting it together after a hard night? A scene from an early Hitchcock film, which we can almost, but not quite, place? Like real film stills, which are not frames from a movie but working photographs, designed to tout a product on billboards or in ads, Sherman's tell stories that viewers can read in different ways. "I wanted them to seem cheap and trashy, something you'd find in a novelty store and buy for a quarter," she told me. "I didn't want them to look like art."

There are sixty-nine in all, sixty-nine single-image dramas in which Sherman plays every role: primly dressed office worker, small-town librarian, jilted lover, bimbo, film noir heroine, suburban high schooler, angry housewife (scowling over a broken bag of groceries). The sheer range of self-transformation is astonishing. Using only makeup, wigs, clothing, and a few props, she

makes herself look vulnerable, sexy, gauche, put-together, a total mess, plump, slender, tough, childlike, worn—like every kind of woman except Cindy Sherman. You could study the pictures for an hour and then fail to recognize her on the street. Some of the characters are loosely based on actresses in specific films (Sophia Loren in *Two Women*; Monica Vitti in *L'Avventura*), but the details are made up, and viewers who tell Sherman they "remember" the scene that is being re-created are remembering wrong. One reason the pictures are so compelling is that Sherman never seems to be acting in them—she projects the character through subtle, understated relationships between her expression, her clothes, the background, the lighting, and a general atmosphere unique to each image. She took many of them herself, using an extended shutter release; for others, she set up the scene and got Longo or someone else to snap it. Her father, who was retired and living in Arizona, took the most famous one, which shows her as a blond waif in a plaid skirt and white socks, standing with her cheap suitcase on a country road at dusk, waiting for—what? Sherman says she imagined the character waiting for a bus, but the picture's unofficial title, conferred by others, is *The Hitchhiker*, which carries a frisson of anxiety about who or what will appear around that darkening curve in the road. Sherman's "Untitled Film Stills" are now considered to be one of the landmarks of late-twentieth-century art. Ten prints were made of each image, and most of them have been sold at least once; the Museum of Modern Art has the only complete set, purchased in 1996, for a price believed to be in excess of a million dollars. According to Peter Galassi, the chief curator of MOMA's photography department, they are the work of "a very young artist who, following her own nose, figured out something that worked for her, and that resonated with all kinds of concerns and passions that were outside her."

Her timing was perfect. In the early 1980s, after a decade of relative quiescence in contemporary art, new energies were heating up the scene. Neo-expressionism, which emerged more or less simultaneously in Germany, Italy, and New York, unleashed a wave of large-scale, semi-figurative painting and sculpture, along with the operatic egos of Julian Schnabel, David Salle, and other local practitioners. The appropriationists, meanwhile, were undermining the whole concept of artistic originality with deadpan re-creations of older art. Another trend had been identified in a 1977 show at Artists Space called "Pictures," the show that made Robert Longo decide to move to New York. Longo, Jack Goldstein, Troy Brauntuch, and the other "Pictures" artists all worked with photographs or photo-based imagery that reflected the media-saturated environment they had grown up with—television, movies, advertising, rock music. Although Sherman was not in the show, her "Untitled Film Stills," some of which were displayed at Artists Space in 1978, in the first of a widening gyre of exhibitions which continues to this day, established her firmly within that group, and when Helene Winer and Janelle Reiring (who had worked for the Castelli Gallery) set up Metro Pictures, in 1980, to showcase the media-oriented newcomers, their core artists were Longo, Goldstein, and Sherman. What set Sherman's work off from the others' was its performance element. As a student in Buffalo, she had admired the work of Eleanor Antin and other performance artists, whose one-person scenarios were often documented in photographs or videos. Although Sherman felt no inclination to perform in public, she had found, in the film stills, a way to use her gifts as a unique and endlessly inventive actress.

She spent the next year teaching herself how to work in color,

and on a larger scale. In her first solo show, at Metro Pictures in 1980, Sherman presented a new series of female characters, posed against outdoor backgrounds that she had photographed and then projected onto a screen in her studio. Sherman and Longo had broken up a year earlier, quite amicably—they remained and still are close friends—and she was enjoying a new sense of independence. She wanted to work in the studio alone—no more depending on others to snap the shutter—and she learned, through trial and error, how to make photography do what she wanted, which was to create characters and tell stories. She was using the camera, as one critic observed, "for an end result that didn't necessarily have very much to do with the camera."

Her next series, after the rear-screen projections, was the result of a 1981 commission from *Artforum*'s editor in chief, Ingrid Sischy, who frequently invited artists to do special projects for the magazine. The format—two facing pages—led Sherman to think about the "centerfold" photographs in *Playboy* and other men's magazines. She came up with several large images, two feet high by four feet wide, showing clothed women in supine or semi-supine positions. The pictures never ran. Sherman remembers Sischy being worried that they might be "misunderstood" by militant feminists. As Sischy explained to me, she thought the pictures, appearing first in a magazine, would look "a little too close" to the pinups in men's magazines, and that the irony in Sherman's approach would be unclear. (It was the only time Sischy ever rejected an art work she had commissioned for *Artforum;* three years later, she commissioned and published another Sherman photograph, and she has been a strong advocate of the work ever since.) At any rate, Sherman wanted to continue with the horizontal format, and she went on to make

a series of "Centerfold" photographs that caused a stir when Metro Pictures showed them, later in 1981. With their highly sophisticated color, life-size figures, and a sense of incipient drama, her new prints had the power and authority of oil paintings. They *were* misunderstood by a number of politically minded art students (male and female), who accused Sherman of undermining the feminist cause by depicting females in "vulnerable" poses.

"I was definitely trying to provoke in those pictures," Sherman told me one day as we were leafing through a catalogue of her work. "But it was more about provoking men into reassessing their assumptions when they look at pictures of women. I was thinking about vulnerability in a way that would make a male viewer feel uncomfortable—like seeing your daughter in a vulnerable state. But the horizontal format was a problem. Filling that space meant using some kind of prone figure, and that made it seem to some people that I was glorifying victims, or something. This one in particular": She stopped at an image of a girl lying in bed, black sheet pulled up to her chin, her damp features and tangled blond hair inundated by harsh daylight. "My idea when I shot it was that this is someone with a hangover, waking up to the sun and thinking, Oh, God, what time did I go to bed? It wasn't anything at all about rape, although that's how it's been described. I realized later on that I have to accept that there will be this range of interpretations that I can't control, and don't want to control, because that's what makes it interesting to me. But at the time I was sort of disturbed that people could so misinterpret my intentions, and I guess that's why I tried to clarify them in the next series."

The so-called "Pink Robes," which came next, are four vertical images of a young woman (Sherman, of course, in nothing

but a pink chenille bathrobe) sitting and glaring straight into the lens. Sans wig, sans visible makeup, she still manages, by means of facial expression and lighting, to look nothing like her real self. Sherman envisaged a centerfold model resting between shots, and "pretty annoyed that this is her lot in life." After that, she went on to do vertical portraits of other characters, including some who are either androgynous or male and don't look vulnerable at all.

One reason Sherman identifies all her photographs by number, rather than giving them titles, is that she wants whatever is going on in them to remain somewhat ambiguous. This didn't prevent radical feminists from claiming her as their anointed vessel. Scores of articles in academic journals used the "Untitled Film Stills" to illustrate studies of gender, identity, and the dehumanizing male gaze. This was okay with Sherman, although she admitted that she never read the articles, and said once that she had never heard of the male gaze. ("It is necessary to fly in the face of Sherman's own expressly non-, even anti-, theoretical stance," one leading feminist concluded.) Sherman shared the feminists' goals, all right, but it wasn't in her nature to be a militant. She was bored by art talk, especially when it bogged down in political issues. Her idea of a good time was to go dancing with friends; the first thing the choreographer Bill T. Jones noticed about her, when they met and became friendly, in the mid-1980s, was that she was a terrific dancer.

Sherman's breakthrough year was 1982. The "Centerfolds" show at Metro Pictures brought invitations for her to exhibit at the Stedelijk Museum in Amsterdam, and at the important Documenta 7 in Germany. She was in the Whitney Biennial in the spring of 1983, and on the cover of *ARTnews* that September. Success made her uneasy. "I was feeling guilty about being

accepted as an artist, especially since some of my friends weren't
getting the attention I was," she recalled. (One of those friends
was Richard Prince, a Metro Pictures artist whom she lived with
for a year or so; they broke up in 1982.) The actor and writer
Eric Bogosian, who had become a close friend, remembers a
Sherman opening at which he sensed enormous discomfort on
her part. "She didn't know what to do with all the attention
she was getting," Bogosian said. "And then later she kind of di-
gested that and moved on, went back to being a new form of
Cindy the way she always was."

Her reaction to success was to make tougher and more
provocative work. Two commissions from fashion designers, for
photographs in Sherman's storytelling manner, produced a run
of images that progressed from hilarious sendups of the clothes
to pictures of ugly women with fake scar tissue and angry or
homicidal expressions. The "fairy tales," which came next, fea-
tured even more nightmarish scenes: a pig-snouted woman
lying in muck; a drowned girl; a turbaned, kneeling houri with
huge fake breasts and horribly grinning false teeth. (Many of the
props came from Gordon Novelty, a gold mine of tricks and dis-
guises that Sherman had discovered on Broadway.) She worked
in sustained bursts of energy, spending long days in the studio
until she had completed a series of images, and then making no
new pictures for several months, or longer. Her dealers marveled
at her apparent lack of ego. "I don't think her ambition is clear
to this day," Helene Winer said last spring. "I know it's there,
because it couldn't not be. But she never even knew or cared who
the important critics and collectors were. I couldn't think of an-
other artist with comparable innocence or disinterest." There is
one slight problem in representing Sherman, according to Janelle

Reiring: "It's very hard to get her to say what she wants. She doesn't like to ask for anything."

In truth, Sherman went through a period of feeling quite negative about the overheated 1980s art world, with its opportunists, and what she called its "nouveau, flavor-of-the-month collectors," who bought whatever their art consultants told them to buy, and its male art stars, like Julian Schnabel, whose big, macho paintings were selling for as much as $90,000 at auction in the early 1980s, while her photographs, which were issued in editions of ten, brought only $1,000 apiece. From the start, Sherman's gallery had presented her as an artist, rather than as a photographer. Some collectors, including Charles Saatchi and Eli Broad, had been quick to recognize this, to see her as a major talent who used the camera for work that was not in essence photographic, but others found it hard to see beyond her medium. The photography world did not recognize her at all—understandably, since her pictures, though technically sound, had nothing to do with the traditional concerns of documentary or fine-art photographs. When Sherman's pictures first started coming up at auction, in the mid-1980s, they were put into the photography sales, and they did rather poorly; later, Sotheby's and Christie's began putting them in their contemporary art auctions, where they did very well.

"Everybody knows Cindy as this incredibly sweet person, but she also has a great edge and anger to her, which comes out in the work," Robert Longo said recently. "At one point in the eighties, I think she got pretty angry about Schnabel and Salle and me, and she made some really nasty work, great work. It was like she was saying, 'Well, fuck you.'" The "Disaster" series, as this work has come to be called, occupied her from 1987 to 1989,

and included some amazingly revolting images concocted from fake body parts, spilled and rotting food, and anatomically re-arranged dolls. In some of them, for the first time, Sherman her-self is not present, or is present only minimally, as in a large-scale close-up of food and vomit, in which her horror-stricken fea-tures are reflected in a pair of sunglasses. Seen from a distance, some of these pictures are remarkably beautiful, their details un-readable in the mass of glowing colors and subtly modulated light and shadow. This was intentional. "I wanted something vi-sually offensive but seductive, beautiful, and textural as well, to suck you in and then repulse you," she told one interviewer. She has nothing against beauty. "What I'm against," she explained to me, "is how your mind is fucked with about what you should be, instead of what you are. Most models in fashion magazines are repulsive to me. The few times I've seen models up close, live, they seemed as freakish as someone with a third eye. The tiny head and long, skinny body and perfectly symmetrical features just looked bizarre." Her increasing fascination with grotesque and ugly images, she said, had "definitely evolved out of the work I was producing," but there was another side to it as well: "The fake blood and false noses and stuff like that were fun for me to use. I saw really interesting things in what other people call ugly. Besides, I find gross things funny." It was the kind of fun she'd had as a child, when she'd make herself look as horri-ble as possible on Halloween.

Success on a truly embarrassing scale arrived with Sherman's 1989 show of "history portraits," at Metro Pictures. By then, she had pretty much "worked out the guilt," as she put it, and much of the anger as well. After being mostly absent from her photographs for several years, she went back to using herself in

this series, costumed in what appear to be the silks and furs and velvets and elaborate hairpieces of Renaissance courtesans and madonnas, biblical heroines, and haughty Old World aristocrats, both male and female. The costumes are constructed from thrift-shop remnants, and the grandees are all somewhat off, with false noses or pendulous breasts, but they are also weirdly convincing. (A bejeweled *virgo lactans*, squirting a jet of milk from one of Gordon's trick titties, has the lush physical presence of a Veronese.) Although Sherman worked on this series while she and Michel Auder, whom she had married in 1984, were spending three months in Rome, most of the poses were suggested by reproductions in art books, and very few duplicate actual paintings. When Metro Pictures showed them in 1989, priced from $15,000 to $25,000, in ornate Old Master frames that Sherman had chosen to set off their bravura scale and sumptuous colors, it was one of those killer art world events—rave reviews, tremendous word of mouth, every available print sold. Naturally, Sherman felt guilty about that—all the more so because the series had been such fun to do. Anyone who knew her could have predicted that more punishing visions lay ahead.

"CINDY, FOR GOD'S SAKE!" Cindy and my wife and I are sitting at a long refectory table in Sherman's SoHo living room, looking at a catalogue reproduction of one of her 1992 "Sex Pictures." This one shows a recumbent figure whose dissociated elements are a granny fright mask and wig, artificial arms bent at the elbow, a fake rubber torso (nude), and a detached groin in which an oversized red sponge-rubber vagina harbors a string of bratwursts. Sherman, as always, is cool and unflustered. She strokes Frieda, her green macaw, who perches on her shoulder

throughout the interview, interrupting us now and then with piercing shrieks. (Sherman has had a bird ever since her college days, when someone gave her a dove. Nancy Dwyer, whom Sherman roomed with for a while after breaking up with Robert Longo, recalls being a little unnerved at seeing the dove, which had gone blind, pecking bits of egg from Cindy's lips at the breakfast table.) But the "Sex Pictures"? "I'd been wanting to do some sexually explicit pictures, with real nudity, but I wasn't interested in being nude myself," Sherman explained, in her matter-of-fact way. "And then I found this catalogue you could get, of medical things, to teach medical students about different bodily functions."

Sherman ordered a number of mannequins from the catalogue, altered and dismembered them, combined them with props from her vast inventory, and photographed them in combinations that make sex look about as appetizing as the bubonic plague. Her sex pictures were in some sense a response to the political storms over "pornography" in art (Jesse Helms versus Robert Mapplethorpe, et al.), and also to Jeff Koons's copulation images, which she had greatly disliked. (She found them puerile and sensationalistic.) The guardians of public virtue never turned a hair over Sherman's images, which have been widely exhibited, and which strike me as far more confrontational than anything produced by Mapplethorpe or Koons. In a gruesome way, they are also extremely funny. The series was not nearly as popular as the history portraits, though, which came as a relief to Sherman.

Honors rained down on her nonetheless: a Whitney Museum retrospective in 1987; a second major retrospective, organized in 1998 by the Museum of Contemporary Art in Los Angeles, which traveled to six other museums; steadily rising prices; a Guggenheim Fellowship and a MacArthur Foundation "ge-

nius" grant; a Vesuvius of critical articles and catalogues and monographs, so many by now that a graduate student could specialize in Sherman studies. With each new show, it seemed, Sherman challenged herself and pushed her talent to a new level. She kept surprising the critics, many of whom reacted to her work with uncritical admiration. They, and many artists, agreed that she had put photography, for the first time, on the same plane as painting and sculpture. Peter Galassi, who took over as chairman of MOMA's photography department in 1991, is unequivocal in assessing her impact: "The rhetoric of the postmodernist revolution has turned out to be a good deal less persuasive than it first seemed to many people," he said last week, "whereas Sherman's work only seems more and more persuasive."

The more famous Sherman became, the more she withdrew from the art world. She avoided interviews, refused invitations from the David Letterman and the Charlie Rose shows, stopped going to parties and openings. She spent a lot of time at a house that she and Auder had bought in Stephentown, New York, in the Hudson River highlands. She cooked (beautifully, of course); she patronized the local antiques shops; she made imaginative Christmas gifts for friends. Auder is an expert skier, so she became one, too. He had a daughter and a stepdaughter from his previous marriage to Viva, Andy Warhol's former superstar. Unable to have a child of her own, Sherman grew very close to her stepdaughters, whom she has continued to see since she and Auder were divorced; they stay in her loft when they come to New York. "I thought about adopting a child," Sherman said once, "but in talking to my husband it seemed like maybe it wasn't a good idea." According to Janelle Reiring, "She was really happy with Michel, and he was great about her success for a long time." In the end, though, her success was too

big, and the marriage foundered. "Cindy didn't want it to end," Helene Winer told me. "She went through a lot of therapy. But when she saw it really was over, she wanted it over that day. She's still sad about it, but right now she's the best I've ever seen her."

THE NEW WES CRAVEN slasher flick, *Scream 3,* is playing all over, and I arrange to see it with Sherman. She slides down in her seat like a teenager, knees pulled up, and giggles at the gory parts and the in-jokes, like the casting of Roger Corman in a bit part. Afterward she says it isn't anywhere near as scary as Craven's *A Nightmare on Elm Street,* which is one of her all-time favorites, along with *The Texas Chainsaw Massacre.* She loves the adrenaline rush that she gets from even the worst of these films, and she also believes that they help fortify you for the horrible events that can invade your life at any moment. When the independent producer Christine Vachon came to a Sherman Christmas party in 1994 and said she would love to produce a low-budget horror film directed by Sherman, Sherman was immediately interested. The result, three years later, was *Office Killer,* which had a brief run at a few art houses in 1997. (It is currently available on video.) Miramax bought the rights, but sold them to another firm, which never got it into general release. One thing to be said about *Office Killer* is that the film, though written by someone else, could have been made only by Cindy Sherman. The protagonist is a clinically repressed copy editor (played by Carol Kane) who accidentally kills a male colleague, and then, not accidentally, dispatches several others and a couple of children selling Girl Scout cookies, and arranges the corpses in sociable groups in the basement of her house. Lau-

rie Simmons, an artist who is one of Sherman's best friends, says she literally can't watch some scenes in the movie, such as the one where Kane, humming to herself, repairs the rotting chest cavity of her first victim with Scotch Tape. "I've never worked on a movie where I felt the director and I were both creating the character, and that she was as much a part of the character as I was," Kane told me. "She even did my eyebrows every day." As a director, Kane went on to say, Sherman was open to suggestions from everybody on the set. "She was definitely in control, but never needed to show her control. There was a lot of laughing involved, too. The gorier things got, the happier she was." The film received bad reviews, and must be judged Sherman's only nonsuccess to date, but some people loved it. "I could not stop laughing," Ingrid Sischy said. "It was my favorite movie of the year. It should have won an Academy Award." Sherman would like to direct another film sometime, but only if she can write the screenplay.

SHERMAN DOES HER WORK in a long, euphorically cluttered room that adjoins the living room in her loft. Built-in cedar closets and drawers line the walls on two sides, and every one is crammed with props: costumes and fabrics, wigs, fake body parts (one drawer for heads, another for hands), costume jewelry, cosmetics, toys and novelties, masks, fake ants and bugs— twenty years' worth of insatiable collecting. At the far end, in front of a pull-down paper backdrop, is a hard wooden chair flanked by professional tungsten lights, facing a Nikon on a tripod and, just to the right of it, an adjustable, full-length mirror. For the portraits in her Gagosian show, Sherman sat in the chair and developed each of her characters through a thousand small

changes of costume, makeup, lighting, and expression. "I'll just sit there and ham it up," as she once explained, "looking in the mirror to see what works." She has no preconceived ideas of what she wants. The character emerges through the process. Sherman has described that process as "trancelike," and it can take a very long time. "When it works, it's really exciting," she once explained. "There is a flash when you see somebody else." When it works, there is a moment when "something else takes over" and the character comes to life, but even then she doesn't know exactly what it's going to look like on film. "My way of working is that I don't know what I'm trying to say until it's almost done."

This is all hearsay, because only Sherman's ex-husband and her cleaning lady have ever seen her at work here. She does everything herself—costumes, makeup, lights, camera, action. A young photographic artist named Susan Jennings works for her two days a week (in a separate office around the corner), doing paperwork and dealing with the outside world, but in twenty years Sherman has never used a studio assistant. Come to think of it, watching her work might be a little creepy. How many of us have actually observed an artist in the act of disappearing into art?

To her friends, there is something mysterious about Sherman. Nancy Dwyer, who has known her since they were students in Buffalo, told me that, even back then, "she had a detachment that made it so she didn't have to engage in showing who she was. Detached but kind. Sometimes you felt as though you weren't getting to know her." Brooke Alderson says she has "the banality of a great actress." Sherman is not nearly as bland as she can appear to be: There is an edge to her opinions, and no one has ever accused her of sentimentality. But she is terribly nice, to

everyone ("It's sickening," she concedes), and how do you reconcile that with the anger and the violence and the horrific images that keep cropping up in her work? You don't. With this artist, the work and the life connect in ways that are as surprising to her as they are to us.

—*May 15, 2000*

Sherman continues to avoid the spotlight and do her work. She divides her time between New York and Sag Harbor, and she has settled into a mutually rewarding relationship with the innovative musician David Byrne, who cofounded the new wave band Talking Heads. *Her photo-based art hews to its own unique direction. "I'm at a point where when I feel like using myself I will, and when I don't I won't," she said the other day. "As time goes by, and I get older, it'll be interesting to see how I incorporate that into the work."*

JULIAN SCHNABEL

Julian Schnabel, painter and film director, wearing an ungirdled camel-colored bathrobe over blue pajamas, welcomed me to his house on West Eleventh Street with a double *abrazo,* his curly reddish-brown beard brushing both my cheeks. "Did you watch the awards?" he inquired, looking simultaneously amused and pained. "Can you believe it?" He was referring to the Golden Globe awards in Hollywood, two nights earlier. Javier Bardem, who plays the lead in Schnabel's new film, *Before Night Falls,* had been one of five nominees for best actor of the year, but the award, given annually by the foreign journalists' association in Los Angeles, had gone to Tom Hanks, for his performance in *Cast Away.* Schnabel couldn't quite suppress the news that he, personally, had found *Cast Away* "idiotic." His flight back from the West Coast had got in late the night before, but he looked fit and glossy—relaxed, genial, a bit more svelte than I remembered him. "I've been on a diet for three months,"

he confided. "I've lost twenty-five pounds. I was starting to look like Orson Welles."

Other voices could be heard as we progressed down the front hall, a baronial corridor punctuated at either end by towering, totemic-looking bronze sculptures by Schnabel. Olatz Lopez Garmendia Schnabel, Julian's Spanish-born wife, her dark beauty set off by a white terry-cloth robe, emerged from the bedroom and waved. Cy and Olmo, their seven-year-old twin sons, raced barefoot from the kitchen; they shook my hand unself-consciously before racing off again. In the kitchen, Javier Bardem was talking in Spanish on a cell phone. In spite of the domestic ebb and flow, being in Schnabel's house is like being in another country—baroque, theatrical, pre- rather than postmodern. A cast-bronze table in the dining alcove, with tiles set into the top at irregular intervals, is fourteen feet long. (Schnabel made it himself.) Schnabel's huge, dark paintings, with their weathered surfaces and abstract forms, could have been on the walls for centuries. The ceilings must be twenty feet high.

Julian wanted me to talk first to Bardem, whose breakthrough performance in *Before Night Falls* had repositioned him as an international star. When Schnabel chose Bardem for the part—after Benicio Del Toro turned it down—a lot of people wondered how this relatively little-known Spanish actor, whose work in films usually featured him in macho, tough-guy roles, could possibly play Reinaldo Arenas, the homosexual Cuban poet and novelist whose searing memoir is the basis of Schnabel's film. Casting is the key to directorial success, of course, and even though Schnabel had directed only one film before this (the 1996 *Basquiat*), he had decided, on the strength of Bardem's performances in Pedro Almodóvar's *Live Flesh*, J. J. Bigas Luna's *Jamón, Jamón,* and several other Spanish films, that this was an

actor who could do anything. Unfaltering confidence in himself has always been one of Schnabel's strongest points—or most irritating flaws. By now, though, even the doubters were conceding that he had drawn from Bardem an astonishing and deeply affecting performance, one that was being talked about, even before the Golden Globes, as Oscar material, and Julian, needless to say, felt good about that. "All these actors have been coming up to me," he said. "George Clooney told me how great he thought my movie was, and Ray Liotta, whom I don't even know, said, 'Just tell me where to be, man, and I'll be there.' They all want to be in my next film. Francis Ford Coppola sent me the script for *On the Road,* by Kerouac. It's really wild. Now, if Fine Line"—the distributor of *Before Night Falls*—"would just spend some money advertising my film, instead of putting it into some dumb, poorly acted, waste-of-time movie like *Thirteen Days . . .*" Julian said this mildly, without rancor. "I always want more," he added. "I want the public to be smarter. Maybe that's a pretentious idea?"

When Bardem got off the telephone, Julian took us into what he calls "the red room," a vast salon with oversized burgundy sofas and four huge, predominantly red paintings from his "Los Patos de Buen Retiro" series, and announced that he was going to leave us alone to talk. We sat down at one end of a long sofa—the end with a hippopotamus skull on a Biedermeier table—and Bardem, who, with his bushy hair, broken nose, and mobile mouth, really does look a lot like the photographs of Reinaldo Arenas, talked about working with Schnabel on the film, most of which was shot on location in Mexico. "It was hard, really *hard,*" he said. "We work eighteen hours every day for three months. Julian is not a mechanical director. He doesn't know exactly how he's going to shoot a scene, which is great, because

he makes you responsible. He makes you live the role twenty-four hours a day. Once, back in New York, we were shooting this scene in the kitchen where I break a glass and cut my hand, and I was nervous, I didn't know how to do it. I say, 'Julian, I need you to tell me how and what I have to do, which you haven't done in all these months.' He says, 'What am I supposed to say? You are the man. You are Reinaldo.' A good answer. He gave me this trust. The movie talks about freedom, and we have to be free to act."

TO THE SURPRISE of those who consider Schnabel undisciplined, he brought the film in on time and within its $8 million budget, and he earned, according to Bardem, respect and real affection from his crew and from the cast, which included his pals Sean Penn and Johnny Depp in supporting roles. The movie hews very closely to Arenas's book, with some scenes from other Arenas books or from Schnabel's imagination. (Schnabel wrote the screenplay, in collaboration with Cunningham O'Keefe and Lázaro Gómez Carriles.) It tells the story of a dirt-poor peasant boy who joins the ragtag Castro guerrillas, is educated by the revolution, becomes a writer, gets his first novel published, and is then undone by his *defecto*—which in this case is not just overt and insatiable homosexuality but a compulsion to tell the truth as he sees it. Censored, harassed, and eventually jailed by the regime, he keeps on writing, hiding his manuscripts or smuggling them out of Cuba. Eventually, he slips into exile with the Mariel boatlift and spends his last years in New York, where, dying of AIDS, he finishes his devastating memoir and commits suicide. A grim tale, it is also a literary dynamo that generates erotic energy, humor, and bitter wisdom, qualities that Schnabel has caught in his film. *Basquiat,* a meditation on the short life

of the New York painter Jean-Michel Basquiat, was very much a painter's film, drenched in the gritty chromatics of downtown lofts and city streets. *Before Night Falls* is a painter's film, too—a visual object, a movie whose look and weight and feel carry the story as much as the script does. But Schnabel's new film is a huge step beyond *Basquiat.* Among other things, it's the most authentic portrait of a writer I've ever seen on film. I liked it more the second time, finding all sorts of connections I hadn't noticed before; the scenes go by very quickly in the first forty minutes or so, with swift, sure strokes that make their point and don't linger, so it's easy to miss the visual and aural innovations that Schnabel has pulled off. Alone among the 1980s art stars who have tried their hand at filmmaking, Schnabel has not only mastered the craft but made a film that succeeds, in mass-market Hollywood terms and on its own terms, as a work of art.

Predictably, the New York art mafia was now saying that Julian Schnabel had found his true métier, as a filmmaker—the implication being that we can forget about him as a painter. Ever since the early 1980s, when Schnabel's broken-plate paintings helped shatter the decadelong strictures of Minimal and Conceptual art, and his brash self-confidence gave voice to a new era of artists as media stars, certain critics and quite a few artists have wished that he would go away. Schnabel was the most visible and the most talkative of the neo-expressionists, a far from cohesive international group that included David Salle, Eric Fischl, Francesco Clemente, Sandro Chia, Anselm Kiefer, and Sigmar Polke, among others. He was the one who wore pajamas or a sarong to public functions, who went up to museum curators in restaurants and asked why they didn't show his work, and who said things like "I'm the closest you'll get to Picasso in this life." His chutzpah and his naïve, unguarded self-admiration made

him an irresistible target, and he got blamed for many of the perceived excesses of the 1980s—self-promotion and media hype, inflated prices, speculation buying, art collecting as a means of social climbing. When the art boom went south, at the end of that decade, and a backlash set in, Schnabel's reputation and his prices entered a decline from which they have only recently started to recover. Not a catastrophic decline, mind you. Schnabel paintings that might have brought between $500,000 and $600,000 at auction in the mid-1980s went for half that much in the mid-1990s, but his dealer, the Pace Gallery, continued to sell his new work—there was always plenty of new work—for high prices (between $100,000 and $150,000 for a large picture), and museums and collectors continued to buy it.

To help finance *Before Night Falls,* whose production costs Schnabel paid, he sold one of his early plate paintings, for $700,000. His work has kept right on bringing in more than enough to support him and his children (he has five) and his houses—besides the one on West Eleventh Street, he owns a Stanford White gem in Montauk—and the household and studio assistants, and the vacation trips, and the furniture and art works and *objets* and foodstuffs and wines and cigars that a man of his overflowing appetites requires. "Listen," he had said during a recent screening, when someone asked whether he was going to make films instead of paintings from now on. "Listen, I've made a thousand paintings and I've made two films. I'm a painter. Does that answer your question?"

THE PAINTER DRIFTED back into the red room ten minutes after leaving us there—maybe he had tried to stay away longer but couldn't—and started telling me how Javier Bardem turned himself into Reinaldo Arenas. "I have to leave the room," Bardem

said, after a few minutes. "Too much compliment." He hugged Julian, and they exchanged a few words in Spanish—since his marriage to Olatz, Julian has become fluent in Spanish. "We should go upstairs to the studio," he said, after Bardem left. "It's important to dispel this idea that I'm an artist who's turned filmmaker. I didn't paint while we were shooting the film, but I've done a lot of paintings since then, and I thought you'd like to see some of them." Upstairs we went, accompanied by Zeus, Julian's pit bull. Zeus (pronounced Zay-oos) is a crotch-bumper but friendly. I've visited this studio a number of times over the past ten years, but its dimensions still awe me. The scale, let's say, is in keeping with Julian's capacity for wonder. Two twenty-foot-high paintings stood against the left wall. Each had "Zeus" and "Duende" painted on it, the words flowing above, below, or on top of vehement abstract passages. "I started those paintings in 1992," Schnabel said. "When I got through with the movie, a year ago last November, I came back and finished them by putting in the 'Duende's and 'Zeus'es." He took the word *duende* from García Lorca. "If somebody plays something with great inspiration, you could say they do it with *duende*. A *duende* can be a dwarf, or a magic character, or the thing that makes you do whatever you do well." And Zeus? Zeus was Zeus, one more bearer of the mythical dimension that Schnabel has always liked to build into his work. In Mexico, scouting locations, he saw a white pit bull watching him attentively from behind a fence. He asked what the dog's name was, and when he was told it was Zeus he persuaded the owner to sell the dog to him on the spot.

A somewhat smaller, brighter, and more colorful painting in a heavy white frame was displayed on a metal stand. Its swirling reds and yellows looked as if they'd been slathered on with his fingers, instead of a brush, and Schnabel confirmed that they

had been. "There are seven of these, and six smaller ones," he said, "all done last summer in Montauk." He lifted the painting out of the frame, waving off my attempt to help, and replaced it with another the same size. This one had "Olatz" painted across the surface in lush, broadly spaced letters; there was a sense of landscape, sunlight: a windy day at the beach. "I like painting outdoors, where the light keeps changing," he mused. He has painted on tennis courts and parking lots, and in an outdoor studio he built on Andy Warhol's Montauk estate, which he used to rent. Now he's building a permanent outdoor studio on his own property.

"After making the movie, and having to be so communicative with people, it's interesting to make a nice, hermetic painting that says everything I want it to say," Schnabel observed. "I made a lot of different kinds of pictures. They're more infantile than ever, don't you think?" "Infantile" was good—the new paintings had an exuberant playfulness that smacked of pure id. Julian can't help painting too many pictures, and his batting average fluctuates accordingly; at the moment, I would have said it was about .280. That's not bad, of course, considering that on a good day he can still hit one out of the park.

Schnabel usually paints in series, five or ten pictures in the same general idiom, working through its various ramifications. The main image in one of the new series was a sort of high, wavelike, cresting dune, with lush purples and browns and looping bright-red skeins draped across the surface horizontally. ("They were done in Spain. Olatz has a house in San Sebastián, and we went there last summer with the kids.") Another series had the word "Licaboles" scrawled across the surface in red or yellow. "Every morning," he explained, "I wake up to the sound of my dog licking his balls—that's *'licaboles.'*"

Cy Schnabel darted into the studio to ask a question. "How come you're not wearing your shoes, sweetheart?" Julian asked plaintively. "You have a cold. Put on some slippers, please, I'm sorry." Cy is named after Cy Twombly, one of the few contemporary artists for whom Julian's admiration is unqualified. His brother Olmo is named after the Gérard Depardieu character in Bertolucci's film *1900*. Julian's three other children, who are from his first marriage, to the Belgian photographer Jacqueline Beaurang, are Lola Montès Schnabel, a nineteen-year-old art student, named after the Max Ophuls movie *Lola Montès;* Stella Madrid Schnabel, seventeen, who was downstairs, looking after Cy and Olmo; and Vito Maria Schnabel, fourteen, whose name pays homage to Rainer Maria Rilke and *The Godfather,* Parts I and II (from which Schnabel, who has an encyclopedic film memory, can quote pages of dialogue at will), but emphatically not to *Godfather III,* which he considers an abomination, a desecration of the temple of cinematic art. "I loved making these paintings," Julian said, gazing benignly at his work. "Other people can make movies, but who else can do this?"

A FEW DAYS LATER, on a Sunday morning, Schnabel called me at home. "Why don't you come down?" he said. "I'm all alone." Alone, as I learned when I got there, meant that the twins, their babysitter, and Zeus were present but Olatz was out. We sat in the red room, where for about three hours we reviewed Julian's forty-nine years on earth.

"My father left Czechoslovakia in 1926, when he was fifteen," he told me. "He went to Antwerp for a few years, and then stowed away on a boat to New York, where he met my mother." The youngest of three children, Julian spent his first fifteen years in Brooklyn. He remembers drawing a lot when he was little, and

being encouraged to do so by his mother. "I was my mother's best friend," he said. "My brother and sister were eight and twelve years older than me, so they weren't around that much. My mom took me to the Museum of Natural History, and to the Met to see *Aristotle Contemplating the Bust of Homer*, and she enrolled me in the Brooklyn Museum School when I was only nine and too young to use oil paints. I never thought for one second about being an artist. I never saw the future, and I still don't; there's just the present and nonexistence. It was always like that."

Jack Schnabel, Julian's workaholic father, was in a number of different businesses—fur collars, high-grade meat products, supermarkets. In 1966, he moved his wife and youngest son from Brooklyn to Brownsville, Texas, where he had a new business, selling used clothes to Mexicans on both sides of the border. The cultural adjustment took some effort. "I grew up in a place where everybody was Jewish, so I didn't even think about it," Julian remembered. "There weren't many Jews in Brownsville, and they wondered why I seemed so comfortable with Gentiles. The fact was, I didn't really fit in anywhere." He spent the next three years going to the local high school, smoking marijuana, and hanging out with a bunch of blond-haired, laid-back surfers. "The beach was about twenty-four miles from Brownsville, so I learned to surf. Those guys were pretty cruel to me at first, but I got better at it, and we became friends. One summer, another guy and I drove across Mexico. We drove from Monterrey to Zacatecas to Guadalajara to San Luis Potosí, up through Durango and over to Mazatlán, and then back down the coast the other way to Puerto Vallarta, where they made *Night of the Iguana*. It was like seeing the world for the first time. That trip freed me from my past, from being a kid in this ordinary house in

Brooklyn, with ordinary furniture. I saw things that were old, hacienda-style houses in the country with courtyards and pools, and I saw shacks made out of sticks." Julian fell in love with Mexico—the language, the architecture, the colors, the dust, the poverty, the oldness of it. "I was in Mérida thirty years ago," he said. "So when I wanted to find somewhere that looked like the Vedado section of Havana for my film I knew just where to go. I remembered it. All the stuff I do is about memory, and time."

Feeling that he didn't fit in anywhere never put a damper on his self-confidence. This was a kid, after all, who climbed up on the stage at a Catskills resort his parents took him to when he was five years old and belted out a solo version of "Hound Dog." At the University of Houston, he took the studio arts program. The teachers left him alone, more or less, but one of them recommended him for the Whitney Museum Independent Study Program, a one-year postgraduate study grant that offered a small stipend and studio space in New York. Julian sent his slides to the Whitney in a brown paper bag, sandwiched between two slices of white bread, "so they'd notice them." He was accepted, and he moved back east in the summer of 1973. It took him only a few weeks to register his presence on the art scene. He met most of the downtown art crowd at Max's Kansas City, which had become famous as Andy Warhol's hangout. This was the decade when painting was supposed to be dead, replaced by video, installation art, performance art, body art, language art—all the new strategies that were banishing illusion (that discredited subterfuge) in favor of the real thing, the thing-in-itself, which so often turned out to be dishearteningly drab. Schnabel's semi-figurative paintings, with big, flat images that looked like Richard Lindner's, certainly did not fit in with the

art of the 1970s, but that never worried Schnabel. Although he revered Pollock and Rothko, he felt closer to the Mexican muralists Rivera and Orozco than to the heroes of the New York School and their theory-bound successors. The artist who impressed him the most in those years was Joseph Beuys, the charismatic German conceptualist and teacher. Beuys came to New York in 1974 and spent a week at the René Block Gallery, on Spring Street, wrapped in a felt blanket, locked up in a steel cage with a live coyote. (The work was called *Coyote: I Like America and America Likes Me.*) "The humor, the poetry of it, the selection of materials, the space—I loved seeing that," Schnabel told me.

Schnabel went to Europe for the first time in 1976, with his Texas girlfriend Jean Kallina. They went to Paris and Milan, where Jean tried to get work as a model, and when she decided to go home Julian stayed on. Dead broke, and speaking no Italian, he somehow persuaded a collector to commission ten paintings and provide a studio and materials for him to paint them. Italy's effect on him was as powerful as Mexico's. He went to Arezzo to see the Piero della Francesca frescoes, and to Assisi and Padua for the Giottos. "I loved the Fra Angelico paintings in the monastery of San Marco in Florence. That dry surface, the way the color sat, the drawing being so simple—and the fact that they were painted on architecture, that they were connected to the size of the room, the thickness of the walls."

BACK IN NEW YORK, Schnabel worked as a cook at Mickey Ruskin's Ocean Club restaurant, and later at another Ruskin restaurant, called Locale (Ruskin had owned Max's Kansas City, which folded in 1981). His paintings got larger and emptier. A few images recurred in mostly abstract spaces: a male torso; a

treelike form, sometimes abstracted to a cone; branching lines, like veins. Religious (mainly Catholic) titles and references— Julian's response to Italy and to his own exfoliating ambition— appeared in more than one picture; he painted a *St. Sebastian,* a *St. Francis in Ecstasy,* a *Giacomo Expelled from the Temple,* and, for an ecumenical clincher, a *Portrait of God.* He wanted the pictures to look rough and unwieldy, like walls. Schnabel was trying to work out something, a kind of tension and conflict he felt between the solidity of the surface and the image he painted on it. The eureka moment came in 1978, in a hotel room in Barcelona. A gallery in Düsseldorf had offered him a show, and after the opening there he had gone to Italy again, and then to Barcelona, where he was bowled over by Gaudí's fantastic mosaics in the Park Güell. "After seeing those," he told me, "I went to some restaurant that had a crummy mosaic on the wall, a white mosaic, and I thought, Shit, I'm going to break a bunch of plates and use them as the surface of a painting. I was staying in a room on the Ramblas that cost two-fifty a night, and there was a closet that came out into the room, very human-size. I measured it with my arms, and when I came back to New York I had a guy build me two Masonite armatures with those dimensions. I went to the Salvation Army and bought a bunch of plates. The guy who sold them to me had trouble reaching over the edge of the cardboard box, and I told him just to drop them in, don't worry if they break." It took a while to master the plate tectonics. He stood the first painting upright too early and stayed awake all one night listening to fragments falling off the canvas and hitting the floor. But he knew he was on to something. "The plates seemed like light," he recalled, "and when you drew a line on them the line had a different depth of field from the plates. The work had its own body and dynamic, it didn't have anything to

do with anyone else's work, and it was asking me to make other versions."

Not many exhibitions have had the impact of Schnabel's plate paintings at the Mary Boone Gallery in November of 1979. (It was actually his second show there; the first had been eight months earlier.) A new, bravura kind of energy had brought back heroic painting, it seemed, and this was confirmed by the New York débuts of Salle, Clemente, Chia, Kiefer, Immendorff, and a dozen other native and foreign painters. Within two years, Schnabel's top prices had soared from $2,000 to $40,000 a picture, and he was showing jointly with Mary Boone and Leo Castelli, the master dealer, whose gallery represented Robert Rauschenberg and Jasper Johns; Schnabel was the first young artist Castelli had taken on in twelve years. (When Julian left Castelli and Boone, in 1984, for the uptown Pace Gallery, Castelli was stunned. According to Julian, Castelli's parting words were "You have all my contempt.") Collectors who had more or less quit buying in the 1970s joined the rush to acquire Schnabel and the other neo-expressionists, and European galleries vied to show them. Some critics couldn't stand Schnabel's work, but most of them took it seriously; his talent was too big and obvious to ignore. Even Hilton Kramer, our live-in reactionary, conceded in 1981 that "despite the crockery and the claptrap, Mr. Schnabel is at times a painter of remarkable powers." *The Times* critic Michael Brenson, calling his talent "unmistakable," wrote in 1984 that there were "very few artists around . . . who have anything approaching his ability to make paintings that seize hold of the space around them."

A Schnabel retrospective, organized by the Whitechapel Gallery, in London, came to the Whitney Museum in 1987. The airplane carrying the paintings broke down in Abu Dhabi, and

Schnabel pitched in to help Lisa Phillips, the Whitney curator, pull together a temporary, alternative exhibition in time for the opening; the substitutions didn't particularly upset him, since he tends to think everything he does is pretty marvelous. The Museum of Modern Art, however, has consistently shunned him—its Schnabel holdings today are limited to two drawings, three prints, and the promised gift of a plate painting. (When, in 1984, *The Times* reported that "the Modern has not yet acquired" a Schnabel, William Rubin, MOMA's director of painting and sculpture, fired off a letter of correction; the sentence, he said, should not have included the word "yet.") Schnabel's personality often got in the way of his art. If you didn't know about his openhearted generosity—the efforts he makes to help other artists (until they become rivals) and his willingness to give paintings to any number of worthy causes—you could easily be put off by the things he has said in published interviews. "My peers are the painters who speak to me: Duccio, Giotto, van Gogh," he declaimed to one reporter. "Julian is unedited," says Ingrid Sischy, who is probably his closest friend. "He says things sometimes that, if you love him, you think, God, I wish he hadn't said that. But Julian's unedited quality is what allows him to be the kind of artist he is. It's what allows him to take the leap of faith, to throw into his paintings all those elements, some of which so often work brilliantly."

Whatever was going on in his life, he kept making paintings. He made them on broken plates, on velvet, on wood, on cowhide, on maps of the world, on old tarps, on backdrops for the Kabuki theater sent to him by his Japanese dealer, on mattresses, on nineteenth-century landscapes that he bought in junk shops and painted over, on a patched canvas that was once the floor of a boxing ring at the Gramercy Gym. His paintings could be

austerely empty, with a few iconic forms in muted earth tones, or sometimes with just a word or a phrase painted in huge capital letters ("Spinoza," for example, or "The Teddy Bears' Picnic"). They could also be lush and Dionysian (and occasionally bombastic), teeming with religious symbols and abstract organic forms. Looking at the childlike scribbles and blobs on a Schnabel canvas, an unconvinced museum curator gibed, "He got a lot from Cy Twombly, but not enough."

FIFTEEN YEARS AGO, Schnabel invited me to come to his studio, which was on White Street then, to see three new paintings he had done in Mexico. They were on heavy canvas tarps, the kind used to cover tractor-trailer loads; driving near Zihuatanejo one day, Julian had stopped his car and bought one tarp for $70, from a man whose truck had broken down, and then he had gone looking and found two more. They were about twenty feet long by seventeen feet wide, stained and grimy from hard use, and the images he had painted on them were nightmarish: elongated figures with savage, part-human features, tubular bodies, and ferocious, ostrichlike legs and feet. They looked ancient, malevolent, evil. Julian had painted them outdoors, rigging bamboo poles to hang the tarps from palm trees, using a ladder to reach the upper areas. "I felt like all the blood and the history and the horror of Mexico was coming up from the sand through my feet, making those paintings," he told me.

In the mid-1980s, he started doing a lot of portraits. By now, he has done more than fifty of them, and a few, such as a triple portrait of the billionaire shipowner Stavros Niarchos and one of Julian's friend the novelist William Gaddis, are up there with his best work. Portraits keep the cash flowing, as Andy Warhol found out. Critics who had attacked Schnabel for

grandiose behavior, self-indulgence, and lack of self-criticism could now attack him for hanging out with rich people. Robert Hughes, reviewing Schnabel's somewhat fatuous 1987 autobiography (it was called *C.V.J.—Nicknames of Maître d's & Other Excerpts from Life*), compared his painting to Sylvester Stallone's acting, "a lurching display of oily pectorals—except that Schnabel makes bigger public claims for himself." Hilton Kramer, cured of his earlier, grudging admiration, wrote a 1989 diatribe whose headline read "GHASTLY SCHNABEL SHOW A FIT ENDING TO GHASTLY DECADE FOR ART WORLD." "I'm sort of counting on you to set the record straight about me," Schnabel used to say to me when we saw each other, but I didn't think I could do that. There was just too much work, and probably too much Julian. What I think is that he's a major artist whose paintings are almost always interesting, even when they're not major.

The art of the 1980s is up for reconsideration. The work of Schnabel, Salle, Fischl, and other painters has been around for twenty years, and some younger artists, critics, and curators are looking at it now with considerable interest. "I think his example helped a lot of artists who probably wouldn't admit it," the painter John Currin has said. "The thing that affected me was this idea that you could do something embarrassing. . . . Don't edit your taste, which is what I'd been doing." Schnabel's unedited risk-taking was very important to his own contemporaries and rivals, as David Salle noted the other day. "Julian had a way of playing fast and loose with images that was liberating—the idea that you could accept or deny their meaning," he told me. It has been widely reported that Schnabel and Salle's friendship broke up over a painting exchange in 1980, when Schnabel, after choosing a Salle diptych, reversed the two panels and painted Salle's portrait in orange on one of them. The story, according to Salle, was more

complicated. "Julian called me up and said, 'Your painting is ready,'" he recalled. "I went to his studio, and there was a big rectangle covered by a sheet, with two chairs placed in front of it. Julian clasped me to his bosom and said, 'I've done something which will join us together in history,' and then he unveiled this painting. I was momentarily flabbergasted, but very quickly realized it was okay. Its audaciousness was exciting. It was simultaneously an act of brotherhood, transgression, complicity, and aesthetic challenge." They owned it jointly, and sold it jointly to the collectors Eugene and Barbara Schwartz.

I WENT UP TO ALBANY with Schnabel for a screening of *Before Night Falls* at the Albany campus of the State University of New York. The screening was in an auditorium on the downtown campus, and the sound system was not great—in fact, the sound went out entirely for about a minute toward the end of the film, so Schnabel, affably enough, got up on the stage afterward and recited the dialogue we had missed. The full house applauded him warmly. Later, at a restaurant dinner arranged by his friend William Kennedy, the novelist, Julian maintained his affability for another two hours, talking about the film, answering questions, saying things that could sound, to someone who actively disliked him, like the rants of an egomaniac. "I think I made the best film of the year," he said at one point. "I know it's bad form to say that, but it's the way I feel." It has never seemed plausible to Schnabel that anybody could actively dislike him. He says things that most artists think but usually find ways of keeping to themselves.

On the train back to New York the next day, I asked Schnabel what had induced him, a Brooklyn-born Jewish heterosexual, to make a film about a gay Cuban poet. "I saw a documentary on TV

about Reinaldo," he said, "and I thought, This guy is funny, and modest, and then I read his book *Before Night Falls*. A lot of stuff had happened to him, and not just to him. It was also about Cuba, this little country that's been such an obsession with us, although nobody knows anything about it. And I guess my wife being Spanish—Olatz grew up in Spain and France, but when we got married she was dying to go to Havana, and we went several times. Anyway, when I saw that documentary, I knew I wanted to do the movie." Schnabel's film makes brilliant use, in voice-over, of two Arenas poems. The first, called "The Parade Begins," describes the euphoric optimism of the revolution's early days— "*banderas, banderas,*" flags everywhere. It plays off against one written twenty years later, "The Parade Ends," which repeats the word *cerrado* (closed): "*Todos cerrados, cines cerrados, parques cerrados*"—forty years of Cuban history and betrayal. "My favorite line in the film," Julian said, "comes at the end, when Reinaldo is dying in his room in New York, and he touches the cheek of Lázaro, his friend, and says, 'I have never met a boy as authentic as you, Lázaro.' It's a terrible life, Reinaldo's, but it was leaning toward the divine light."

A few days later, Julian picked me up in his car, a Toyota SUV, for a trip out to Montauk. He hadn't been out there for a couple of months, and he wanted to check on the progress of the new studio he's having built. Julian sat in front with Wilfredo, his driver, who is part of his largely Spanish-speaking New York ménage. Julian wanted to play the newly released CD of the soundtrack for *Before Night Falls* on the car stereo, but he kept turning it off to make or receive calls on his cell phone, most of them regarding the movie's promotion and distribution. Spouting questions and rapid-fire technical details, he sounded like a producer. At one point, he spoke with Olatz at the dubbing

studio; she was directing the dubbing of the Spanish-language version of the film, which would have its premiere in Madrid in late February. Olatz has told me that, if there was anything she could change about Julian, it would be the amount of time he spends on the telephone, and maybe also "his attachment to his things, his houses, his objects. When he was shooting the movie in Mexico, we had to send him his sheets and pillows. He wanted his feather pillows." Olatz plays Reinaldo Arenas's mother in the film. All five of Julian's children are in it, too, and so are Julian's parents, who are seen, briefly, as an elderly couple entering the apartment building where Reinaldo's friend Lázaro works as a doorman. "You know what my profession is, don't you?" Jack Schnabel said the other day, on the phone from Miami. "My profession is being Julian's father. All the people that have children should have a boy like that."

On the way to Montauk, Julian had Wilfredo turn off at Bridgehampton so that he could show me the house on Job's Lane where he had lived with Jacqueline, his first wife, and which she still owns and uses in the summer. From the front, it looked like an ordinary shingled house, closed up for the winter, but things got grander in back. Julian pointed out a massive stone wall he had built, with the help of a local mason, and an eighty-four-foot swimming pool he had dug; his twelve-foot-high bronze sculpture *Helen of Troy* stood guard at the far end. He showed me his wisteria and his rosebushes, and the bronze door handles that he had made himself, and the handprints that his daughters, Lola and Stella, had pressed into wet cement at the pool's shallow end. "I tried to invent a place for my kids so they would have the kind of memories I never had, of screened-in porches and things like that," he said. Both Lola and Stella used to ride on his shoulders in the studio while he painted. "I

always watched him work, and he always encouraged me," Lola recalled. "Watching what he was thinking about go through his hand onto the canvas—that was something."

We stopped for lunch in the village of Montauk, at the Shagwong Restaurant. (A sign in the window read, "Piano Player Wanted. Must Have Knowledge of Opening Clams.") Julian's place was about ten minutes farther east, near the end of Long Island. He went first to the new studio, where six workmen were muscling huge rocks into position for a fireplace whose opening was six feet high. Julian walked me through the studio and out to the back, to his open-air painting arena: three sixteen-foot-high wood walls and, beyond them, a swimming pool even larger than the one in Bridgehampton, with an island at the far end that has two cherry trees growing on it. "This is where I live," he said happily. "I got the sky, I got these three walls to lean stuff on, and when I feel overheated I can jump in the pool." Swimming has been a big thing with Julian since he was three and jumped into a swimming pool and had to be rescued by a lifeguard. His daughter Stella said, "The three things that relax my dad are *The Godfather,* getting his back tickled, and floating in water."

The house, one of seven summer homes that the Stanford White firm built here in the early 1880s, is named Grandview. It sits on a hill overlooking the ocean, and it has three floors, ten bedrooms, an emphatic staircase, and a good many art works by Julian Schnabel. He bought the place in 1997, and he spends a lot of time here in the summer, painting and surfing and enjoying family life. Some people argue that Julian's real talent is for interior decorating—this is another way of dismissing him as a major artist—but the Montauk house is not nearly as theatrical inside as the house on West Eleventh Street, and Olatz had as much to do with decorating it as he did.

At dinner that night, in the dining room at Grandview, Julian talked about painting and filmmaking, and how the two processes are not all that different. "The director of photography on my film told me I never shot a scene that was rehearsed—I just shot the rehearsal," he said. "As long as it's unknown territory, I feel excited. That's the same in painting. I think often that I'm painting in time, not just composing within the rectangle. Traveling around in time has always been important to me, which is one of the reasons I like movies— Does your tummy hurt?" Noticing that I had a hand resting on my stomach, he was suddenly concerned about me. I said my tummy didn't hurt.

"Listen," he resumed, "painting has always gotten me out of trouble. It's gotten me into trouble, too, but it's always gotten me out. I sold a lot of art this year. Obviously, there are people interested in my painting, or I wouldn't be able to live in my house. All these years, I've been able to paint my way through pain and difficulty, and I've never had to compromise. I couldn't have afforded to go off and make this film if it hadn't been for my painting."

Schnabel was in Paris promoting his movie when he got the news about the 2000 Academy Award nominations. Javier Bardem had been nominated for best actor, for his performance in *Before Night Falls*. There was a message from Schnabel on my answering machine, asking me to call him at the Ritz. "Well, you know," he said, when I reached him, "maybe there's a little justice in the world." He ran through the names of the other nominees—Tom Hanks, Russell Crowe, Geoffrey Rush, and Ed Harris—and said, "I think we got a pretty damn good chance of winning this thing. Isn't it insane? I'm very, very pleasantly surprised, because I really didn't expect it. I'm not the kind of person who wins awards—people think I have everything, so they don't want to give it to me."

He called two days later, from Saint-Moritz, where he was staying for a few days in a house owned by his Swiss dealer, Bruno Bischofberger. Box office sales for *Before Night Falls* were up 90 percent since the Academy Award nominations, he said. Rudi Fuchs, the director of the Stedelijk Museum, was talking about organizing a new Schnabel exhibition. "It's beautiful here," he added. "I'm making a really great painting. I'm still a kid, just getting warmed up."

—*March 19, 2001*

The 2000 Academy Award for Best Actor went to Russell Crowe (for Gladiator*). Schnabel's next film,* The Diving Bell and the Butterfly, *which was released in 2007, drew rapturous and somewhat astonished reviews, and won the best director award at the Cannes Film Festival. It was also nominated for four Academy Awards, including the one for best director. The fact that it won none of them, coupled with the tendency of a whole new echelon of admirers to think of him primarily as a filmmaker rather than a painter, confirms his judgment that there is no justice in the world. With Schnabel, too much is never quite enough.*

RICHARD SERRA

In the long and often embattled career of Richard Serra, no event has been more cathartic than the opening of his exhibition at the Gagosian Gallery in the fall of 2001. The opening had been delayed by the terrible events of September 11, and in the aftermath of the catastrophe there was no telling how many people would show up. More than three thousand did, as it turned out, and, according to Ealan Wingate, the gallery's director, "Everybody was bathed in antidote."

Six monumental sculptures filled the exhibition space on West Twenty-fourth Street. The scale and ambition of his new work were no surprise; Serra's sculptures have been overpowering viewers since the late 1960s, when he showed his early propped-lead pieces at the Guggenheim and Whitney Museums. What amazed me and many others was how far Serra, at the age of sixty-two, had moved beyond the breakout innovations of his Gagosian show two years earlier. Once again, it

seemed, he was carrying the art of sculpture into new areas, taking great risks and pulling them off, and there was something thrilling and deeply reassuring about that.

All six sculptures at Gagosian were enormous: leaning walls of two-inch-thick industrial steel plate; two forty-ton rectangular solids that devoured the space of two rooms; a strange, exquisitely calibrated monolith that looked like a great ship listing dangerously to one side. There were also two "torqued spirals," coiling thirteen-foot-high steel enclosures that you could walk into. Shown for the first time last summer at the Venice Biennale, the spirals offer viewers a spatial experience that is simultaneously disorienting and exhilarating. Because the encircling walls are never plumb (they either bend in or bend out from the vertical at all points), you have alternating sensations of confinement and expansion as you walk into them. The weight of COR-TEN steel on either side makes the walk fairly frightening, but then, emerging at last into the open space at the center, you get a jolt of euphoria, space rushing away from you on all sides and the whole vast form becoming buoyant and seemingly weightless. Serra has said that the subject of his sculpture is the viewer's experience in walking through or around it—that what he is doing is not creating static objects but shaping space. Never before, however, has his sculpture played so directly and unequivocally with the spectator's emotions. People wandered through the spirals at Gagosian with rapt looks. They reached out to touch the walls, whose patina of rich brownish-red rust invited contact. Some sat down inside and stayed for a while; others came back again and again during the three months that the show was up. One young couple got permission to be married in *Bellamy,* the spiral that Serra had named after the late Richard Bellamy, his close friend and early dealer. (The other one was called *Sylvester,*

after the British art historian David Sylvester, who died a few months before the show opened.) For the first time in my experience, I found myself responding to Serra's work with intense joy and delight.

Long inured to negative or even hostile reactions to his work, Serra seemed indifferent to the virtually unanimous praise this time. "Whatever the work is evoking in people, I don't dictate that," he told me, "so I don't know how to account for it." His attention, in any case, was focused mainly on the unprecedented number of new sculptural commissions or proposals that he had in various stages of development. There was an eight-hundred-and-sixty-five-foot-long serpentine wall of steel plates being set into the landscape of a private client in New Zealand—the longest continuous sculpture he had yet conceived. There were major projects for the Toronto airport, for the Kimbell Art Museum, in Fort Worth, for Caltech and UCLA and MIT, and for public or private sponsors in Germany, Italy, England, Belgium, and Qatar. Busy as he was, Serra nevertheless agreed to play a leading role in *Cremaster 3,* the latest in a much acclaimed cycle of films by the young artist Matthew Barney, whose work he likes a lot. His role is that of the Great Architect, who (symbolism ahoy!) is murdered by the Apprentice.

Early in December, Serra and Clara, his German-born wife, retreated to their house on Cape Breton Island, where they spend about five months a year. Serra does much of the planning for his sculptures up there, and he also makes a great many drawings, which have no connection to his sculpture but which are an important part of his œuvre. When I went to see him at his Tribeca loft in February, the day after he got back from Cape Breton, he immediately took me downstairs to the ground-floor studio to see the new drawings: twenty-seven large-scale abstract variations, in

thickly impastoed black oil stick, on the circular motif that has occupied him for several years. Serra was hyperkinetic, and dauntingly articulate. A stocky, powerful-looking man with a large head, a fringe of close-cropped gray hair, and black eyes whose intense stare reminds you of Picasso's, he wore his usual outfit of jeans, work boots, and a hooded sweatshirt. He moved quickly from one drawing to the next, explaining, in answer to my question, how he puts handmade paper face down on top of compacted oil stick and then draws through the back of it with a piece of metal, forcing the line into the thick black pigment. A real Serra process, I thought: physical, aggressive, laborious. And yet the drawings themselves were complex and sensuously, almost lusciously beautiful.

We went back upstairs to the sixth floor, which the Serras share with their three boisterous Chesapeake Bay Retrievers. The living room is about forty feet long by thirty feet wide: high ceilings, two large skylights, Mission chairs and tables, African wood sculptures, ancient Cambodian earthenware pots on a high shelf, a fireplace with stacked wood covering the wall on one side, and, on the other side, a single, very large Serra drawing in black oil stick. We talked about Serra's recent appearance on the Charlie Rose show, during which some viewers thought he spoke disparagingly about the architect Frank Gehry. Serra didn't agree that he had spoken disparagingly. Charlie Rose (like Matthew Barney) "was trying to make me an architect," he said, "and to make Frank Gehry an artist. The guy said to me, 'What do you think you have to do better than an architect, if you're a sculptor?' And I said that, for one thing, you've got to draw better. He asked me if I thought I drew better than Gehry, and I said, 'Sure I draw better. Absolutely.' What's wrong with saying that?"

Charlie Rose had hit one of Serra's hot buttons. Gehry is not

among the architects with whom Serra has clashed publicly over the years—in fact, the two men are close friends who have been "talking to each other through our work," as Gehry puts it, for a long time. But Gehry's new Guggenheim Museum in Bilbao is the most acclaimed building of our era; it has been referred to again and again as a major work of art and Gehry himself as a major artist, and this does not sit well with Richard Serra. "If you analyze what I said," he insisted, "I didn't take a public slap at Frank. I said that art is purposely useless, that its significations are symbolic, internal, poetic—a host of other things—whereas architects have to answer to the program, the client, and everything that goes along with the utility function of the building. Let's not confuse the two things. Now we have architects running around saying, 'I'm an artist,' and I just don't buy it. I don't believe Frank is an artist. I don't believe Rem Koolhaas is an artist. Sure, there are comparable overlaps in the language between sculpture and architecture, between painting and architecture. There are overlaps between all kinds of human activities. But there are also differences that have gone on for centuries. Architects are higher in the pecking order than sculptors, we all know that, but they can't have it both ways."

I told him I'd recently talked with Gehry about this. Gehry's view was that an architect solves the client's problems, solves the building department's requirements and all the other issues, but that "there's something that takes it from just a building to architecture, maybe fifteen percent of the effort, and that's where our decisions are similar." Gehry had added, "I'm dealing with context, form, surface—all the things Richard is dealing with."

"Did Frank give you the 'fifteen percent' line?" Serra said now, his voice rising. "Okay, I've got it. I'm building a functional building for a client, which happens to be a shoe store, but fifteen

percent of it is where the art is. He wants to claim art as part of his process? Come on. He doesn't need that, and we don't need it!" What sounded like animosity was something different—passionate intensity. "I think you have to take Richard as Richard," Gehry had told me. "He's sometimes angry, he's jealous, he's critical, impatient, a perfectionist, demanding, difficult. But the people who love him say, 'Oh, well, that's Richard.' I remember an incident soon after I first met him, in 1978, when he was staying at [the print publisher] Stanley Grinstein's house in Los Angeles. He'd left one of his drawing books open on the kitchen counter, and Berta, my wife, innocently looked into it, and Richard came in and told her she shouldn't do that, said it so stingingly he made her cry. That was the first time I understood you've got to be careful, this one bites. When he gets like that, there's no arguing with him."

Even so, Serra and Gehry have spent a lot of time together during the past thirty years, and learned a lot from each other. Gehry "is one of the few architects of this century who has brought the procedures and thought processes of contemporary art into the world of architecture," Serra said recently. Gehry has consistently praised Serra's work and has tried to arrange commissions for Serra sculptures to be sited in or adjacent to his buildings. Their only real falling-out occurred in the late 1970s, and it was over a Serra sculpture that Gehry had persuaded Marcia Weisman, a Los Angeles collector, to commission for the garden of her house in Beverly Hills. As the steel sculpture was being lowered on its crane, Weisman got into a violent argument with Serra about its orientation, and then, half an hour later, she told him she wanted to have an opening party at which a bottle of champagne would be broken against its side. Serra said it wasn't a ship, and he wouldn't put up with that. Angry words

ensued, Weisman threatened to have the sculpture removed, and Serra stormed out. Gehry, who was also present, called Serra that evening and advised him to send her a dozen roses and say he'd like to come over and talk about it. "Two hours later," according to Gehry, "a box of two dozen roses comes to me, with a note from Richard saying, 'Shove 'em up your ass.' And then he didn't speak to me for two years."

"What roses?" Serra barked, when I relayed Gehry's story to him. "Did I do that? I may have done that, and I can tell you why. Because where does Frank Gehry get off calling me up and telling me to placate Marcia, after she's just offed one of my pieces? Get serious." Marcia Weisman did have the sculpture removed. It has been sold twice since then, most recently to a gallery for $1.2 million.

GETTING ALONG WITH SERRA has never been easy. His father used to try to discipline him by having him move large sand piles from one part of the backyard to another. "After I'd spent all day shoveling, he'd come home and say, 'Okay, tomorrow I want it over there,'" Serra remembered. His father was Spanish, from Majorca. He had immigrated to America and married a Russian Jewish girl, and they had settled in San Francisco, where Richard Serra was born, in 1939. His father worked during the Second World War as a pipe fitter in a shipyard, and after the war as the foreman at a candy factory. Serra and his two brothers (one older, one younger) grew up in a house on the sand dunes between the zoo and the Cliff House. The family next door was named di Suvero; their oldest son, Mark, would also become a world-famous sculptor. The two of them didn't spend much time together, because Mark was the same age as Serra's older brother, Tony, whose long shadow Richard struggled to get out from under. A brilliant

student and a gifted athlete, Tony Serra became the most cele-
brated defense lawyer in San Francisco. (James Woods played him
in the film *True Believer,* which was about one of his cases.) Serra
thinks he got interested in drawing as a kid because it was one
thing his older brother couldn't do. Both parents encouraged his
drawing, and he drew every night, on sheets of butcher paper—
airplanes, cars, baseball players, boats, himself in the mirror. "I al-
ways felt I could do that and would do it," he told me, "but when
I went to college I decided to major in English."

In 1957, he entered the University of California at Berkeley,
but transferred in his sophomore year to UC Santa Barbara,
because "I'd broken my back playing football at Berkeley, and I
wanted to go to a place where I could major in English and surf.
I was a relatively good surfer." Every summer, he worked in a
steel mill. "I started doing that when I was fifteen, rolling ball
bearings in a little plant where I lied about my age. It was very
useful. It's probably why I do what I do. I respect the working
class. If you're making art, you don't know what class you're in,
but if you work in a steel mill you're part of the working class."
At Santa Barbara, he took a lot of art courses, but he still
planned to go on to Stanford for graduate work in English. His
faculty adviser suggested, however, that he think about apply-
ing to Yale's School of Art, which was recruiting gifted art stu-
dents from all over the country. Serra sent Yale twelve of his
drawings, Yale wrote back offering a scholarship, and the chance
to get that far away from Tony's shadow proved irresistible.

Serra's three years at Yale, from 1961 to 1964, could not have
been better timed. Josef Albers, the former Bauhaus teacher and
artist, had retired three years earlier as head of the art school,
but his program continued to attract the most talented and
ambitious art students, many of whom would go on to become

well-known artists. "The great thing about Yale was the student body," Chuck Close, who was in Serra's class, said. (Other classmates included Brice Marden, Nancy Graves, Rackstraw Downes, and Stephen Posen; Robert Mangold was one year ahead of them; Jonathan Borofsky and Jennifer Bartlett were a year behind.) "There were thirty-five or forty kids," Close said, "each with a different attitude and different gods. We asked more of each other than the faculty asked of us, but we knew we were students. There was no confusion about that, no thinking you could take your graduate work to New York and hope to get a show." The Yale faculty was augmented by visiting artists from New York: Ad Reinhardt, Jack Tworkov (who would become the dean there in 1963), Robert Rauschenberg, Frank Stella, and other stars, whose visits often generated loud arguments among the students. Abstract Expressionism still reigned supreme at the school. Serra, who thought of himself as a painter then, was churning out what he calls "bad de Koonings," but he was also absorbing art history at a frenzied pace. "You could always tell who Richard had been studying when you'd go to the library and find a book all stuck together with paint," Close said. "He distinguished himself by his intensity. He took things more personally than anybody else. Huge fights, smashing of chairs, throwing of loaded brushes. When he thought you were wrong, you were an idiot—but he'd always come around the next day to see how you were doing. There was something supportive about his negativism." For Close, who became an important painter, staying friends with Serra was worth the effort, but not always possible.

In 1964, armed with an MFA degree and a Yale travel grant, Serra headed for Paris. He shared an apartment off the Boulevard Raspail with Nancy Graves, his Yale girlfriend, who was

there on a Fulbright; their Swiss landlady threatened to throw them out when she discovered they weren't married, so they got married. Graves had met the future composer Philip Glass on the boat coming over, and Glass and Serra became good friends. "Phil took me to see Buster Keaton films, which I'd never seen before, and I took him to Brancusi's studio," Serra remembered. Serra spent a lot of time sketching in Brancusi's studio, which had been re-created in the Musée d'Art Moderne de la Ville de Paris. "It was the first time I looked at sculpture seriously," he said. "I really responded to the strength and simplicity and abstraction of the work. I just found myself being drawn back to that studio every day." In the evenings, he and Glass would go to La Coupole and stare at Giacometti. "I'd written a thesis on existentialism at Santa Barbara," Serra said, "and I was just starstruck. One night, he must have noticed us staring, because he said something. I asked if we could come by his studio the next day, and he said yes, come at such-and-such a time. We did, and nobody was there."

After a year in Paris, Serra got a Fulbright of his own, and he and Nancy Graves spent the next year in Florence. They also traveled: Greece, Turkey, Spain. Serra's first exposure to Velázquez, at the Prado, was a life-changer. "I'd come out of Yale as a painter," he said, "but I didn't quite know how to move painting on. When I saw *Las Meninas,* I thought there was no possibility of me getting close to that—the viewer in relation to space, the painter included in the painting, the masterliness with which he could go from an abstract passage to a figure or a dog. It pretty much stopped me. Cézanne hadn't stopped me, de Kooning and Pollock hadn't stopped me, but Velázquez seemed like a bigger thing to deal with. That sort of nailed the coffin on painting for me. When I got back to Florence, I took everything I had and dumped it in

the Arno. I thought I'd better start from scratch, so I started screwing around with sticks and stones and wire and cages and live and stuffed animals." An Italian dealer saw some of his stacked cages with objects inside, and gave Serra a show of them at his gallery in Rome. It was like a premonition of Arte Povera, a European movement keyed to the use of non-art materials, which would surface a year or so later. "That was in the air," said Serra, "but I didn't know it was in the air."

NEW YORK, WHEN Serra and Graves moved back, in 1966, made Paris and Florence seem like artistic backwaters. Pop art had broken the hegemony of Abstract Expressionism; its bumptious, mass-cult images were attracting a whole new audience to an art that seemed immediately comprehensible and highly entertaining. Minimalism, the austere and impersonal aesthetic laid down by Frank Stella's stripe paintings, Donald Judd's machined metal boxes, Carl Andre's rows of bricks or steel plates, and other strategies that dispensed with composition, metaphor, and any hint of self-expression, was looking stronger and stronger, its lack of popular appeal offset by its ability to generate dense thickets of critical analysis. Within a few weeks of his arrival, Serra had plunged into the downtown art scene and caught minimalism's second wave, becoming one of a group of young artists (the others included Robert Smithson, Bruce Nauman, Michael Heizer, and Eva Hesse) who were roughening up the movement's smooth surface with weird materials and a distinctly personal touch. They met almost every night in the back room at Max's Kansas City, the downtown restaurant and bar that Mickey Ruskin, its owner, had turned into an artists' hangout. (Andy Warhol and his entourage held down the big table in the corner, under a neon-light sculpture by Dan Flavin.) It was like

Yale again—impassioned arguments and violent disagreements, plus a lot more drinking. "I remember him filling the room with energy, and being impulsive and competitive," recalled Nancy Holt, an artist who was married to Bob Smithson. "He was always trying to provoke you and get responses. Bob was somebody he had to take on, challenge." Serra and Smithson were two heavyweight intellects, testing themselves against each other; their abrasive friendship was important to them both. Serra smoked a lot of marijuana in those days. He could be a bully, and a real pain in the ass sometimes, but the others respected his ambition and commitment. "Richard comes across as this macho bulldog, and he is that, but he isn't just that, and the other part is just as strong," Elizabeth Murray, another artist of that generation, told me. "I don't know anybody who goes into things as deeply as Richard does."

Serra had started working with scrap rubber, which he picked up from a nearby warehouse that was throwing it out; he folded it, hung it, and combined it with neon-light tubes in random assemblages. Richard Bellamy, a young dealer with a great eye but not much business acumen, liked the work and put it in a group show at the Noah Goldowsky Gallery. (Bellamy had shown Rosenquist, Lichtenstein, Oldenburg, and other emerging stars of the previous generation at his Green Gallery in the early 1960s; when the Green went broke, many of his artists gravitated to Leo Castelli.) Nobody in Serra's group wanted to do anything that had been done before. Most of them were involved with the idea of process; like a lot of others on the downtown art scene then— dancers, filmmakers, performance artists, musicians—they believed that the process of making something was more interesting and more important than the result. There was a lot of cross-influence between disciplines. Serra and his friends went to the

performances at the Judson Dance Theater, whose young innova-
tors (Yvonne Rainer, Simone Forti, Steve Paxton) were experi-
menting with ordinary, nondance movement and chance
procedures in much the same way that the artists were using
latex rubber, rocks and dirt, and random placement. (Although
Serra had no interest in performing, he was and is an excellent
dancer; on the day Elvis Presley died, he and Helen Tworkov,
Jack Tworkov's daughter, danced for three hours to Presley
songs.) Serra's faltering marriage to Nancy Graves came apart
when he fell in love with a performance and video artist named
Joan Jonas. Graves had hit her own artistic stride by then, with a
highly acclaimed show at the Graham Gallery of realistic life-size
sculptures of camels.

Process art had political overtones. By getting rid of the
pedestal ("the biggest move of the century," according to Serra)
and using cheap, easily available materials like scrap metal and
fabric, sculptors were rejecting hierarchy and authority and re-
ceived wisdom of all kinds. Serra, the former English major,
wrote down a list of verbs: "to roll, to crease, to fold, to bend,
to twist"——dozens of active verbs. "I was very involved with the
physical activity of making," he said. "It struck me that instead
of thinking about what a sculpture is going to be and how you're
going to do it compositionally, what if you just enacted those
verbs in relation to a material, and didn't worry about the result?
So I started tearing and cutting and folding lead." He had been
introduced to lead by Philip Glass, who was working part-time
as a plumber. (Serra supported himself then with local moving
jobs; he had a truck, and several friends willing to man it two
days a week, which earned them enough money to spend the rest
of the week doing their own work.) Lead was almost as malleable
as rubber, but it had weight and solidity. He tried propping

heavy lead plates against the wall in various ways, often with sheets of rolled lead. Serra and Glass, who was helping him, did more than thirty propped-lead pieces. "Some of them didn't amount to anything," Serra said, "but others did." He also tried splashing molten lead against the wall, which was dangerous but exciting; the splashed lead, when it dried, came away in beautiful, lacy, V-shaped strips. Serra had a splashed-lead piece, a lead-prop, and a rubber scatter piece in a group show at Leo Castelli's uptown warehouse gallery in December of 1968. The show included work by most of the process-oriented artists, and announced a major shift in the development of minimalism. *The New Avant-Garde,* an influential 1972 book by Grégoire Müller, with photographs by Gianfranco Gorgoni, had a dramatic shot on the cover of Serra in a welder's mask, flinging molten lead from a ladle; he looked like a working-class Poseidon.

THE CASTELLI WAREHOUSE show got a lot of attention, and it led directly to exhibitions of Serra's work in a number of important group shows here and in Europe. Soon enough, he had a team of people helping him. Philip Glass had quit his plumbing job to become Serra's paid studio assistant. The painter Chuck Close, Serra's Yale classmate, the musician Steve Reich, the writer Rudy Wurlitzer, the actor Spalding Gray, and two or three others could be counted on to help assemble and install the heavier pieces, such as *One-Ton Prop (House of Cards)*—a freestanding sculpture made of four-foot-square lead plates, upright and balanced at the top corners. "He was smart enough never to have a sculptor as an assistant," Close commented. "One Friday night, we put up a bunch of the lead-prop pieces for the show at the Castelli warehouse. At that point, he hadn't started mixing antimony into the lead to make it stiffer. The warehouse was

closed for the weekend, and the pieces all came down." Luck-
ily, no one was around to get hurt. "I don't think Richard
meant danger to be an element, although they were very dan-
gerous," Glass told me. Serra insists that the possibility of col-
lapse was never part of his aesthetic. "I wasn't interested in
that at all," he told me. "I wanted them to reveal the principle
that they were interdependent and self-supporting, and not
bolted or welded." He started adding antimony to the lead af-
ter a three-piece lead-prop collapsed in St. Louis, taking out
the back wall of Joe Helman's house. Helman, a collector who
became a dealer, kept right on buying and selling Serra's work
for years afterward.

Serra resisted the idea of working with steel. "Steel was such
a traditional material I wasn't going near it," he said. "Picasso,
González, Calder had all done great things with steel. But then
I thought, Well, I can use steel in the way industry uses it—for
weight, load bearing, stasis, friction, counterbalance. I knew
something about steel, so why not?" In 1970, he wedged a big
slab of hot-rolled steel into the corner of a room, so that it was
held up by the corner itself. The idea had come to him the year
before, when he was making a splashed-lead piece that Jasper
Johns had commissioned. Johns, whose influence on Serra's
generation was as immense as Pollock's, had wanted to buy the
splashed-lead Serra he had seen in a 1969 group show at the
Whitney Museum; because that one was not available, Serra
agreed to make another in Johns's studio on Houston Street. He
put a small, freestanding lead plate in the corner there, to splash
against, and this made him realize that a corner could be a struc-
tural support. *Strike,* the steel corner piece he finished in 1971,
was twenty-four feet long by eight feet high, and Serra had to
hire industrial riggers to set it up. "That's when I left the whole

studio idea behind," he said. "It was a real sea change for me. I began to think about declaring or dividing the space of a room, and about the spectator walking through and around a piece in time, rather than just looking at an object. The spectator became part of the piece at that point—not before. After *Strike,* my studio really became the steel mills."

A lot happened in the next two years. He and Joan Jonas went to Japan, where they spent five weeks visiting Buddhist temples and gardens and going to performances of Noh and Kabuki plays at night. The gardens gave him "a new sense of how to control space in relation to time," as he put it. Back home, he went to see Michael Heizer's *Double Negative,* a pioneer work of land art made by bulldozing two deep cuts in a Nevada mesa. Serra had helped Bob Smithson, his closest friend and archrival, to stake out *Spiral Jetty,* a winding archipelago of rocks, dirt, and crystals at the northern end of the Great Salt Lake, in Utah. Although Serra would not become an earth artist like Smithson and Heizer, shaping the landscape in remote areas, he was impressed by the scale and the evocative power of both these projects, and they were certainly in his mind when he accepted his first major commission, from the publisher and art collector Joseph Pulitzer, for a piece on the grounds of Joe and Emily Pulitzer's country house outside St. Louis. "I was very anxious about the Pulitzer piece," Serra said. "The house there had one of Monet's 'Water Lilies' paintings, and a beautiful Ellsworth Kelly sculpture, a Matisse sculpture, a Brancusi, and paintings by Rothko and Cézanne, all at a very high level, and you don't want to go there and make a fool of yourself." It took him more than a year to finish it. Serra's anxieties nearly undid him a couple of times. At a dinner party at Joe Helman's house in St. Louis, he flew into a drunken rage and attacked everyone at the table, including Joe Pulitzer, a man

whose personality, lifestyle, and politics he greatly admired. (Pulitzer's *St. Louis Post-Dispatch* was one of the first newspapers to come out against the Vietnam War.) Helman and others remember the evening as a total disaster, but everyone got over it, as people did with Serra, and the piece got finished: three sixty-foot-long COR-TEN–steel plates set into a field at precisely calibrated angles, which made the landscape into a work of sculpture embracing space, time, and the walking viewer.

Fierce struggles against obstacles that were partly self-imposed: This seemed to be the pattern of Serra's career. Commissioned to do an outdoor sculpture for a new building at Wesleyan University, he designed a forty-foot tower of overlapping steel plates—it came right out of *House of Cards*—which was rejected, because the university's architect said it was too tall. (Four years later, the piece was installed on the grounds of the Stedelijk Museum.) A Serra proposal for the exterior of the Centre Pompidou, in Paris, also got turned down, because Renzo Piano, one of the building's architects, considered it intrusive. Serra talked himself out of what would have been the biggest sculptural commission of the decade, for the Pennsylvania Avenue Redevelopment Corporation, in Washington, D.C. He clashed repeatedly with Robert Venturi, the architect in charge. When Serra was shown a watercolor rendering of two pylons designed by Venturi with stars and stripes on them, he said there might just as well be a swastika and an eagle on top; he was fired soon afterward.

In 1971, a two-part prop sculpture by Serra fell while it was being taken down at the Walker Art Center, in Minneapolis, pinning a workman underneath. The workman died on the way to the hospital. At the trial that followed, responsibility for the accident was assigned to the fabricator, for not following the design specifications, and to the rigging crew, which had ignored

the engineer's written instructions, because the foreman couldn't read. Industrial accidents happen all the time, of course: Nobody had blamed Alexander Calder when a piece fell off a sculpture of his that was being installed at Princeton in 1970, killing two workmen. But Serra's reputation for arrogant and aggressive behavior led a number of people to condemn him over the incident. "I was harassed, ridiculed, disgraced, and was told by friends, other artists, museum directors, critics, and dealers to stop working," he said. Serra was devastated by the tragedy and its aftermath. "It sent me into analysis for eight years," he said, "and it put me on the road. I went to Europe and started building there."

FOR A MAN who was often his own worst enemy, he could inspire and reciprocate deep loyalty. When Bob Smithson died in a small-plane crash, in 1973, at the age of thirty-four, Serra went out to Texas and helped Nancy Holt finish *Amarillo Ramp,* the piece Smithson had been working on at the time. He did a lot to further the careers of Philip Glass and the filmmaker Michael Snow, arranging concerts and screenings for them in Europe; it was Glass, in turn, who introduced Serra to Cape Breton Island, where they both have been going since the early 1970s. ("What I really like about Nova Scotia is the light," Serra says. "Northern light is like light after it rains. I don't like fat, lazy, Mediterranean light.") Serra was deeply grateful to Leo Castelli, who became his dealer in 1969, stood by him after the Minneapolis accident, and kept giving him annual shows even though he had trouble selling his work, but the person he says he owes the most to is Alexander von Berswordt-Wallrabe, his German dealer, with whom he has worked since 1975. Von Berswordt's connections gave Serra high-level access to German steel mills

(his father-in-law was a director of Krupp), and his tireless advocacy led to many commissions. It was at von Berswordt's gallery in Bochum, moreover, that Serra met Clara Weyergraf, a German art historian and Mondrian scholar, with whom he began living in 1977 and whom he married in 1981. Serra's mother had committed suicide a month before he met Clara, and Serra thinks this had a lot to do with his finally managing to form a stable relationship. "When your mother commits suicide, it pretty much changes your relation to women," he said. "Before, I don't think I could have been as open or as vulnerable." Serra also told me that his mother's suicide, which nobody in the family could explain, had "pretty much conflicted the relationships" between him and his two brothers. He occasionally sees his younger brother, Rudy, an artist who teaches sculpture at Rutgers, but for the past twenty-five years he has had virtually no contact with Tony, in San Francisco.

Although he would continue to set sculptures into natural landscapes, as he had done with the Pulitzer piece, Serra preferred to work in urban settings. His ideal site was a place with a "density of traffic flow," like the traffic island facing the train station in Bochum, where, in 1977, he and von Berswordt managed to install a vertical steel-plate piece called *Terminal*. In the early 1980s, he was offered three such sites in downtown Manhattan. It was a terrific opportunity to triumph on his own turf, and to demonstrate the contempt he felt for artists like Noguchi and Calder, whose public sculptures failed, in his view, because they had nothing to do with the contexts in which they were placed. ("At best," Serra said, "they are studio-made and site-adjusted. They are displaced, homeless, overblown objects that say, 'We represent modern art.'") The Castelli Gallery sponsored and paid for *St. John's Rotary Arc*, a two-hundred-foot-long, gently curving

twelve-foot-high steel wall in an unused open space at the exit
from the Holland Tunnel. Visible mainly from above and by peo-
ple in cars, it caused no controversy and was generally considered
a great success. *TWU,* the second piece (the initials refer to the
Transport Workers Union), was financed by von Berswordt's
Galerie M; it took the form of three tall steel plates (thirty-six
feet high) set vertically on a narrow triangle at the intersection
of West Broadway, Leonard Street, and Franklin Street, an area
where many artists lived and worked, and, judging from the tone
of the graffiti that regularly defaced it ("Kill Serra," for example),
local admiration was decidedly mixed. The third of these New
York commissions was *Tilted Arc,* which became the most contro-
versial art work of the 1980s—a sculpture whose fame stemmed
from the battle over its removal.

Tilted Arc was commissioned by the General Services Ad-
ministration of the federal government, under a program that
allotted one-half of one percent of a government building's con-
struction budget to a work or works of art. The GSA reviewed
and approved Serra's proposal at every stage of the design
process—drawings, models, on-site mockup—and knew exactly
what it was getting: a curving, slightly inward-leaning wall of
COR-TEN steel, twelve feet high and a hundred and twenty
feet long, which bisected the open plaza in front of the Jacob K.
Javits Federal Building, in lower Manhattan. From the moment
it was erected, in 1981, however, the piece generated unusually
hostile reactions. This didn't surprise Serra. "The work I make
does not allow for experience outside the conventions of sculp-
ture as sculpture," he had said in a 1980 interview. "My audi-
ence is necessarily very limited." Serra thought that in time
people would come around to *Tilted Arc.* People, after all, were
an essential part of it—his intention was to bring them into the

sculptural experience. "It will . . . encompass the people who walk on the plaza in its volume," he said. "The placement of the sculpture will change the space of the plaza. After the piece is created, the space will be understood primarily as a function of the sculpture."

There is no doubt that, for many office workers in the Javits Building (itself an unusually depressing example of government architecture), *Tilted Arc* was an eyesore, a menacing, intimidating barrier whose tilt made some pedestrians feel it was about to fall on them. They hadn't asked to have a sculptural experience in their lunch hour, and they didn't want this one. But the arc might still be there if Edward D. Re, a federal judge whose office was in the building, had not mounted a one-man lobbying campaign against it. Judge Re wrote letters to the GSA, and he railed ceaselessly against the "rusted steel wall" that "desecrated" the plaza, and in his view harbored rats, posed unspecified security risks, and prevented the plaza from being used for concerts and other frolicsome events. His efforts apparently hit a nerve. In 1985, the GSA scheduled three days of public hearings, at which fifty-eight people spoke out against *Tilted Arc* and a hundred and twelve defended it. The defenders included well-known figures like Joan Mondale and Mrs. Marion Javits, representing former senator Jacob Javits, after whom the building was named, as well as a significant cross-section of the New York art world. Some of them did not particularly like the sculpture, but they felt that to allow the public art process to be overturned in this way would set a terrible precedent. The pro-Serra forces also complained that the GSA's regional administrator for New York, William J. Diamond, had compromised the issue by speaking out prior to the hearings in favor of "relocating" the sculpture—an option that Serra, with his usual intransigence, had vehemently ruled out. The work was

"site-specific," he said. "To remove the work is to destroy the work." When the GSA decided, soon after the hearings, that the sculpture would nevertheless be removed, Serra brought a $30 million lawsuit against the agency for breach of contract. The case dragged on for several years, but in 1989 the court decided against him, and *Tilted Arc* was carted away to a government parking lot in Brooklyn.

Serra is still angry and bitter over what he considers this betrayal by his own government. The episode hurt his career, he feels, and kept him from getting new commissions in the United States for a long time. It should be noted, however, that the Museum of Modern Art put on a major Serra retrospective in 1986, that Alexander von Berswordt continued to get important commissions for him in Europe, and that Serra's work kept right on growing in authority, inventiveness, and sculptural power. He is one of those rare artists whose careers seem to have had no weak or fallow periods. Material success, moreover, has hardly been withheld from him: Just about every major museum in the world now owns at least one Serra, and since he branched out from the Castelli Gallery, in 1992—showing with Blum Helman, with Pace, with Matthew Marks, and now mostly with Larry Gagosian—the pecuniary rewards have kept up with an almost unprecedented outpouring of critical acclaim. (One of the torqued spirals at the recent Gagosian show sold for more than $3 million.) "Richard has managed to stay within a very strong vocabulary that's clearly his, but never to rest on his laurels," according to Kirk Varnedoe, who acquired several major works by Serra for the Museum of Modern Art when he was the director of the painting and sculpture department there. "His pieces have moved away from the brutality and raw aggressive menace of some of the early things, into something you could

properly call sublime," Varnedoe told me. "I can't think of any-
thing that's rivaled this. And the idea of reaching for the monu-
mental scale without any sense of the undercutting subversion
of irony—that's hard to find in contemporary art."

Since *Tilted Arc,* Serra's contracts for commissions have been
handled exclusively by John Silberman, a lawyer who specializes
in working with artists. Under the system devised by Silber-
man, when a client (private or corporate) wishes to commission
a Serra, the artist visits the site and decides whether or not he
wants to make a proposal. If he does, the client must agree to
pay his proposal fee, which might be in the neighborhood of
$50,000. Serra then has a year to prepare a design, which the
client can accept or reject. (To date, there have been no rejec-
tions.) Once a design is accepted, the client pays Serra a much
larger fee (in the seven figures); this covers the purchase price
and the fabrication costs, but not the transportation or installa-
tion expenses, which are paid for directly by the client. There
have been rumors that Serra makes his clients sign legally bind-
ing pledges never to move a sculpture that he has sited and
installed, but Silberman assured me that this is "absolutely not
true." Serra's refusal to compromise in his work does not prevent
him from being highly professional and realistic in negotiations
over contracts. "When he calls someone a motherfucker, it doesn't
help, of course," von Berswordt said, "but he rarely does that
without a reason."

ON A COOL, OVERCAST DAY in February, my wife and
I drove upstate to Beacon, New York, a Hudson River town
where the Dia Foundation is converting a former Nabisco plant
into a museum for its collection of post-1960 art. Dia collects
the work of fewer than twenty artists, but it does so in great

depth: Among the anointed are Joseph Beuys, Andy Warhol, John Chamberlain, Donald Judd, Dan Flavin, Hanne Darboven, Walter De Maria, Michael Heizer, Cy Twombly, and Richard Serra. Although the museum would not open until the following spring, three very large Serra sculptures were already in place, and we had come to watch the installation of a fourth, a torqued spiral, which had been shipped over from the factory in Germany a few days earlier. We were issued hard hats and escorted to a covered shed adjoining the plant, where the Nabisco freight cars used to load and unload. Three torqued ellipses, forerunners of the torqued spirals, filled the huge space so snugly that there was barely room to squeeze by them on one side. Serra was at the other end of the floor, conferring with Ernst Fuchs, his German rigger, who oversees the installation of his most difficult pieces. In his hooded sweatshirt and wool watch cap, Serra looked indistinguishable from Fuchs and the eight or ten other riggers on the job, except that he carried his omnipresent black sketchbook and drawing pencil, which he used now and then to demonstrate some verbal idea or instruction. He wasn't wearing a hard hat, and neither was Clara, a slim, handsome woman whose quiet competence is indispensable to Serra's work, but who makes it clear that she takes no part in his aesthetic decisions.

Four of the spiral's five elements were already in place at this end of the building, suspended an inch or so from the floor by overhead cables, and the fifth was being lifted by crane from a flatbed truck on the road below. It came down very slowly, guided by three workmen on the floor, until its bottom edge rested on three smallish, wheeled dollies called skates. A rigger then mounted a ladder and unhooked the clamps that connected it to the crane. It hadn't dawned on me until that moment that

this enormous slab of steel, fourteen feet high and weighing twenty-two tons, could stand by itself, without support. "The tendency to overturn is always inside the line of balance," Serra explained. "A lot of them curve both back and forward, but when you put them down they're stable." Serra was keyed up, buoyant. ("He jumps age groups when an installation is going well," Ealan Wingate, Gagosian's director, had told me. "He's like a seven-year-old with a new truck.") A moment later, he ran off to speak to the crane operator. "I wanted to thank him," he explained when he came back. "They're bringing in a new operator. This one said, 'Don't thank me, go tell my boss and save my butt,' so I did that, too." If Serra treated everyone the way he treats riggers, his life would run more smoothly. Some people say he has mellowed, but others (including a former Serra dealer) say he can be as irascible and ruthless as ever. His old friend Chuck Close, whom he recently threatened to sue over a dispute involving an interview with Serra in a book by Close, describes going up to Serra at a party and trying to tell him (in spite of Serra's having stopped speaking to him) how much he had admired his recent show at the Guggenheim Bilbao, and Serra saying, "You think I give a shit what you think?" ("I didn't say that," Serra told me. "I didn't say anything. I turned my back and walked away.") "I still consider Richard a friend, someone extraordinarily important in my life," Close said. "I think he's the best sculptor working today, and maybe the best artist. I don't think he's a bad person. But it's a goddamn good thing he is a great artist, because a lot of this stuff wouldn't be forgiven."

At Dia that day, during a coffee break at a nearby bakery, I brought up the paradoxical alliance between nineteenth-century-scale industry and twenty-first-century art: factories morphing into museums, the German steel mill that works exclusively

with artists, not to mention Serra's career of shaping industrial-weight steel into huge and poetic works of sculpture. "Spinoza predicted that art would dematerialize," he said, "and to a large degree it has. In a sense, my work is antithetical to that. But then, simultaneously, other things go on. As art dematerializes, the scale has grown larger. I'm using tons of steel to make the situation look lighter."

He thought for a minute, and said, "Listen, I just saw the Warhol show in London, and I loved it. But that's a very, very different experience from walking through a torqued ellipse. It's different in kind. When you go see Campbell's soup cans, you're playing a strategic game of the relevance of painting to figuration, to media, to commercialization. Abstraction gives you something different. It puts the spectator in a different relationship to his emotions. I think abstraction has been able to deliver an aspect of human experience that figuration has not—and it's still in its infancy. Abstract art has been going on for a century, which is nothing." Serra cut the conversation short because he was in a hurry to get back to Dia. The riggers wanted to work late, so they could finish installing and not have to pay for another day's crane rental, and he wanted to oblige them. "I've worked with riggers all my life," he said happily. "I have a very good relationship with them. I admire people who do a hard day's work, whatever it is."

—*August 5, 2002*

Serra's second career retrospective at the Museum of Modern Art, which was organized in collaboration with the Dia Art Foundation in the summer of 2007, came close to canonizing him as America's

greatest living artist. Certainly no one else, with the possible exception of the painter Ellsworth Kelly, has done more to reassert the continuing viability of abstract art as a carrier of profound meaning and emotional truth.

JAMES TURRELL

For sheer aesthetic tenacity, nothing beats the saga of James Turrell and the Roden Crater. Since 1974, Turrell's working life has centered on the effort to turn an extinct volcano on the western edge of the Painted Desert in northern Arizona, into a naked-eye observatory for celestial events. Turrell is an artist whose medium is light. His work is not about light, or a record of light; it *is* light—the physical presence of light made manifest in sensory form. At the crater, he has built nine underground chambers and one huge outdoor space (the crater's bowl) "to capture and apprehend light" from the sun and the moon and the stars— and also to demonstrate how we create and form our perceptions of the visible world. After years of struggling just to hold on to the land and keep the project going, Turrell has received substantial funding from two private foundations in the last four years. The first phase of construction is virtually complete as a result, but a great deal remains to be done, and the future of the crater,

whose total cost will probably exceed $20 million, is far from assured. As obsessions go, this one could outlive Turrell.

At the wheel of his dark-blue diesel pickup, careering down a dirt road and accelerating around curves to minimize vibration from the washboard surface, the artist manages to look both rugged and distinguished. Turrell, who is fifty-nine, is a big man, big in the shoulders and chest and, these days, in the middle as well. He wears jeans and cowboy boots, and a made-to-order shirt of pin-striped blue gabardine, with buffalo nickels for buttons. His hair is white, and so are his full beard and flowing mustache. A mountainous serenity envelops him as he sits behind the wheel, steering with one hand and pointing out things with the other as we hurtle past. "There you see some first-time mothers with their calves," he says, waving at two dozen small and smaller dark-brown cows. "The heifers will have theirs a little later." Turrell became a cattle rancher sixteen years ago, so that he could get a bank loan on his land; banks don't lend money to develop craters as art works. His ranch, Walking Cane, now has just under a thousand head of cattle on a hundred and fifty-six square miles of land, about half of which he owns outright. (He leases grazing rights to the rest.) "It's paid off," he says. "Agriculture is actually subsidizing art. I'm not sure if it's harder making a living as a rancher or an artist, but I think people behave better in ranching."

The crater is about half an hour's drive from Turrell's modest ranch house and studio, which makes it an hour from Flagstaff. The landscape changes dramatically as the altitude drops, from Flagstaff's seven thousand feet to five thousand at the crater. Ponderosa pines and aspens give way to piñon and juniper, and now we are barreling along through arid grasslands on the eastern edge of the San Francisco volcanic plateau. Rounded cinder cones

loom on all sides, some much bigger than Roden. "That's Saddle Crater," Turrell says, "the one that looks like a shark took a bite out of it. There's one called Merrill Crater, after a member of the family that made Merrill Lynch, although I think it should be after another member, James Merrill, an amazing poet." A little farther along, he points out a tiny log house, which he built in the early 1980s and lived in for nineteen months, studying the crater and the light and "trying to understand what happens throughout the year." When Roden Crater comes into view a few minutes later, it is instantly clear why he chose it: a symmetrical black-and-red cone that's all by itself in the landscape, with an unobstructed horizon. "There were four parts to its explosive cycle," Turrell explains, "and you're looking at two of them. The black crater was first. The red crater blew out of it later. That was three hundred and eighty-nine thousand years ago. It's kind of a young crater, modest in scale, but very handsome. We're coming to a place here where the two of them look almost like that painting by Man Ray, of lips in the sky. Do you see it?" I see it. Northern Arizona is irresistibly pictorial. The redrock country around Sedona, sixty miles to the south, inspired not only John Ford but Max Ernst, who lived there for a while in the 1940s. The silhouetted buttes in the backgrounds of Krazy Kat comics were drawn mostly from life by George Herriman, who spent a lot of time in Flagstaff.

DRIVING SLOWLY NOW, Turrell navigates the winding dirt road up Roden Crater. It's four-thirty in the afternoon, and the work crew has just knocked off for the day. (Navajos compose a large portion of the construction crew on the crater; their lands lie to the east.) Halfway up, he stops to show me the nearly finished guest lodge. It is built right into the black cinder slope, an

elegantly spare concrete bunker with floor-to-ceiling windows facing south across the valley. Turrell designed every facet and detail, including the furniture, which is being made. There is a suavely efficient kitchen, and four bedrooms with private baths. Two other lodges are planned, elsewhere on the crater. All three together will accommodate at least twenty overnight visitors at a time. Since many of the celestial events to be viewed involve the night sky, serious visitors will want to sleep over; the best viewing hours are from sunset to midnight, and from just before dawn to a little after sunrise. If the immediate funding comes through as planned, Turrell thinks he can finish Phase I of his construction plan in a year and a half. It will take at least four more years to carry out Phases II and III.

About three quarters of the way up the slope, Turrell parks his truck and heads toward what is clearly a temporary entrance to the crater's interior. We enter a high-ceilinged room called the Sun and Moon Space, which has a seventeen-foot-tall white stone monolith in its center. On the far side of the monolith there is an upward-sloping tunnel oriented to the southwest, to receive the moon at its southernmost apogee. Another tunnel, scheduled for construction during Phase II, is oriented to the northeast, to receive the rising sun. Every year, at the solstice, the sun will line up precisely with its opening and imprint its image on the monolith. Once every 18.6 years, the moon will register a detailed reverse image of itself on the monolith's other side. The Sun and Moon Space functions like a pinhole camera. It also suggests ancient rituals, of which Turrell is keenly aware. His thinking has been shaped by visits to Newgrange, in Ireland, Abu Simbel, in Egypt, and other sites where openings cut into the rock were aligned so that sunlight could penetrate to the deep interior at certain times of the year.

We start walking up the completed tunnel, which is shaped like a keyhole. It is nine feet high and eight feet wide, with an arched ceiling. At the far end, nearly nine hundred feet away, daylight is visible through a round opening. The floor is rough concrete, with small lights placed about eight feet apart on either side. Our voices reverberate and echo in the tunnel, except at certain intervals, or "nodes," as Turrell calls them, where the sound goes dead. "The tunnel is tuned like a flute," Turrell says. "I treat sound and light very similarly. I learned a long time ago that when you work with light, and the surfaces are hard, either you pay attention to the sound or it's just going to be chaos."

As we near the tunnel's end, what had looked from below like a round window is revealed as an oculus in the ceiling of a large, elliptical room called the East Portal. Turrell has made many rooms like this during his career, in many parts of the world. He calls them skyspaces, and they are designed to turn the sky's changing light into a physical presence, like a membrane that viewers feel they could touch. There is a skyspace at P.S. 1, the contemporary art museum in Long Island City, which you can see at dusk, if it doesn't rain or snow. A panel in the ceiling there slides back, and as you sit quietly under the opening a rectangle of sky changes from deep cerulean blue to subtly darkening shades of purple which seem increasingly tangible as they verge into soft, velvety black. "The big thing about a skyspace," Turrell says, "is that the sky is no longer 'out there.' It's brought down into our territory." Sandstone-faced benches line the walls on either side of the East Portal. A recessed ellipse in the middle of the floor, directly under the opening, will be filled with white sand to filter rainwater into hidden drains, and at night, according to Turrell, the sand will reflect the stars. "Starlight itself is very beautiful," he says. "You are going to be able to gather

starlight that is over two billion years old, older than our solar system. There will be fresh light from the sun, eight and a half minutes old, and ancient light that's shifted toward the red, with its own character and feeling. You'll be able to see your shadow from the light of Venus alone—I've made a space for this." (Designed a space, he means; the North Space is scheduled for excavation and construction during Phase III.) The difference between night-sky viewing at Roden Crater and at P.S. 1 or anywhere else is that there won't be any man-made interference. In 1997, Turrell persuaded the authorities of Coconino County to pass a "dark sky" ordinance, ruling out any upward-directed lighting, commercial or domestic, within thirty-five miles of Roden Crater. He also won permission to construct a perilously steep flight of bronze stairs from the floor of the East Portal to the elliptical oculus, so that intrepid viewers could (theoretically, at least) walk up and out into the open-air bowl of the crater. Local ordinances would have required handrails, but Turrell, who knew that handrails would destroy the sight lines, pointed out that in nearby Hopi kivas, which were in use before Europeans discovered this continent, elderly men still walk down near vertical ladders carrying snakes in either hand. Rather than waiving regulations that would have applied to many other aspects of the crater, Coconino's farsighted building officials amended the building code to allow for a new category, called "land art." "Some amazing people around here," as Turrell puts it. "They really went to bat for me."

Two winding corridors lead off from the East Portal. One goes to the Crater's Eye, a skyspace with a circular oculus. The other leads up and out to the bowl itself, an immense space where bulldozers have moved more than a million cubic yards of rock and earth to shape a graceful oval whose rim is the same height

all around. At the bowl's center, four massive, somewhat pharaonic-looking limestone platforms surround the opening to the Crater's Eye. I do as Turrell directs, and lie down on one of these, on my back. The platform inclines so that my head is lower than my feet. All I can see is sky, more sky than I've ever seen in my life. It's an intensely blue, hemispherical dome, as enclosing and nearly as intimate as the sky in Giotto's frescoes in the Arena Chapel. What I'm experiencing is the perceptual phenomenon called celestial vaulting. We can get something like the same sensation by standing in an open field, but at a certain distance above the ground it becomes much more intense, overwhelmingly intense, in fact, and extraordinarily beautiful. Turrell can't really explain why we see it this way. He tells me that it has something to do with our yearning for "closure"—for closed sets, finite dimensions, a human scale. What he was looking for when he discovered Roden Crater, back in 1974, was a place to make the experience of celestial vaulting available to the rest of us. Turrell isn't interested in giving people his interpretation of natural events; he wants us to experience them firsthand. "My art," he says, "is about your seeing."

A bit disoriented from all that sky, I follow Turrell as he leads the way up the fairly steep slope of the bowl. The wind is blowing hard up here, making it difficult to hear him. I am astonished to see a few tiny green plants in the hostile red cinders underfoot, clinging on for dear life; eventually, the bowl will be blanketed in native black grama and Indian rice grasses and wildflowers. As we reach the rim, Turrell points out how, from this height, the surrounding landscape appears to curve up toward the sky, in a sort of reverse vaulting. Airplane pilots know about this— Turrell first read about it in Antoine de Saint-Exupéry's *Wind, Sand, and Stars* when he was a teenager, before he became an avid

flier himself. (He got his student pilot's license when he was six-teen, and he figures that he has logged more than six and a half years of his life in the air.) We come down out of the wind and reenter the long, echoing tunnel. "The idea that we do a large part of forming our reality—that's something people are not too aware of," he says. "We actually give the sky its color as well as its shape. You go into a skyspace, and you see that the sky is a cer-tain color, but then if you walk outside you can see that it's not a color. I can change the color of the sky by changing the context of vision; it's the same effect as those perceptual tests where they show you a blue spot on a green field, and the same blue spot on a red field, and you see the spots as different colors. It's what's behind the eye that forms this reality we create. I recently did a lighting job for the Roman aqueduct in Nîmes, and at night there you can now see green sky, red sky, blue sky between the arches. We like to think that this is the rational world we're re-ceiving through our senses, but that isn't the way it works. We form our reality. All of the work I do is gentle reminders of how we do that."

TURRELL'S MOTHER AND GRANDMOTHER were Quak-ers. When he was seven or eight, the youngest of three children growing up in Pasadena, he remembers his grandmother telling him what to do at a Quaker meeting: "Go inside and greet the light." He knew this meant the invisible inner light, but even then he was fascinated by light's physical presence. As a child, he laboriously pricked holes in the blackout curtains in his bed-room, to simulate the stars and constellations during the day-time. (The curtains had been installed following an air-raid scare in 1942, the year before he was born.) Turrell stopped going to Quaker meetings when he was in his teens. Two years

ago, however, he designed a Quaker meetinghouse in Houston, and since then he has been going to meetings and referring to himself as an "un-lapsed" Quaker. The house in Houston is a simple, beautifully proportioned rectangular structure with a skyspace, where inner and outer light coexist in quiet harmony.

His father was an aeronautical engineer who ran the technical school at Pasadena Junior College. He died when Turrell was ten, and not long afterward Turrell's mother, who had trained as a medical doctor but never practiced, joined the Peace Corps and went off to teach zoology in Nyasaland (now called Malawi). An independent child with a strong scientific bent, young Turrell was an Eagle Scout, an honor student in high school, the president of his class, and Pasadena "boy of the year" in 1960. But he didn't graduate with his class in 1961. The year before, he had volunteered for the draft as a conscientious objector (true to his Quaker heritage) but was willing to serve in other ways. His alternative service, as it turned out, was as a pilot with an air-transport agency that worked with the CIA. For much of 1960 and 1961—or so it has been reported—Turrell flew small planes into Tibet and brought out Buddhist monks who had been involved in the revolt against China's puppet regime. Turrell has never talked about the experience, and he won't talk about it today; some of his old friends find the story hard to believe. "I'd just rather leave those things out," he said, when I asked.

In the fall of 1961, he entered Pomona College, in Claremont, California, where his classmate Jane Livingston remembers him changing from an eager kid into a long-haired hippie. "He was very serene," according to Kate Ganz, another classmate. "All of us were so full of angst, but Jim just sort of floated among us. He was friendly, sweet, and warm." He majored jointly in mathematics and perceptual psychology, and he took a lot of

art courses—both art history and studio art. Pomona had a first-rate art department—James Demetrion and Bates Lowry, who went on to become museum directors, were both on the faculty—and Turrell, whose studies in perceptual psychology emphasized optics and visual phenomena, found himself more and more interested in making art. After graduating from Pomona, he decided to continue his art studies at the University of California at Irvine. Turrell's main interest then was in painting. He had been struck at Pomona by the work of Mark Rothko and Barnett Newman, whose canvases seemed to generate an inner light, but even then it sometimes occurred to him that instead of making art that contained light he could work with light itself. Turrell's first light pieces, which he made at Irvine, used flammable gases to create flat flames. "I had trouble controlling them," he said, but "the flames were tremendously beautiful and exciting."

TURRELL'S PRINCIPAL TEACHER in graduate school was John Coplans, who taught art history and ran the university's art gallery. An artist himself, and a former pilot in the Royal Air Force, Coplans thought Turrell was an exceptionally bright student with very little knowledge of modern art, so he had him spend most of his time reading books and periodicals in Coplans's private art library. One day, while reading an essay by the art historian Michael Fried, Turrell suddenly shouted, "That's it! I've got it!" His eureka moment was triggered by a disparaging comment of Fried's about the work of Donald Judd and other minimal artists—that their impersonal, machine-made sculptures had the look of images from projected slides.

Turrell was no fan of slide lectures. It bothered him that every projected image—whether it was the *Mona Lisa* or a monumental

abstraction by Barnett Newman—came out the same size on the screen, and quite often with a luminosity that was missing in the original. And lately his attention had been wandering more and more from the screen to the beam of light itself, with its dust motes and its smoky, flickering colors. Fried's comment gave him the idea for a light piece, which he worked out during the next few weeks and installed, with Coplans's encouragement, in the Irvine art gallery. Using a blank slide in a high-intensity projector mounted near the ceiling, he directed a beam of light across one corner of the room, where it formed what appeared to be a floating, three-dimensional white rectangle. This was something remarkable, Coplans remembers thinking, when he saw the piece. "I told him, 'You don't need us. Go be an artist.'" Turrell left Irvine after one semester, but not because of what Coplans had said. He was arrested in 1966, in a sting operation by the FBI, for counseling potential draftees on how to avoid going to Vietnam. This is another phase of his life that he's reluctant to discuss, except to say that "sometimes you can be so naïve as to think that your own self-righteousness will carry the day."

In 1967, after serving some time in jail, Turrell moved back to Los Angeles. He had a little money saved up, which he used to take a lease on the old Mendota Hotel, a small, derelict building in what was then a sort of slum, the Ocean Park section of Los Angeles, where Richard Diebenkorn and a number of other artists had studios. Setting aside two rooms in front, on the street, for his studio, Turrell proceeded to seal them off from the outside world, blocking out the windows and painting the walls, floors, and ceilings a uniform white. Then he made some carefully calibrated openings that allowed light to enter the rooms under controlled conditions. In the daytime, shafts of sunlight would move slowly across a section of wall or floor. At night, the headlights of

passing cars created moving patterns. He experimented with variations on the cross-corner projection he had made at Irvine, and with more complex projections of colored light on flat walls. Coplans exhibited several of these works in 1967 at the Pasadena Art Museum, where he had become chief curator—it was Turrell's first solo show—and he published his catalogue essay on them in *Artforum,* of which he was the West Coast editor. Turrell was becoming known in the Los Angeles art community as a slightly mysterious character who occasionally invited people to the Mendota to see his work, but who wasn't interested in selling it. He even turned down the Los Angeles County Museum, which wanted to buy some of his drawings.

Turrell supported himself by rebuilding old cars—he is an ace mechanic—and by flying airplanes. In 1969, he bought his first plane, a single-engine Helio Courier. He flew for the Neptune Society (aerial burials) and as a crop duster, until Sam Francis, an artist who had flown P-38s in the Second World War, got him a better job, delivering mail to little towns up and down the San Joaquin Valley. In the early 1970s, Turrell and three others started a small company to rebuild antique airplanes, something he loves doing, and has continued to do, on his own, to this day.

IN THE 1960S, you kept hearing that Los Angeles was about to become a major art center. A gifted younger generation of artists (including Ed Ruscha, Billy Al Bengston, Robert Irwin, Ed Kienholz, and about a dozen others) had emerged, and several new galleries and two museums seemed eager to support their work. California minimalism, with its bright colors and hand-polished surfaces, was putting a sunnier spin on the somber industrial artifacts of Donald Judd, Robert Morris, and their minimalist peers in New York. The California light-and-space

artists, on the other hand, seemed indigenous to the West Coast. The main practitioners of light-and-space art—Irwin, Turrell, Douglas Wheeler, and Maria Nordman—never functioned as a group, and didn't agree on much of anything. What they did share, more or less, was an interest in perception—in how we see what we see—and also a high-minded disdain for the commercial side of art making. A lot of artists felt this way in the 1960s. Michael Heizer and Walter De Maria went into the desert and wrestled with raw nature, shaping it into forms that very few people ever saw. Robert Smithson moved tons of rocks and earth to build his *Spiral Jetty*, at the northern end of the Great Salt Lake, whose waters soon rose to make it invisible. Of course, these so-called earth artists often had wealthy patrons backing them, and they showed (and sold) drawings and photographic blowups of their work in New York art galleries. To function outside the system seemed to require some help from the system.

A recognition of this dilemma may have had some bearing on Turrell's sudden decision to withdraw, in 1969, from an intense, year-and-a-half-long collaboration with Robert Irwin. The two artists had been working together on a project sponsored by the Los Angeles County Museum's Art and Technology program, which paired artists with scientists to explore areas of mutual interest. Turrell and Irwin were paired with Edward Wortz, a physiological psychologist who was also involved with training astronauts for space travel. They experimented with sensory deprivation in soundproof chambers, and also with ganzfelds—controlled environments filled with an undifferentiated, homogeneous light that removes all visual clues to where you are—and until Turrell's defection all three of them were excited and stimulated by the collaboration. "At one point, Jim just disappeared," according to Irwin. "Didn't say goodbye, didn't even hint."

Neither he nor Wortz, he said, was ever able to figure out why. Turrell told me, "What happened there, to be frank, was that my situation became difficult. Irwin had a New York gallery, so if he got ideas they could immediately come to the marketplace. I didn't have a gallery. For my own protection, I thought it was best for me to withdraw."

Yet it was Irwin who introduced Turrell to Arne Glimcher, the director of the Pace Gallery in New York, where he showed. Glimcher visited Turrell's studio in 1968, and offered him a show the following year, advancing him the money to make ten new works for it. Turrell made the works but decided that he didn't want to have them in a gallery. (He paid back the advance.) Turrell preferred to keep on transforming rooms in the Mendota Hotel. He made dreamlike spaces divided by walls of colored light that looked solid until you came close to them. He made ganzfelds in which the viewer lost all sense of dimension. Turrell cut his first skyspace in the roof of the Mendota Hotel. His landlord found out and made him repair the damage, but Count Panza di Biumo, an adventurous Italian art collector who visited the Mendota in 1972, commissioned Turrell to do a skyspace and several other works at his palazzo in Varese. This was Turrell's first commission, completed in 1974. That same year, a group of Hollywood investors bought up his entire block in Ocean Park, forcing Turrell and several other artists, including Sam Francis and Richard Diebenkorn, to find new studios.

"I chose that moment as an opportunity to do what I really wanted, which was to take art into nature," Turrell told me. For the next seven months, using the money from a fortuitous Guggenheim Foundation grant, he flew his Helio Courier from the Canadian border to Mexico and from the Rockies to the Pacific, looking for a site. What he wanted was a truncated cone, a

mastaba-shaped formation that rose from six hundred to a thousand feet above a flat plain—high enough to optimize the experience of celestial vaulting. He would use it the way he had used the Mendota Hotel, carving out tunnels and light-sensing chambers, isolating and channeling particular kinds of natural light. He was in the air for something like seven hundred hours in all; at night he unrolled his sleeping bag under the wing of the plane. Roden Crater, when he found it, was not only the obvious choice; it was familiar territory: Turrell and his parents had camped at nearby Sunset Crater National Monument when he was a child. Although it took him three years to talk the owner into selling him the land ("Son, I don't sell land; I buy land," said Robert Chambers, whose twenty-three-thousand-acre ranch included the crater), Turrell immediately started to work on his grand design.

Count Panza came through with seed money, and later he sent his son over from Italy to work on the project. The money to lease and then to buy the crater and the surrounding land (six hundred and forty acres, at $100 an acre) came largely from the Dia Foundation, a uniquely freewheeling organization set up by Heiner Friedrich, a German art dealer, and Philippa de Menil, a young American heiress to the Schlumberger oil fortune, to help artists realize large-scale, visionary projects. Two of the earliest Dia grants went to Roden Crater and to Walter De Maria's *Lightning Field,* in New Mexico. Dia was soon supporting about a dozen other artists here and abroad, supporting them quite lavishly, in some cases, until the oil crisis in the early 1980s knocked the bottom out of Schlumberger shares, and the de Menil family in Houston intervened. "I found out about it when the checks stopped," Turrell told me. "I had loans for more than four hundred thousand dollars, on equipment and stuff, and I

had to sell things quickly. I ended up with thirty-eight thousand of negative equity. It was a tough time."

Tough in several other ways as well. Turrell's career before that had looked like it was taking off. He had had an important show at the Stedelijk Museum in 1976, and in 1980 he had two well-received New York shows, one at the Leo Castelli Gallery (his first solo gallery show) and the other at the Whitney Museum. Castelli didn't ask him to join the gallery, however, and the Whitney show turned out to be a financial disaster. Three viewers separately mistook a wall of light for a solid wall, and fell slap into the art. One of them broke her wrist, all three of them sued Turrell and the museum, and in one case the museum sued Turrell. This suit was quashed at the insistence of Flora Miller Biddle, the museum's president, but the individual cases cost Turrell time and money before they were settled out of court. Turrell's first marriage, to a professional harpist with whom he'd had two children, was breaking up at this time, which also happened to be the moment that the Dia Foundation withdrew its support. Turrell retreated to Arizona, where he spent the next nineteen months living alone in his cabin on the side of the crater.

From then until the mid-1990s, what support there was for the Roden Crater project came mostly from Turrell. He found various ways to keep it afloat. He continued to rebuild vintage airplanes, his workmanship so exquisite that he could resell them for a substantial profit. He became a cattle rancher, doing much of the heavy work himself until he could afford to hire a manager, who promised to make the ranch break even, and did so; this involved buying or leasing the grazing rights to considerably more land around the crater. In 1984, Turrell was awarded one of the so-called "genius grants" from the MacArthur Foundation. (Robert Irwin also got one that same year; they were the first two

visual artists to become MacArthur fellows.) He did a lot of lecturing, and at a certain point he found he could charge a fee for installing shows of his light pieces—as much as $10,000 per show. One year, he had sixteen solo shows in this country, Europe, and Japan, and made $160,000 doing it. Today, he estimates that he's had more than three hundred shows in all. (He shows in New York at the Pace Wildenstein Gallery, which took him on permanently in 2001.) There were also commissions here and abroad for skyspaces and other installations. Although not too much work got done on the crater during the 1980s and the early 1990s, quite a few of his solo shows were also trial runs of ideas he wanted to realize there. When he wasn't traveling or lecturing or installing exhibitions, he stayed at his ranch in Arizona and worked on the increasingly complex master plan for the crater. Patience, cunning, and a sense of humor kept him sane. "If you don't fund an artist right away," he joked, "the project becomes more expensive."

THE PROJECT HAS taken its toll, in years and relationships. Turrell has always been an elusive type; a young woman he lived with for a time in the 1970s told me that he just "evaporated" from her life, without warning, for reasons she could never discern. "He's an escape artist, in more ways than one," according to his old friend Alanna Heiss, the director of P.S. 1. "He escapes from responsibility, from domestic situations, from commitments. But the nature of his art is to escape from reality of all kinds, and he allows viewers to do the same." Turrell's second marriage, to Julia Brown, a museum professional who is currently the director of the American Federation of Arts, broke up in great bitterness in 1996, after eleven years and three more children. (He has six children in all, including one by a woman

he didn't marry. His first child, who was two years old when he started the crater, and who is now a doctor in Flagstaff, recently gave birth to his first grandchild.) The divorce settlement with Brown involved a division of property, and as a result Turrell had to buy back her share of the ranch; he came as close as he ever has to going under financially, until the Lannan Foundation, in Santa Fe, decided in 1996 to devote major funding to the Roden Crater, among other art projects. Dia, restored to financial health and led by an imaginative and daring young director, Michael Govan, came back into the picture in 1998. Dia now raises money and acts as the administrative arm of the crater project, having taken over from the Skystone Foundation, which Turrell himself had set up after Dia pulled out, in 1981.

His optimism these days is contagious. "It's like beginning," he tells me. "I should be a forty-year-old artist, in terms of the opportunity that's come now. Art went somewhere else in the eighties. It was a time for other artists, with the neo-expressionist scene that developed. We do have our time, our period. You have to deal with that, and with your ego, with the hubris that put you in this position, sitting on this mountain." His big frame shakes with quiet laughter. We are sitting in the airport cafeteria in Sedona, where he has just landed his 1939 Champion Scout two-seater (totally rebuilt and re-outfitted by Turrell), after flying me over Roden Crater. We are having breakfast with my wife and Kyung-Lim Lee, the Korean-born artist he lives with, who maintains a studio in New York but spends a lot of time at the ranch in Arizona; they drove down together from Flagstaff to meet us. One reason Turrell had wanted to fly me over the crater was to point out how little he has interfered with its natural shape and appearance. Banking low in a tight circle, at what seemed like only about ten feet above the bowl, I could see the openings for the

Crater's Eye and the East Portal, and the four stone platforms for celestial viewing, but aside from that Roden looked more or less untouched. "It's a powerful geological form," he says now, sitting in the sun and putting away a high-calorie Western breakfast of eggs, bacon, and fries. "I wanted to keep the strength and beauty of that form. This is different from the land art of Smithson and the others. They want to make a place. Of course, Roden Crater is a place—now, you do feel that. But I don't want it not to be a volcano. I don't want to take that away." Then, after a longish silence, he adds, "It's such a privilege being involved with art."

—January 13, 2003

Phase I of the Roden Crater's development is now complete. The Dia Foundation no longer supports the project, but Michael Govan, who left Dia in 2006, is helping to fund Phase II in his present capacity as director of the Los Angeles County Museum of Art. There is no estimated completion date for Phase II, and no slackening in Turrell's absolute commitment to his goal.

MATTHEW BARNEY

In today's art world, an artist who brings what Victor Hugo once described as a "new shudder" runs the risk of immediate and unthinking acclaim. Matthew Barney encountered this at his New York début, in 1991, when crowds packed the Barbara Gladstone Gallery to watch a video of the artist, naked, scaling the gallery's walls and ceiling with the aid of a rock climber's harness and titanium ice screws, and a sort of critical euphoria has attended his career ever since. Instant recognition, however, seems to have left this young man's very real talent unscathed. At the age of thirty-five, he is about to have a vast, multimedia exhibition at the Guggenheim Museum called "The Cremaster Cycle," focusing on the last eight years of his work in film, video, sculpture, drawing, photography, and music. A full-fledged apotheosis is at hand, although, in truth, what Barney has brought us is still something of a puzzle.

If you ask him, he will tell you that his work is sculpture.

The five films in the "Cremaster" cycle are vehicles for the sculptures he makes for them, he has said, and the strange, nonverbal, and sometimes impenetrable stories that each film tells are also sculptures—narrative sculptures, or maybe sculptural narratives. To most of his admirers, however, Barney is primarily a filmmaker. The five "Cremaster"s, shot on video, were transferred to film and shown in movie houses and museum auditoriums here and abroad, and Barney soon gained a following as a new kind of auteur, one who uses autobiographical material, landscape, biology, architecture, dramatic actions, private fantasies, classical myths, elaborate costumes, prosthetic devices, and transforming makeup to create worlds that are unlike any you'll see at the multiplex. In *Cremaster 3*, for example, there is a horse-racing scene at the track in Saratoga Springs, where, as the camera moves closer, we become aware that the ten trotting horses in the race are flayed, their muscles, tendons, and viscera rotting away from their fast-moving bodies. Another sequence in the same film shows Barney (who appears prominently in four of the five films), wearing a voluminous kilt and a huge, shocking-pink shako, climbing the interior walls of the Guggenheim Museum, using handholds to hoist himself from tier to tier, and encountering bizarre obstacles at each level: a Rockette-like chorus line of girls in lamb suits; a mosh pit between two violently dueling heavy-metal rock bands; a beautiful fashion model who turns into a fanged cheetah-woman; the sculptor Richard Serra (played by himself) flinging molten Vaseline against a parapet wall. Every scene connects in some way to the dreamlike structure of the "Cremaster" cycle; although the connections may not be clear to an untutored viewer, the cycle's hermetic aspects have not impeded its acceptance, by a significant segment of the international art and film worlds, as a major work of art.

One thing Barney has certainly done is draw attention to a word that was not in everyday use. The cremaster, as any Barney fan now knows, is the muscle that raises or lowers the testicles, in response to changes in outside temperature or involuntary reflexes. Ascending and descending actions of one kind or another have figured in Barney's work since his undergraduate days at Yale, but in the "Cremaster" cycle it is not the muscle itself that really concerns us. It is, rather, the process of sexual differentiation that takes place within the womb. For the first eight weeks of pregnancy, a fetus exists in a state that is neither male nor female. During the ninth week, barring the sort of complications described in Jeffrey Eugenides's *Middlesex,* the internal gonads begin to move either upward, to become ovaries, or downward, to become testicles. The underlying motif of the five films, whose combined running time is just short of seven hours, has to do with the organism's struggle to resist that fateful moment of sexual definition.

To those who might wonder how this struggle—undocumented so far in medical literature—could serve as the basis for a five-film epic, the answer is simply that it has. Barney's "Cremaster" films have been compared by more than one critic to Richard Wagner's Ring cycle, as a kind of *Gesamtkunstwerk* of the multimedia age. It should be added that Barney does not take himself or his work that seriously. An extremely engaging young man whose clean-cut looks and quiet good manners tend to veil the intensity of his ambition, he occasionally bursts out laughing at the more ridiculous aspects of his epic. But this doesn't mean that he thinks it's a joke; irony, the postmodern calling card, has no place in Barney's thought process, or in the "Cremaster" cycle.

"There's nothing disguised about Matthew," Chelsea Romersa,

the associate producer of the last three "Cremaster"s, says, but even she finds him something of an enigma. For someone who frequently uses his naked body as a material for art, Barney in person reveals very little. He resists talking about himself, and Romersa and the other members of the closely knit team that works on his projects guard his privacy as carefully as he does. None of them will say much, for example, about his current liaison with the Icelandic rock star Björk, except that Matthew, who had been totally submerged in his work for the last decade, seems happier now. Barney will talk about his work, when pressed, but the long and sometimes excruciating silences that punctuate these conversations (excruciating for the listener, not for Barney), while he thinks about what he wants to say, suggest how difficult such discussions are for him.

"In the impulse to make something," he said to me last fall, "there's an assumption that you can finish it, and that it can be a resolved thing. I think what the 'Cremaster' project is suggesting is that this is impossible." Barney revels in unresolved endings, in unfinished stories that turn back on themselves to offer alternative or competing visions. In *Cremaster 5*, which takes the form of a nineteenth-century opera, the Queen of Chain (Ursula Andress, coaxed out of semi-retirement by Barney for the role) is in love with her court magician (Barney), who also seems to be Harry Houdini. At one point, the magician throws himself, naked and manacled, from a parapet of the Lanchid Bridge—the Chain Bridge—over the Danube, in Budapest. The Queen believes that he has leaped to his death, but this, Barney says, is her misunderstanding. "I was interested in the need to have a dramatic ending," he explains, "but in terms of the 'Cremaster' cycle I also wanted the story to bite its own tail and return to *Cremaster 1*." In a related scene, we see the Queen's Giant (Barney,

again), standing thigh-deep in Budapest's opulent Gellert Baths. The warm water and a sextet of nude water nymphs are about to precipitate the final act in the "Cremaster" saga, which is the long-delayed descent of the male testes. But maybe not, for at this moment a flock of Jacobin pigeons, all-white birds with impressive feather ruffs, flies upward toward the painted ceiling, bearing colored ribbons that are attached to the Giant's scrotum. Do the birds (which were trained for the role by the artist Mary Farley, Barney's wife at the time) hijack and restore the embattled organs to their nondifferentiated state, which they enjoyed in *Cremaster 1*? Does art triumph over biology? Is it art at all, or just pretentiously gorgeous nonsense? Whatever you make of it, the scene, with its ravishing colors, amazing images, and lush operatic score by Jonathan Bepler, Barney's composer of choice, is hilariously Wagnerian in its over-the-top ambivalence.

MATTHEW BARNEY may be the first American artist whose early ambition was to play professional football. Growing up in Boise, Idaho, where his father ran a food services company, he had been the quarterback on a high school team that won the state championship one year and was runner-up for it the next. He had a great arm, but he wasn't quite big enough for the Pac-10 teams he wanted to play for ("I'm six-zero, if I stand up straight"), and so, being a top student and president of his senior class, he went to Yale instead. Yale didn't offer athletic scholarships, and Barney's father, who was having financial problems, couldn't afford the tuition there. "Matthew looked at me," Robert Barney remembers, "and said, 'Don't worry, I'll make it happen.' And he did. To be honest, I was always so impressed with Matthew that I often felt he was way ahead of me." Barney's parents had been divorced when Matthew was fifteen; Marsha Gibney, his mother,

who had a graduate degree in studio art, had moved to New York. Barney and his older sister, Tracy, stayed in Boise but visited Marsha on their vacations, and it was she who inspired Barney's interest in contemporary art.

Marsha had lined up a job for him in New York the summer he graduated from high school, as a carpenter's assistant, but it fell through, and then somebody told him he should try modeling. The Click agency hired him on the spot. His lean, chiseled look was perfect for Ralph Lauren, J. Crew, and several other clients, and during the next four years his modeling fees put him through Yale, at the expense of his football career. (Ivy League athletes can't appear to endorse products.) It was a tough decision. Football had been the ruling passion of his school years. He loved the physical contact, and the training, and he loved "the thing that happens when you're a drop-back passer, and in that chaos of people you see a hole and know you have to throw there." His other sport in high school had been wrestling, but it was football that he lived for. After making his decision, at any rate, he didn't waste time regretting it. He registered for premed studies at Yale, with the idea of eventually becoming a plastic surgeon. After two semesters, though, he dropped out of premed and switched to the art department.

He'd been getting more and more interested in art, going to the New York galleries on weekends and hanging out with Marsha's artist friends. Yale's undergraduate art department is not particularly distinguished, but its graduate School of Art attracts gifted students from all over the country. A couple of these students soon noticed Barney, and one of them, Michael Rees, pulled strings so that he could have his work looked at by visiting artists from New York. Rees even arranged for him to get

a private studio to work in, rare for an undergraduate. What impressed everybody was how hard Barney worked. "There was a lot of rigor at Yale," according to Leo Villareal, who was a class behind Barney in the undergraduate art department. "But Matthew was more focused than anyone else, more unyielding." He did a lot of abstract drawings and paintings, and a lot of sculptures that seemed to come out of Minimal and Process art—Villareal remembers steel shelves holding objects that looked like animal organs stuffed inside condoms—and in his junior and senior years he began experimenting with video and performance art. He did a series of "drawing restraint" pieces, in which he'd tether himself with a rope and then struggle against it to climb up a ramp and draw something on the wall. "I was trying to use my own experience as an athlete," he told me, "thinking about how the body functions in training—how the muscle breaks down under resistance and then heals larger and stronger. I was trying to use that process of resistance to create form."

His senior-thesis project was a two-part video called *Field Dressing,* which he shot and then presented in two rooms of the Payne Whitney Gymnasium at Yale. The first part showed Barney, wearing football cleats, athletic gloves, a Speedo bathing cap, and a complicated harness suspended from the ceiling, strenuously winching himself up and down and sideways above a large bed of Vaseline, which he periodically scooped up and applied to the various orifices of his nude body—eyes, nose, mouth, navel, anus, genitals. (Vaseline, a training-room lubricant with multiple uses, made its début here as an art material.) In the second video, he wore a full-length white wedding gown, and performed an enigmatic procedure involving metal cylinders, a wrestling mat, and a hydraulic jack. "Seeing him metamorphose from

male to female, in that male gymnasium with all that athletic equipment around—it was riveting," said the artist Alice Aycock, who taught sculpture at Yale. "And he did it with such honesty, no showboating. It was stunningly beautiful, but there was also a discomfort level which I liked a lot."

Barney graduated in 1989, came to New York, and kept right on working, first in Brooklyn and then in a studio on Leroy Street that he shared with Michael Rees. He'd quit modeling by then. He already knew quite a few people in the art world, and there was interest in his work almost immediately. His *Field Dressing* videos appeared in a group show at the Althea Viafora Gallery in 1990. Clarissa Dalrymple, who ran the Petersburg Gallery and had a way of spotting new talent before anyone else, offered him a show early in 1991. Two weeks before the opening, the gallery folded, and she asked her friend Barbara Gladstone, whose gallery showed a lot of cutting-edge art, to look at Barney's work. Gladstone and Richard Flood, the director of her gallery, went separately to Barney's new studio—he had moved by then to West Thirteenth Street, in the meatpacking district—and both of them were hugely impressed. "He took me downstairs to this empty basement, freezing cold, where he had a Vaseline-covered bench that made me gasp," Gladstone said. "It was unearthly, and ghostly. I'd never seen material used that way—drawings in picture frames made of self-lubricating plastic, objects made out of cast tapioca. Everything had a very specific meaning, which he talked about as though it were common knowledge. When he talked, it made sense, although ten minutes later you'd go, 'Huh?' " To Flood, the artist was as extraordinary as the art. "His notion of what a work of art could be was completely different from anything that was happening at that moment," Flood told me. "Matthew often seems like every

mother's favorite son, but bringing you the most outrageous information!"

WHERE DID THIS well-behaved, twenty-three-year-old kid from Idaho get his information, and what gave him the confidence to make art out of petroleum jelly and tapioca and athletic equipment? One clue, maybe, was his graduation speech to the class of 1985 at Boise High School, in which he drew an extended analogy between the voyage of life and the path of the sperm. There was nothing especially provocative about it—the school authorities had okayed the text in advance, none too happily—and the audience's nervous giggles over certain phrases were capped by enthusiastic cheers at the end. But it was not the sort of analogy you expect at high school graduations, and it reflected two things about the outgoing class president: that he did not feel constrained by people's expectations, and that he had an absorbing interest in the physiology of the human body. "Matthew thinks through his body," his mother, who now lives fairly close to Barney's studio and who works as a legal reader and editor, told me. "As a young child, he would run right into you, instead of stopping and saying hi. Very strong and very physical." Reading was a problem for him—he still has difficulty finishing a book—and he was "not good at intimacy," according to Michael Rees, but he made up for both those failings with what another friend calls an "almost shamanistic" ability to find out what he needed from other people.

Barbara Gladstone couldn't give him a show until the fall of 1991, but she was so excited by the work that she recommended it to Stuart Regen, her son, who presented it in May and June at his gallery, Regen Projects, in Los Angeles, where it created a stir. *Artforum* put Barney on the cover of its summer issue, and,

when a somewhat different version of the show came to Barbara Gladstone's that October, the opening was an art world event. Hundreds of people crowded in to see an eighty-seven-minute video of Barney driving ice screws into the gallery's ceiling and climbing across it, then descending to a walk-in refrigerator that contained, among other strange objects, a version of the Vaseline bench that had made Gladstone gasp. The actual refrigerator and bench were part of the show, along with a dumbbell made of Vaseline, a curling bar made of cast tapioca, a football jersey with the numerals 00 (for Jim Otto, the legendarily resilient center for the Oakland Raiders), an exercise mat, some gynecological instruments, and a second video that showed Barney, looking very much like Audrey Hepburn in high heels and a long black cocktail dress, straining to push a football blocking sled. Plenty of viewers hated it, of course. Hilton Kramer, in the *Observer*, wrote, "We all know that there is now almost nothing that someone won't do in public in the name of art, no matter how stupid or nasty." A few feminists detected rampant machismo, and the gay contingent, after checking and finding out that Barney was irredeemably straight (he was dating Mary Farley at the time), dismissed it all as "faux gay." Most of the reviews were enthusiastic, however; searching for precedents, critics mentioned Joseph Beuys's animal-fat sculptures, Bruce Nauman's enigmatically ominous videos, and Jeff Koons's self-enchanted sexual icons. "Mr. Barney is the central protagonist in his art," *The Times*'s critic Roberta Smith wrote, "but he plays his roles with a self-effacing concentration that renders him almost invisible: the vehicle of the work, not its star."

"The whole thing was surprising to me," Barney recalled. "When I was in school, finishing up and heading for New York, I didn't think the commercial galleries would be interested in

what I was doing. I was quite content with the idea of showing at the alternative spaces, like the Mattress Factory, in Pittsburgh, or the Capp Street Project, in San Francisco, doing site-specific pieces. But the climate in New York had changed."

It had indeed. The collapse of the overhyped 1980s art market had left a lot of insiders looking for something new and different, and Barney's intense and physically demanding performances and his weird mixture of sports metaphors, medical instruments, and outlandish materials were all of that. "There was a huge buzz immediately," according to Barbara Gladstone. The San Francisco Museum of Modern Art gave him a solo show that December; the following year, he was invited to show at Documenta IX, in Kassel, Germany, the most important of the big international art exhibitions; and in 1993 he was in both the Whitney Biennial and the Venice Biennale, where he won the Europa 2000 prize. Not since Jasper Johns, in the late 1950s, had a young artist made such an impact. Like Johns, moreover, Barney was able to resist the lure of celebrity, which had seduced and eventually jilted a number of the 1980s art stars. Ignoring the publicity machine that was all too ready to play up his exotic credentials— football player, male model—he avoided art world parties and interviews, lived austerely, and channeled his prodigious energy into new work.

Drawing Restraint 7, his contribution to the Whitney Biennial, was a three-channel video excursion into Greek mythology. The action here is colorful and oddly disturbing but relatively uncomplicated, something that could not be said about *OTTOshaft*, the video-and-installation work that Barney presented in an underground parking garage at Documenta IX. In *OTTOshaft*, the video action centers on two main characters, Jim Otto and Harry Houdini (played by Barney), who engage in a competition—nonverbal,

of course—to steal the "Hubris Pill" and subject it to what Barney describes as "metabolic changes related to the digestive process, from glucose to sucrose, to petroleum jelly, tapioca, meringue, and then poundcake, a complex carbohydrate. If it gets to poundcake, then, as a bagpipe, it can play 'Amazing Grace.'" (This is one of the explanations that seem to make sense when Barney is talking.) There is a lot of vigorous physical activity in *OTTOshaft,* and many striking and largely inexplicable images, but, as far as I can make out, the bagpipe never does get to play "Amazing Grace."

Harry Houdini had taken hold of Barney's imagination at Yale, when he was just starting to make performance pieces. The famous escape artist, whose most spectacular feats involved letting himself be manacled hand and foot, confined in a straitjacket and/or a locked safe, and dropped into freezing waters, from which he would miraculously free himself within two or three minutes, became for Barney the Character of Positive Restraint, the personification of self-discipline as a catalyst to creativity. Jim Otto was Houdini's antithesis. He had been the Oakland Raiders' iron man, the center who never missed a game, and who absorbed so much punishment that he ended his fifteen-year career playing on two prosthetic knees. Reached in California, where he is "still involved with the Oakland Raiders" organization, Otto had never heard of Barney and was surprised to learn of his role in Barney's art. "I'm flattered, I guess," he said. I did not tell him that the 00 he wore on his jersey signifies to Barney a "roving rectum," a body subject to penetration and to the indiscriminate expenditure of energy. In *OTTOshaft,* his character is taught to sing "Amazing Grace" by someone who is a dead ringer for the Raiders' famously aggressive owner, Al

Davis, but who is in fact Marsha Gibney, transformed by makeup and her son's minimal, Zen-like direction.

Not many people saw *OTTOshaft* at Documenta, because of its out-of-the-way location. Those who did were impressed, or perplexed, or both. Nicholas Serota, the director of the Tate Museum, in London, was so impressed that he got his museum to buy it. The person it had the biggest impact on, however, was Barney himself. Parts of the piece showed Barney climbing up and down four different elevator shafts in four separate buildings. "I began to think about how expansive that notion could be," Barney told me. "You could take an idea and expand it over four countries, and still understand it as a single thing. *OTTOshaft* was the transition." Soon after this, he made his first drawing for what would become the "Cremaster" cycle. It showed a rough, bagpipe-like form whose pipes emerged in five different locations: "Bronco Stadium," in Boise; "White Sands/Columbia Icefield"; the "Chrysler Building," in Manhattan; "Ireland"; and "Bath House/Istanbul."

Geography was the spur—a longitudinal arc stretching from west to east, with five points of entry, each one rich in autobiographical meaning. Barney's high school team had played its home games in Bronco Stadium. A few years earlier, when he was in junior high, his father had taken him on a five-day bike trip in the Canadian Rockies, from Banff up to the ice fields where, as Barney remembers it, "the mountains are bigger than in Idaho, and you feel like you're seeing the source of something." Manhattan was the place he had chosen to live as an adult, and the Chrysler Building, with its dazzling stainless-steel skin, was a mirror that reflected east and west. Barney's ancestors on both sides had come from Ireland; as he started investigating the region, though, his focus shifted to the Isle of Man, in the Irish

Sea. And Istanbul—well, Istanbul gave way to Budapest, the birthplace of Erich Weiss, who became Harry Houdini, the Character of Positive Restraint and Barney's alter ego. The five films follow this arc in chronological order, but they were not made chronologically. *Cremaster 4* came first, in 1994, followed by *Cremaster 1* (1995), *Cremaster 5* (1997), *Cremaster 2* (1999), and *Cremaster 3,* the longest (at three hours) and by far the most ambitious, whose world premiere, at the Ziegfeld Theatre in New York last spring, made me think of the old gag "Longer than *Parsifal,* but not as funny."

SHALL WE MARCH, you and I, through the "Cremaster" cycle, deciphering its cosmologies, symbolic connections, and bifurcating narrative threads? No, we won't. Let's go instead to the Ritzy Cinema, on the Brixton Oval, in South London, where, last October, Barney and several members of his crew were building, in the lobby, a massive object that would recapitulate the cycle in the form of an abstract sculpture. The sculpture had to be finished by October 25, three days away, in time for the London premiere of *Cremaster 3.* The crew should have been frantic, but nobody seemed to be, certainly not Matt Ryle, the all-purpose operations chief, or Jessica Frost, Barney's unflappable assistant, or Barney himself, who at the moment was working on a piece of plastic material with an electric sander.

Barney wore black jeans, a black T-shirt, and black workman's boots. He hadn't shaved lately, and anybody's mother would have said he needed to gain a few pounds. The project was unusual, though, because neither he nor anyone else had been staying up until three or four in the morning to work on it. One of the things that make the crew so loyal to Barney is that he works harder than any of them, doing whatever needs to be

done, including scut work like sanding. But Barney and Björk had a three-week-old baby girl named Isadora, and he'd been going home for dinner. Barney and Björk have managed so far to keep their careers separate and their private life inviolate. This is no small feat, inasmuch as Björk, a musical phenomenon who released her first album when she was eleven, is an international superstar. Her solo albums sell in the millions, and her performance in Lars von Trier's film *Dancer in the Dark*, whose score she co-wrote, won her an Oscar nomination in 2001 and a best actress award at the Cannes Film Festival. Björk's website makes no mention of Barney, their relationship, or Isadora.

Courteous and friendly in a reserved, low-key way, Barney walked me around the sculpture, which took up most of the lobby. It was an enormous reinforced-plywood mold with curving contours, four feet high by more than sixteen feet wide, filled with a buttery-yellow mixture of three parts petroleum jelly to one part wax—ten tons of it, Barney said, trucked in from a factory in the Midlands and pumped hot into the mold. The mixture was cooling more slowly than anticipated; they had planned to unbolt and take away the mold this afternoon, but the jelly hadn't solidified enough. Hanging over the sculpture were five television monitors, arranged pentagonally, on which the five "Cremaster" films would run continuously during the three weeks that the sculpture remained on view. "I'm taking pleasure in the fact that this is the last piece in the 'Cremaster' cycle," Barney said.

When I asked him how the sculpture related to the films, Barney located a battered canvas backpack, shuffled through a mess of papers, and pulled out a somewhat crumpled line drawing of what looked like a pig lying on its back. This, he explained, was a sort of bird's-eye view of the sculpture, and its contours followed

the narrative line of the five films. "I've come to think of *Cremaster 1* as the spark of the idea," he said. "*Cremaster 2* speaks to the first rejection of that idea, *3* to the phase of falling in love with the idea, *4* to a sort of panic, realizing that a resolution is near, and *5* to a split, double ending—the release and eventual death of the idea, and a cycling back to *Cremaster 1*." Stacked against the wall on one side were some big panels made of white plastic, in different shapes. Barney explained that when the plywood mold was taken away he and his crew would push these panels into the jelly to complete the sculpture. "Once we slide the plates in, the jelly will spill out around them," he said. "It'll be kind of a mess. The sculpture will collapse and then it'll stay."

The Ritzy Cinema project was being produced by Artangel, a London-based arts organization specializing in nonprofit art spectacles. James Lingwood, Artangel's director, has been a Barney admirer since 1991. In 1992, he invited him to do a project in England, and Barney used the invitation to make the first "Cremaster" video. "I was planning to look for a location in Ireland," Barney told me, "a Druid ring or something ancient," but he kept seeing the Isle of Man on maps. The island's scale appealed to him: "It was small enough that it could be dealt with as an object." He went there and did some research, in his usual, unsystematic way, getting postcards and brochures, asking questions, looking into local legends and customs such as the annual Tourist Trophy motorcycle race around the island, which draws contestants from many countries. *Cremaster 4* was made on a shoestring budget ($200,000) in less than a year. It has two linked narrative actions, the first being a race between a pair of motorcycle-and-sidecar teams, who speed off in opposite directions and represent "ascending" and "descending" tendencies. The other action centers on a dandified, red-haired satyr in a white suit (played by

Barney), who tap-dances a hole in the floor of a seaside pavilion, falls through it into the sea, then wriggles and squirms (with immense effort) up a narrow tunnel that's partially blocked by knoblike growths and clogged with Vaseline. There are also three "faeries"—female bodybuilders whose bodies, even when nude, appear to be of indeterminate sex—and a Loughton ram, a breed of sheep native to the Isle of Man, with two pairs of curved horns, one going up and the other going down. The underwater scenes had to be shot in Florida, because the waters around the Isle of Man were too cold and murky. Barney would go under carrying forty pounds of weight, and when his breath ran out somebody would swim over and blow air into his mouth. "I hired an instructor from the scuba diving school to help us," he told me, "but she lasted only one day. She said, 'I've never met people who have less regard for their lives.'" The production costs of *Cremaster 4* were paid for largely by Artangel, Barbara Gladstone, and the Cartier Foundation, in Paris. In spite of rapidly escalating expenses, Gladstone and Barney managed to finance the four other films largely by selling art works that are generated by the "Cremaster" story—sculptures, drawings, photographs, and limited-edition videodisks in elaborate sculptural vitrines.

IN SPITE OF THE PRESSURE he was under to finish his London sculpture, Barney found several occasions to sit down and answer questions. Sometimes the answers were punctuated by long silences, and sometimes they just petered out in midsentence. We did best, I found, when I asked him about specific, practical things, such as why, in *Cremaster 5,* he had insisted on having Ursula Andress play the Queen of Chain. "I wanted the character to manifest some kind of"—long pause—"extreme

physical essence," he said. "Ursula was one of the first athletic sex symbols, or at least that's how I remembered her. I remember the strength of her shoulders in *Dr. No,* and thinking how her ears were higher than her eyes. She had a kind of"—even longer pause, chin in hand—"the way you think of automotive design, where the rear end is higher than the front, to make it look like it's moving faster. There was a sort of violence to her physicality that I always felt was very attractive."

Barney overcame Andress's reluctance to play the part by going to see her in Rome several times. He can be implacably persuasive. Chelsea Romersa, who was the line producer on *Cremaster 5,* says that the people they deal with usually give him what he wants, "even though they think he's crazy." Romersa was constantly asked to do things like find Asian dancers under five feet tall, or contract for a hundred and forty-four truckloads of salt so that Barney could build a salt arena on the Bonneville Salt Flats. In order to measure the distance from the Lanchid Bridge, in Budapest, to the river below, so she could have custom-made a bungee cord of the right length for Barney's plunge in *Cremaster 5,* Romersa stole a spoon from the Gellert Hotel, tied a spool of fishing line to it, and dropped it over the bridge's railing. Barney's bungee-cord leap, at dawn on an icy January morning, looked so exhilarating that several crew members wanted to do it, too, and did. Team spirit keeps the energy level up on Barney's projects. For Romersa, it's like being part of an extended family, and "the perversity level makes it less boring than most jobs."

In *Cremaster 1,* where the bliss of sexual nondifferentiation is undisturbed by any hint of violence, an all-female cast inhabits two blimps that hover over Bronco Stadium, while sixty chorus girls, dressed by Isaac Mizrahi and shod by Manolo Blahnik, move in time to melodies from 1930s Busby Berkeley musicals,

and form patterns on the stadium's blue AstroTurf which relate to the undifferentiated reproductive system. This feminization of Barney's football past had intrigued me, but Barney preferred to talk about the stadium itself, and its goalposts, whose shape "defines nondifferentiation more than any character does."

The plot elements get a lot more complicated in *Cremaster 2*, where landscape, Mormonism, and the murderer Gary Gilmore are major characters. Barney explained to me that he was drawn to the Gilmore story because, in its sordid way, it "was like a version of the whole 'Cremaster' dilemma, of a character in conflict with his destiny, and I suppose it also attracted me because Gilmore was a person who had lived almost his entire life in confinement." Barney had read in *The Executioner's Song*, Norman Mailer's book about Gilmore, that Gilmore's grandmother may have had an illegitimate child by Houdini. He approached Mailer and talked him into playing the part of Houdini in the film. " 'I'm seventy-five years old,' " Mailer remembered saying, " 'I'm arthritic, it's all I can do to tie my shoelaces, and you want me to play Houdini?' And he said, 'It's all right, we'll shoot around you.' " Barney even gave him some lines to speak—a great rarity, since there are only about twelve lines of spoken dialogue in the entire "Cremaster" cycle. Mailer (who edited his lines) became a big Barney fan. "He does things that no one has ever done in movies," Mailer told me. "For people who want to follow the story, it's hopeless, they'll hate the work. But there's an intensity of perception, and a visceral experience you have when you watch his stuff which is extraordinary."

THINGS WERE STILL CALM at the Ritzy Cinema on the morning of October 24, the day before the opening, when Barney and his crew started to remove the wooden framework around

the wax-and-petroleum-jelly sculpture. Matt Ryle unbolted a section in the back and carried it out through the newly installed lobby doors. As other crew members took away more sections, it became evident that the surface of the huge, yellow mass was sinking in the middle. It sank several inches, quite rapidly, and then it began to pull away from the mold in several places. Ryle tried to brace the unbolted side with a plank. He put his whole weight against it, but the mass kept sinking and sliding. Nobody said anything. Ryle finally got a two-by-four wedged between the bottom of the plank and the lobby wall, stabilizing the flow in that area. The crew kept removing parts of the mold. The mass kept right on moving, and Ryle and Barney improvised ways to contain it, bolting plastic forms to the floor in certain places. Within half an hour, the sculpture's level had sunk about a foot. The yellow stuff was oozing out onto the blue AstroTurf (in homage to Bronco Stadium) that covered the floor, but what had looked to me like a full-scale disaster, or, at the least, like a wholly unexpected variation on the lost-wax method of making sculpture, was apparently nothing of the kind. "We're at the mercy of the material," Barney observed, with a smile that was just short of seraphic.

"The Vaseline is behaving like I've never seen it behave," he said, somewhat later. "I think it's because of the amount of the mass and the force behind it. You're getting the kind of shearing that you see in glacial ice. If you're out on a glacier for any length of time, you feel like everything's moving, but you can't see it moving. Which is lovely, that feeling. You have a little of that here." I had to leave around three that afternoon. I learned later that Barney and his crew were there all night, pushing plastic plates into the still unstable jelly.

The opening was set for seven forty-five the next evening. I

got there on time, and found the Ritzy already jammed with people. Most of them were in another lobby, adjacent to the one with the sculpture, because the sculpture had taken over all but a few feet of the blue AstroTurf. It had more or less stopped moving now. It looked like an avalanche, with jagged fissures, and hills and valleys, and crumpled areas where it had piled up on itself. Above it, the five screens were ablaze with scenes from the five "Cremaster"s, whose soundtracks clashed together discordantly. Barney, wearing the same loose black shirt he'd had on earlier, looked tired but extremely alert. I asked him whether he'd expected the sculpture to behave the way it had. "The intention was to emphasize the entropic nature of the 'Cremaster' cycle," he replied, a bit formally. Then, grinning, he said, "It failed more than I thought it would. But I'm very happy with it. You have to surrender a certain control. And the 'Cremaster' cycle *is* this way."

At eight o'clock, the crowd began moving into the main auditorium to watch *Cremaster 3*. Having seen it twice before, I thought I might not stay, but I watched the first few scenes and ended up getting hooked and staying through the whole three (very long) hours. It's not as though one's interest in *Cremaster 3* never wavers. Some scenes drag on forever. But the sense of a completely realized, alternative world is so strong, and so many shots are visually enthralling, that disbelief becomes easy to suspend. Besides, I kept seeing things I hadn't noticed before, or had seen differently. Any film that manages to put together, for example, a battle between two real-life giants; a zombie emerging from the grave; a six-car demolition derby in the lobby of the Chrysler Building; a trotting race run by dead horses; a stunning blond athlete named Aimee Mullins, who happens to be a double amputee, playing several different roles, the first of

which has her slicing potatoes with a metallic device attached to her prosthetic leg; the previously noted interlude in the Guggenheim Museum, with Barney scaling the walls; a Maypole dance inside the spire of the Chrysler Building, with colored ribbons floating down from the top and in through the triangular windows; the killing of the Master Architect (played by Richard Serra, the sculptor) by the Entered Apprentice (played by Matthew Barney, the sculptor); and much more, including a final scene in which the Irish giant flings a stone into the sea, where—in time for *Cremaster 4*—it becomes the Isle of Man, well, a film like this may be one that only Dick Cheney could walk out on without a frisson of self-doubt.

Hubris is a recurring motif in *Cremaster 3*. The Entered Apprentice is guilty of it when he tries to shortcut the Masonic rituals, and the Master Architect is "Hubris incarnate"—as Nancy Spector, the exhibition's curator and organizer, writes in the five-hundred-and-thirty-page Guggenheim catalogue—for "attempting to become god on Earth." Both of them are punished by death, as the classical myths require. The Chrysler Building, which functions as a central character in its own right, is also afflicted with hubris. "I wanted it to have a greater ambition than any of the other characters in any of the other pieces," Barney told me.

New York's glittering, deliriously playful skyscraper escapes permanent damage, however, and this leads me to wonder whether Barney himself counts on a similar leniency. He has had remarkably few bad reviews in his career so far, but he may be knocking against the hubris barrier. Soon after the première of the final film in New York last spring, you could see T-shirts bearing the slogan "I Survived Cremaster 3." Robert Storr, until

recently the Museum of Modern Art's senior curator of painting and sculpture, is someone who liked Barney's early work but who has now become "a doubter," as he puts it—"a doubter who really believes there's something there." In Storr's view, "Matthew has an extraordinary ability to make images, and from the beginning he had this performative side which was very, very impressive. One thing which makes me doubt him now is that the sculptures are less compelling than they ought to be. Stage props or film props have to be read at a distance, and the camera does something to make them fascinating, horrible, and so on, but, when you see his objects in an exhibition, they lose some of their impact. Matthew's work rarely becomes an independently fascinating object. I also think his films are overly long, and the camera work is repetitive, and often agonizingly slow. In a way, what Matthew is doing is making great tableaux, but he's not speaking in time in a way that's really effective, and that's the problem." Storr can't forgive Barney, moreover, for what he did to Richard Serra in *Cremaster 3*. When Serra flings hot Vaseline against a wall, the unmistakable reference is to his own thrown-lead sculptures of the 1960s, works that had a big influence on Barney. "That's the way to kill the father," Storr said, "to make him travesty his own work on camera."

The Guggenheim exhibition—scheduled to open last year but postponed by the financially troubled museum—will give people a chance to see Barney's work the way he wants it seen, with sculpture, drawings, and photographs shown alongside the videos. Barney is grateful for the larger audience that the "Cremaster" films have brought him, but in his mind the cycle was always a sculptural project. The exhibition, which drew big crowds and near ecstatic reviews in its appearances, in the

summer and fall of last year, at the Museum Ludwig, in Cologne, and the Musée d'Art Moderne, in Paris, will fill almost the entire space of the uptown Guggenheim. It is the culmination of eight years of work, and Barney clearly seems to be at a turning point in his life. When I asked what he had in mind to do next, he was silent for a long time, drumming a pencil on his knee. "One of the things I'm thinking about a lot," he said finally, "is how to do something live, a real-time situation, maybe in a proscenium space."

I asked whether he had finished with the theme of sexual nondifferentiation. "All that has something to do with the way I'll be thinking," Barney said slowly, "but those projects I definitely feel are finished."

—*January 27, 2003*

"The Cremaster Cycle" opened at the Guggenheim Museum on February 23, 2003, and was heavily attended over the next three months by young and enthusiastic viewers, many of whom spent hours watching the videos. The critical reception was sharply divided. For Michael Kimmelman, The Times's chief critic, who had previously anointed Barney as the most important artist of his generation, the show confirmed his standing as "the most compelling, richly imaginative artist to emerge in years," one who "gives us an inspired benchmark of ambition, scope and forthright provocation for art in the new century." Kimmelman's colleague Roberta Smith, writing in Artforum, *found "Barney's Bayreuth . . . more like his Waterloo," a spectacle that "simply takes up too much time, space, and expensive materials not to make more sense." Since then, aside from a new film called* Drawing Restraint, *which*

featured himself and Björk in ritual mating activities aboard a Japan-ese whaling ship, the artist has produced no new extravaganzas, and nothing in the nature of a live performance. There are few artists around today whose next move is so avidly anticipated.

MAURIZIO CATTELAN

Ten o'clock on a May morning in Paris, by the École des Beaux-Arts. Maurizio Cattelan, the world's only punctual artist, is slightly late, but the sun is warm, the breeze is cool, and vividly dressed art students crowd through a narrow gate in the tall iron grille that separates the École's courtyard from the Rue Bonaparte. My wife's mobile phone rings. It is Cattelan, calling from his bicycle to say that he's three minutes away. Three minutes later, he glides to a soundless stop beside us. Cattelan is Italian. Tall and lean in his jeans and black T-shirt, he has close-cropped dark hair and a long, quizzical face anchored by an auspicious Roman nose. He wheels his bike into the courtyard, chains it to a stand, and looks around at the architecture. "Not bad," he says, whistling softly.

One of the new international, post-studio artists who go from place to place installing singular and often highly disconcerting

works of art, Cattelan is here to inspect a space that has been offered to him for his latest project. The piece is scheduled to go on view in early October, in a show organized by the Musée d'Art Moderne de la Ville de Paris, but it will take place at a venue outside the museum because Cattelan wanted it to be in a setting that "you go into and come out of." Lucio Zotti, an old friend from Milan who collaborates on many of Cattelan's projects, recommended the seventeenth-century chapel at the École des Beaux-Arts, and two curators from the Musée Moderne, Angeline Scherf and Lauren Bosse, are on hand to show it to him. After brisk handshakes in the French manner, they lead us through an arch and, via a side door, into an ancient, dark, somewhat cluttered chapel with a very high ceiling, where we are joined a few minutes later by Henry-Claude Cousseau, the director of the École Nationale Supérieure des Beaux-Arts. Cousseau, a distinguished-looking man in an expensive sports jacket, gives us what the Michelin guide calls "un peu d'histoire" regarding the chapel. Commissioned originally in 1608 by Marguerite de Valois, the divorced wife of King Henry IV (she was called La Reine Margot), it became, after the French Revolution, a public museum housing important works of French sculpture. In 1836, it was awarded to the École des Beaux-Arts, and it has been used ever since as a repository for plaster casts of medieval and Renaissance sculptures, which students here still study and draw, and for copies of Italian Renaissance paintings sent home by French winners of the Prix de Rome.

Cattelan lopes around the long, narrow space, taking everything in—replicas of Michelangelo's sculptures for the Medici tombs, of Verrocchio's gigantic equestrian statue of Bartolomeo Colleoni in Venice, of Ghiberti's doors for the Baptistery in

Florence. Dutiful copies of paintings by Masaccio, Raphael, Carpaccio, Ghirlandaio, and others cover one long wall, bracketed at either end by Michelangelo's *Last Judgment* and Giotto's frescoes for the Arena Chapel in Padua, Cattelan's hometown. A stranger to modern art, the chapel doesn't know what it's in for. Nor does Cousseau, who has agreed to let Cattelan use the space without knowing precisely what he plans to put in it. This is brave of him, considering some of the artist's completed projects: *La Nona Ora*, for example, a full-size wax sculpture of Pope John Paul II in papal regalia but lying on his side, crushed to the ground by a jagged meteorite; or *Him*, an equally lifelike Adolf Hitler, reduced in size and kneeling in prayer. Just last spring, Cattelan confronted the city of Milan with the spectacle of three adolescent boys (wax models, but very lifelike) with ropes around their necks, hanging from a branch of an oak tree in a public square.

Since the early 1990s, when Cattelan's work began appearing in big international group shows, he has been variously described as a jokester, a sensationalist, a troublemaker, a conceptual artist, and an innovator of unrivaled originality. Cattelan likes to say that his installations provoke debate rather than controversy, but the hanging children upset one Milanese so much that he got a ladder, climbed the tree, and cut two of them down. At that point, the man fell out of the tree and was carted off to the hospital with a mild concussion; the fire department, called in to cope with an increasingly large and restive crowd, cut down the third one. There was plenty of talk about this piece, which was on view officially for only twenty-seven hours, but which drew headlines in the Italian press for several days. The mayor and the city's cultural commission, having authorized it, were obliged to defend their decision at a special session of the city hall council, according to Cattelan's friend Massimiliano Gioni, who, as director of

the Nicola Trussardi Foundation, in Milan, had commissioned the art work. Gioni told me that a neighborhood mother taped an open letter to the tree saying she regretted the loss of the art work, because it had called attention to the problems that real children face growing up in Milan; others wrote comments on her letter during the next few days, and the debate, if that's what you'd call it, was still going on two weeks later. Cattelan, whose English is serviceable but hesitant, resists discussing the ideas behind his work. He has said only that the piece, to him, was "like an act of love."

ON THE DAY of our visit to the École des Beaux-Arts, only a few people were aware that his new piece, called *Now,* would be a life-size sculpture of John Fitzgerald Kennedy lying in a coffin. The two curators from the Musée Moderne knew, along with their colleague Hans-Ulrich Obrist, and so did Laura Hoptman, the curator of contemporary art at the Carnegie Museum of Art in Pittsburgh, where a second version of *Now* will go on view when the Carnegie International Exhibition opens, on October 8, and of course his friend Lucio Zotti, whom the artist describes as his "spiritual consultant, the closest person to me." But Cattelan wanted it kept secret from the rumor-hungry art world, to preserve the impact of its first appearance. "After that, it will lead a different life," he told me. "I hope it will still be a good piece in three months." Cattelan often worries that his art works will fail. Many of them have been failures, in his view. His sculptures depend on the power of images to embody social issues. "I see that art has a great potential to refer to a broader debate, to go out there and reach an incredible audience," he has said. "And if my work can't do that, well, it's useless." This time, he confided, "I've never had such doubt in myself." He sees the

fallen president as "a kind of secular saint." Not someone to be worshiped or idolized, that is, but someone who represented many things about America and American life which Europeans admired. To Cattelan, who was born in 1960, Kennedy's death symbolizes the loss of hope. At the moment, however, he seemed to be almost comically uncertain about the piece. "Am I doing something wrong, because I'm not American?" he asked us. "I don't know anything, I wasn't there, I'm too young. But, still, he represents hope. Kennedy belongs to everybody, I'm sorry."

The following morning, we went by taxi to Clichy, on the outskirts of Paris, to see the model of JFK. Like many post-studio artists, Cattelan delegates the fabrication of his art works to others. The Kennedy figure was being made by Daniel Druet, a master of moulage who executes many of the models for the Musée Grevin, a wax museum in Paris; he had previously done several figures for Cattelan, including the Pope, Hitler, and the model Stephanie Seymour, whose portrait was commissioned by her husband, Peter Brandt. (Cattelan got Druet to do a wax bust of her, which he had mounted, trophylike, on a wooden wall plaque.) An artist-craftsman of the old school, dressed in a full-length white smock, Druet ushered us into his studio, on the second floor of a small industrial building, where he is assisted by a young man who does the casting and a young woman who puts in the hair, strand by strand. Druet does everything else—sculpts the heads and bodies in plaster, paints the skin after it has been cast in wax, and handles all the finishing touches. Photomontages on the walls showed some of his famous subjects: Gérard Depardieu, François Mitterrand, Charles de Gaulle. Harpsichord music played on the stereo; a fine layer of plaster dust coated the floor. Cattelan went off with Druet to the back

room for a first, private look at the new work. After a few minutes he reappeared, and gestured for us to come in.

KENNEDY WAS LYING on a low pallet in the middle of the room, face up, dressed in a black pin-striped suit and black shoes. The skin tones hadn't been painted yet—Cattelan had expected they would be—but the handsome Irish features were instantly recognizable, under a bushy head of hair. Cattelan wanted to know what we thought. I suggested that the hair was slightly off, a little too brown, perhaps, and too unruly. It also struck me that the material of the suit wasn't quite right: It looked very lightweight. Druet seemed pained. He said the material was very expensive. He brought out photographs of JFK attending public functions and press conferences in just such a suit. For the next hour, Cattelan studied the model from every angle, discussing it with Druet in a mixture of French and English. (Cattelan claims not to speak French, though he clearly understands the language; he had brought along a young employee from his Paris gallery to translate.) Several times, he went off to talk on his cell phone, in Italian, to Lucio Zotti, who had made many visits from Milan to Paris to check on Druet's progress. Zotti, it seemed, was furious about something. "Lucio is becoming more secretive than myself," Cattelan explained later. "He doesn't think you should be here."

On the way back in the taxi, Cattelan was disappointed that the face had not yet been painted, but he thought that the likeness was good and that the problems with the hair and the suit would be remedied. "I'm still considering whether the eyes should be open or shut," he said. Why would they be open? I inquired. He considered the question, laughed, and said, "I don't know." I brought out my tape recorder. "Now it gets serious,"

he muttered, sinking down in the seat. "An interview. Will it be American style, with hoods?"

I wanted to know about the thought process that had led to a sculpture of JFK in a coffin. "But I am not a conceptual artist!" Cattelan protested. "I don't have thinking." After some further evasive tactics, he allowed that the idea of using Kennedy had been in his head for about three years. "Why? Because he's a kind of icon, even if he's not. He has all the elements. He had a fantastic life, a mixture of society, politics, so many elements. But Kennedy is so difficult to touch. I mean, every time you have a loss of hope, Kennedy comes to my mind. Now it is more contemporary than ever, don't you think?" Was that because the current American President is—"such a jerk?" Cattelan said, finishing my question. "Ah-h," he chortled, pointing at me. "No, but everything now is so black, you want to have something to hold on to. The fact that once there was someone like him makes you hope there must be another one somewhere." For three years, he went on, "we had Kennedy in all sorts of situations and positions. Kennedy as an outcast, for example, like a homeless person. But then, last January, I said to myself, 'Oh, my God, he has to be in a coffin.' The idea just clicked. It's so silent, so polished, what can you say? When you find a solution like that, when you finalize the image, it's unpayable—I mean priceless, like pure orgasm." The coffin had not yet been chosen, he said. It will be a regulation wooden coffin, with no top, nothing to come between viewer and icon.

Unlike legions of conceptualists who have bored us with variations on the Duchampian mantra that art is a mental act, and that the artist's ideas, rather than any mere artifacts which may (or may not) come out of them, are what count, Cattelan has given us a succession of startling and unforgettable visual images. The fact that his images often make us laugh can get in the

way of his being taken seriously. Cattelan's earlier work, which includes a lot of taxidermied animals and animal skeletons—dogs, donkeys, an ostrich, a domestic cat as big as a dinosaur, full-size horses suspended in midair—used to strike people as funny and outlandish, good for a laugh but not much more.

What has become increasingly evident, though, is the ambiguity in these things, and the presence of more than one layer of meaning: The animals, like the children that keep turning up in Cattelan's pieces, often refer to well-known fairy tales—"The Musicians of Bremen," for example—in which innocent courage is pitted against human cruelty. While Cattelan's distinctive, anarchic humor continues to set him apart from most artists working today, he has shown a growing tendency to engage with larger issues—social, political, and moral. Several critics have pointed to a preoccupation with death in his work, and also to some strange tensions involving religion and the Catholic Church. "Anyone growing up in Italy has a twisted relationship with religion," Cattelan once said. More often, though, he will insist that his work is about everyday problems and the struggle to get by in life. "Listen," he told me in the taxi coming back from Clichy, "I have the answer to the question you were asking, about how do I come up with such and such an idea. The answer is that I don't use my brain, I use my stomach. It's the same as when you recognize danger. No brain; you react in a physical way. Little by little, maybe, I learn to work with the backside of my stomach, to be more relaxed, to be more trusting of myself. But, anyway, failure is always waiting for you at the next corner. I think the moment you think you are successful, failure will be there for you."

TO HEAR CATTELAN TALK, he has been a failure at everything. "I couldn't keep a job for more than two months," he has

said. "I couldn't study: School was torture. And as long as I had to respect rules I was a disaster. Initially, art was just a way to try a new set of rules. But I was very afraid of failure in art as well."

In Padua, his father was a truck driver and his mother did housework for other people. Maurizio spent the first year of his life living with family friends and relatives, because his mother had lymphatic cancer; she went on to have two more children after that, both girls, and she lived for twenty more years, a fervent devotee of the Catholic Church who became "a center of spiritual activity," he said, "helping people in the community." Cattelan got his first job when he was twelve, selling religious images in the local church. Bored, he drew mustaches on some statuettes of St. Anthony. "The priest asked who had done it," he recalled. "Nobody answered, so he pointed at me, and said, 'I know it was you.'" Cattelan left home when he was eighteen, to live by himself in Padua, and for the next few years he worked at a succession of low-paying jobs: janitor, mailman, assistant at the local morgue. He hated all of them but was terrified of slipping back into the near poverty he had known as a child. Padua, a university town, was a center of left-wing activity in those days; Cattelan steered clear of it as assiduously as he steered clear of the church. One day in 1985, he quit his job at the morgue and moved in with a girlfriend who lived in the town of Forlì, near Bologna. He remembers this as a before-and-after moment. He had decided that he would never again work for somebody else.

His new companion was five years older than he was, and interested in becoming a journalist, or an artist of some sort. Cattelan himself had recently discovered art. When he was still in Padua, he had stopped to look in the window of a small gallery at some works by the contemporary Italian artist Michelangelo Pistoletto, whose paintings on mirrors obliged spectators literally to

enter the composition. Puzzled, Cattelan went inside. The gallery owner answered his fumbling questions, and gave him a book by the art historian Carlo Giulio Argan. Cattelan tried to read the book, but what really interested him were the pictures in it, reproductions of modern and contemporary art, which he had never seen before. For someone who had a problem with rules, the practice of art in the 1980s must have looked like nirvana. Art could be anything at all, it seemed. The leading Italian art trend of the moment, Arte Povera, made use of common, throwaway ("poor") materials to bring art-making down to earth and demonstrate contempt for the commercial promotion of so-called high art. Body art, language art, appropriation art, neo-expressionism, neo-Pop, neo-geo, and a dozen other approaches littered the post-minimalist landscape, where art schools disgorged increasing numbers of ambitious graduates. Anyone with a video camera could be a performance artist, carrying out activities which required neither practice nor skill, and anyone with a degree in art history could make conceptual art. Stoned on Joseph Beuys's shamanism and Andy Warhol's showmanship, on Damien Hirst's pickled sharks and Jeff Koons's high-end pornography, young artists everywhere were searching for the right shtick, the idea or image or material that nobody had happened on before.

Some of the new work was brilliant and intellectually rigorous, but the sheer proliferation of self-indulgence could make you weep. Art galleries and museums and *Kunsthallen* around the world made "transgressive," rule-free art an increasing part of their program, commissioning young artists to do temporary works for special exhibitions or permanent installations in public settings, and out of this changing art market a new kind of practitioner emerged: the biennial artist, whose work appeared

mainly in the large international group shows held every two or three or four years in cities around the world, from Venice and Basel to Johannesburg and Tokyo. Cattelan and the art critic Jens Hoffmann made sport of this development in 1999, when they invited ten of their friends, most of them biennial regulars, to participate in the Sixth Caribbean Biennial on the island of St. Kitts; participation involved spending ten days on the island and doing whatever they felt like. Cattelan and Hoffmann had raised the necessary travel funds from private sponsors, and persuaded the owner of the Golden Lemon Inn to provide free room and board. Rirkrit Tiravanija, one of the participants, told me recently that the artists all had a good time, but that "we were also quite aware that there was more to it than that." They had the somewhat uneasy sense of being in a work by Maurizio Cattelan.

Unlike other artists of his generation, Cattelan never spent a day in college or art school. After his move to Forlì, suddenly unemployed and with no idea how to support himself, he began making some things for his girlfriend's apartment: chairs of found metal and chicken wire, iron lamps welded in designs that seemed to lie somewhere between function and art. A lot of innovative design work was going on in Italy then, and Cattelan soon found that he could sell his work to dealers, in Milan and elsewhere. He developed a relationship with a furniture store in Milan—its manager was Lucio Zotti—and began spending half his time there. (Zotti let him sleep on the beds in the showroom.) A gallery in Bologna showed his work. He met other artists, and the functional element in his designs became less evident. What he considers his first legitimate art piece is a black-and-white photograph of himself in an old-fashioned silver frame, called *Family Syntax* and dated 1989. He is bare-chested, facing the camera, both hands forming the image of a heart over

his heart. A year later, he moved to Milan, sans girlfriend, and began, very tentatively, to think of himself as an artist.

Few artists have used their self-doubt so fearlessly. In Cattelan's case, the release mechanism was humor. Unable to come up with an idea for a 1992 group show in Milan, he went to the police station, filled out a report on a stolen art work, and exhibited the framed report. A few months later, he was invited to be in another group show at the contemporary art center Castello di Rivara, near Turin. On the night before the opening, he knotted white sheets together and hung them from the window of the empty third-floor room that had been allotted to him. ("I let myself down from the window and ran away.") His first solo show as an artist was in 1993, at the Galleria Massimo De Carlo, in Milan. Perplexed viewers, finding the gallery door bricked over, discovered that by peering through an opening in the window they could just see, in the darkened and otherwise empty gallery, a motorized toy bear riding back and forth on a wire. His oddball reputation gained momentum. He was invited to show at the 1993 Venice Biennale, the oldest and most famous of the big international exhibitions. Stumped once again (or pretending to be), he sold his space to an advertising agency, which used it to display a huge ad for Schiaparelli perfume. Some critics considered this an act of cynicism, conflating art and commerce; for Cattelan, it expressed sheer panic—he called it *Working Is a Bad Job.*

HE CAME TO NEW YORK for the first time in 1993. "I didn't have a penny," he recalled. "I was surrounded by garbage, but it was like a dream. 'I'm in New York! I'm in New York!' I had a feeling for this city, I don't know why." Offered a show at the Daniel Newburg Gallery, in SoHo, he brought in a live donkey

and tethered it beneath a crystal chandelier, where it remained, braying and excreting, until officials from the Department of Health closed down the show. He returned to Italy, but within a few months he was back in the Big Apple, living in a two-room apartment in the East Village. His move was made possible by the Oblomov Foundation, which Cattelan had conceived in 1992. The Oblomov Foundation, named for the slothful character in Goncharov's novel, offered a $10,000 grant to an artist who would agree not to make any art for one year. Cattelan raised the money (he can be astonishingly persuasive with donors) and tried to interest a number of young artists in applying, but there were no takers, so he used the $10,000 to establish himself in New York. He didn't have another show here for six years; he was showing all over Europe, though, and making life unusually difficult for his dealers there. In 1995, for his first solo show at the Emmanuel Perrotin gallery, in Paris, Cattelan induced the youthful Perrotin to wear, every day for six weeks, a costume that transformed him into a gigantic pink penis, with rabbit ears on the top. Perrotin says the show got a huge reaction and changed his life, although he denies that he was ever (as the costume implied) a notorious womanizer. A few years later, Cattelan pinioned his Milan dealer, Massimo De Carlo, to the gallery wall with several layers of heavy-duty duct tape, a tableau vivant that had to be deconstructed short of its planned three-hour time frame when De Carlo found that he could no longer breathe.

Cattelan also dallied with theft as an art form. When the De Appel Foundation, in Amsterdam, invited him to be in a group show there, in 1996, Cattelan and five student-curators removed an entire exhibition from a local art gallery and re-installed it at the foundation. "It was not an appropriation," he explained to me. "It was more like reframing something, a

displacement—temporary, of course." Failing to see the humor in displacement, the gallery owner notified the police, and it took much diplomatic negotiating by the De Appel Foundation's director (who had not been informed of the plan beforehand) to keep Cattelan out of jail. A year later, for his second solo show at Perrotin's in Paris, he had exact duplicates made of every work in a concurrent show by the Belgian artist Carsten Höller, at the gallery next door. "Prices were the same, everything was the same, even the press release," he said. "The idea was to create confusion . . . to question identity."

Another sort of confusion is still being spread by *Permanent Food,* the magazine founded in 1996 by Cattelan and Dominique Gonzalez-Foerster, a young French artist he was dating at the time. *Permanent Food* is composed entirely of pages reprinted from other magazines. Cattelan and Gonzalez-Foerster invited their artist friends to contribute pages to it, and the magazine has been appearing mysteriously and irregularly ever since, in art bookstores and a few other locations. Produced these days by Cattelan and his friend Paola Manfrin, in Milan, it is a random assembly of unrelated images—ads, news photos, fashion shots, porno, urban scenes—with occasional flurries of text in various languages. (A note buried in issue no. 8 reads, "Permanent Food is a second generation magazine with a free copyright.") When I questioned Cattelan about stealing images, he seemed quite hurt. "Oh, that's interesting," he said. "Do you think Warhol was a thief, or Rauschenberg? No, I don't steal. It's just that you add something to the grammar. The fact that you put together two images makes the meaning of those images completely different. But listen, *Permanent* is just the desire of a kid to have his own magazine. That's the real reason." Last March, Cattelan received an honorary degree—in sociology, no less—from the

University of Trento, in Italy. Getting it meant a lot to him. ("My mother always told me that without a degree you cannot go anywhere," he said.) In his acceptance speech, written jointly with Massimiliano Gioni but delivered by a member of the university's faculty—Cattelan had managed to get himself semi-immobilized in a plaster cast, after what he claimed was a skiing accident the day before—he said something quite revealing about the ambiguity of images: "I do not know exactly why, but it seems to me that images do not belong to anybody but are instead there, at the disposal of all."

CATTELAN'S WORK APPEALS to many people who miss the self-mocking anxiety behind the jokes. Everybody loved the oversize papier-mâché caricature of Picasso's head that he had made for a "projects" show at the Museum of Modern Art in 1998. The head was worn by a professional actor (sometimes an actress) who circulated inside and outside the museum, signing autographs and posing for snapshots like a Disney World character. It was a little unclear what was being Disneyfied, Picasso or the museum, and the implied raillery seems to have caused some uneasiness at MOMA; but Cattelan, whose favorite artists are Picasso and Warhol, was also making fun of artists like himself, who blur the line between art, advertising, and popular entertainment. Autobiographical references abound in his work. *Charlie Don't Surf* (1997) consists of a school desk, a chair, and a child mannequin who sits at the desk, his hands nailed down to it by two pencils. In *Bidibidobidiboo,* a work described by the curator and critic Francesco Bonami as being "about tenderness and despair," a squirrel that has just committed suicide sits slumped at a tiny kitchen table, near a sink full of dirty dishes, with a squirrel-size revolver lying at its feet. "The squirrel's

kitchen is my parents' kitchen," Cattelan said to me. "I grew up in this kitchen." Cattelan's distinctive nose and droll expression turn up again and again in his work, from *Super noi,* a 1992 piece made up of fifty portraits of Cattelan by a police sketch artist, based on verbal descriptions by other people, to more recent works such as *Mini-me* (he borrowed the title from the "Austin Powers" movie), a miniature Cattelan looking down from a bookshelf, and *Charlie,* a three-year-old Cattelan on a remote-controlled tricycle that zipped around the grounds of the 2003 Venice Biennale, causing startled viewers to jump out of its path. Cattelan has no signature style or manner, and much of his work is not self-referential at all. His off-site contribution to the 2001 Venice Biennale was a full-scale re-creation of the famous "Hollywood" sign, transplanted to a desolate hillside in Palermo. He financed it himself—the costs included arranging charter flights to take people from Venice to Sicily and back—and six months later he paid to have it disassembled. "Later, we wanted to send it to the desert," he told me. "We tried to do something in Saudi Arabia, to make it like a mirage, but then came September 11, and we abandoned it."

Cattelan's life in New York these days is fairly austere. He lives alone, in the same apartment he rented ten years ago. The furnishings, according to one of the few friends allowed into it, include a cot, a table, a stereo, and not much else. Vanessa Beecroft, an Italian-born artist with whom he has had a long and competitive relationship, says that he buys a new set of clothes every year, and throws out the old ones. Having virtually no possessions, he loves giving odd presents to his friends, whose moods and eccentricities he observes with keen attention. (His gifts to my wife include a large three-dimensional display ad for Oscar Mayer franks, and a slightly shopworn toy alligator

wearing a Batman cape and mask.) Cattelan can be simultaneously considerate and outrageous; his pantomimes and saturnine kidding (in a deep, rasping baritone) remind people of the actor Roberto Benigni. Removing his jacket in a Manhattan restaurant one evening recently, he gazed mournfully at Vesna, the maître d', and moaned, "Vesna, Vesna, you make me hot. If only you were two years younger." Vesna melted, as usual.

He keeps fit by swimming laps for seventy minutes every morning, at a public pool downtown, and by riding his bike, which he refers to as "my girlfriend." His studio is the telephone. He is constantly on the phone with one or another of his international band of friends and collaborators—Lucio Zotti, Massimiliano Gioni, Francesco Bonami, Ali Subotnick, and Paola Manfrin—who provide counsel, criticism, and other unpaid services. (They all have jobs and careers of their own.) At any time, they can expect to hear Cattelan's urgent voice on the line, saying "I need an idea." The ideas almost always originate with Cattelan, but he needs to test them out on others, and to get their reactions. Gioni, who edited the magazine *Flash Art* before he became director of the Trussardi Foundation, has often acted as Cattelan's spokesman, giving interviews to people who think they are talking to the artist, and even delivering an occasional lecture that Cattelan doesn't feel qualified to give himself. Cattelan refers to all this interaction as a "family business"; when discussing his work, he almost always uses the plural pronoun "we" instead of "I," and he often says that, without the others, "I am nothing."

Like many people who have decided to work for themselves, though, Cattelan works more or less all the time. He travels a great deal, attending to future projects in Europe and elsewhere, and he has several ongoing activities in New York. The Wrong

Gallery, which consists of two minuscule spaces behind blocked-off doorways in Chelsea, puts on exhibitions by young artists. *Charley* is a new magazine, edited by Cattelan, Gioni, and Subotnick, which documents work by artists they like. And there is the Marian Goodman Gallery, on West Fifty-seventh Street, which represents Cattelan in this country. For his first show there, in 2000, he presented a plastic-and-resin baby elephant covered by a white sheet with holes cut out for its soulful eyes; the title was *Not Afraid of Love*. His second, in 2002, featured mannequins of two uniformed New York policemen, turned upside down and propped against a wall. Goodman is one of the most astute dealers in New York. She had passed on taking Cattelan two years earlier, when she first looked at slides of his work, but later realized that she had made a mistake. It is said that Cattelan wanted to be with her gallery, which represents Gerhard Richter, John Baldessari, Thomas Struth, and other heavy hitters, to counter the impression that he isn't a serious artist. Goodman, who has not allowed herself to be taped to the wall or made to wear an embarrassing costume, has presided skillfully over his spectacularly rising prices. His small *Mini-me* sculpture recently sold for $355,200. *La Nona Ora* (the Pope laid low) brought just under a million dollars in 2001, and *The Ballad of Trotsky,* the first of the suspended horses, went for $2 million at Sotheby's last spring.

ON THE MORNING of September 11, 2001, Cattelan was in a taxi, on his way to La Guardia Airport, when he saw black smoke pouring across the river from Manhattan. He watched the second plane hit the north tower. He checked in, but then all flights were canceled. Taxis being unavailable, Cattelan walked back to Manhattan, pulling his suitcase on its built-in

wheels. It took him most of the day. Crossing the Fifty-ninth Street Bridge, he recalled, "everybody was walking the other way. I've never seen people, strangers, talking on the street like that." Since then, he feels, "it's not the same America I knew when I came here. The image of the country is being transformed." I asked him recently whether this feeling had anything to do with his decision to do the Kennedy piece, and he nodded emphatically. "A lot, a lot, a lot," he said. "Just last week, I saw the Michael Moore film"—*Fahrenheit 9/11*—"and I thought, Perfect, more than ever we have to do it. Even though my piece has nothing to do with this moment, it's like the—what we call the *spettro,* the ghost of something missing."

One of the people he had to persuade was Laura Hoptman. As a curator at MOMA, Hoptman had worked with Cattelan on the project show featuring the Picasso head. He had driven her crazy with his impossible demands and prankish behavior; she once found him sitting in the museum's Maserati sports car, one of the treasures of the design department, which, as she screamed at him, was absolutely off limits. They became close friends, however, and in the end she decided that he was a very important artist; when she moved to Pittsburgh two years ago to organize the 2004 Carnegie International Exhibition, the first person she invited to be in it was Cattelan. Hoptman wanted her show to focus on "work that wrestles with the big issues, make-or-break work," and she had set her sights on Cattelan's *Him,* the sculpture of Hitler praying. In addition to being the embodiment of evil, *Him* was also, according to Hoptman, about "the problem with Catholic doctrine, which says that everyone is absolved if they ask for it, and here is Hitler on his knees, asking for absolution. The question is, If there's a God,

will this God forgive Hitler? Very few recent works of art deal with issues like that." Cattelan agreed to let her show it, but then, last January, he called her and said he had a new project, which he wanted her to show instead. He described the Kennedy piece, and Hoptman argued strenuously against it, expressing doubt that Kennedy would work as a subject. Cattelan kept pressing her. "He said, 'I'm showing it in Paris, Laura, and it's very important to me that it comes to America right after Paris,'" she told me. In the end, he convinced her. "The straw that broke the camel's back," Hoptman said, "was when he told me what it would be called: *Now.*"

ON OUR LAST NIGHT in Paris with Cattelan, I brought up the problem of fame. We were sitting by the river on the Quai de Conti; the Bateaux-Mouches were going by, and a group of young people, theater students, probably, were rehearsing a scene just out of earshot. It had struck me that Cattelan was very adept at avoiding the pitfalls of success. He has given relatively few interviews; there have been no mid-career retrospectives, and only one book-length monograph (in 2000) on his work. Having spent so many years being concerned about failure, I asked him, did he now worry about success and fame? "Are you crazy?" he said. "Being famous inside the art world—that's a real achievement? It's like one thousand people! Nobody stops you on the street. You can sometimes open up the debate with a new kind of work, but, in the end, who cares?" He did concede that in the last three years he had turned down a number of invitations for retrospective exhibitions, but that recently he had been thinking about how one could be done. "It might be interesting to do it using different venues," he said. "In Manhattan, for example, a specific venue for

the Pope, where he can be displayed properly, and then in Queens something else, so between one work and another you can have a sort of dialogue. It would be like a dinner that doesn't give you indigestion. And maybe not all in museums, either."

I asked if he thought his work had a social function. He turned the question around, asking whether I thought it did and, if so, what was it? After some badinage over the question, he said, "Maybe I'm not prepared for this. Okay, I have a tendency to talk with an audience, but not so much in a thinking way. It's strange. I was born stupid and I'm still stupid. Meanwhile, I learn a little something, and this something comes from daily experience. For sure, I was really seduced by the possibility of aiming at a different type of audience, trying to get out from the usual art world. Milan was an example of that. But, you know, I don't feel like I'm the owner of the work. The work is the boss, or probably it's more suitable to call it a mistress. It gives me pleasure, and also a lot of worries. Whatever comes out of me is not me; it's something inside of me, but I'm not the master of it. Maybe I'm schizophrenic or something." He was quiet for a few moments, sitting on the wall and looking at the river. "What I'm doing is something I love," he said then. "I really think that without art I would have had a miserable life. But I don't think about tomorrow in terms of what I'm leaving."

Just the other day, Cattelan called from Europe. He'd been to Japan, to see about a new project, and he'd been to Berlin, and he'd just spent several days hiking in the Alps, something new for him. He had also been back to Druet's studio in Paris to check on the Kennedy figure. "Lucio kept saying the shoes were not right, so I finally said, okay, no shoes, and no socks," he reported. "It reminds me more of someone who's a saint. Also, we decided to do

closed eyes. The guy is definitely dead, but there's no finality. It has to be ungraspable. I'm so happy about the bare feet."

—*October 4, 2004*

Since Now, *Cattelan has spent much of his time curating exhibitions by other artists. He was one of the organizers of the highly acclaimed Berlin Biennial in 2006, and he oversees the shows at the Wrong Gallery in its new location, at the Tate Modern in London. His new work, seen mainly in Europe, includes a sculptural group, in Carrara marble, of nine life-size corpses in body bags, and another of three male arms projecting out from the wall in what could be interpreted as a fascist salute or a blessing; its title is* Ave Maria. *He has also done an untitled, full-size horse mounted in reverse, head buried in the wall, body and legs dangling. Cattelan's mordant reflections on war, power, and authority may be taking him into deeper waters these days, but he shows no sign of yielding to the temptations of fame.*

JASPER JOHNS

The artist Jasper Johns lives alone in a large gray field-stone house in northwestern Connecticut. Built in the nineteenth century, the house stands on a hillside overlooking a hundred and thirty acres of meadows and woods and a distant lake, and from the outside it has a staid and formal aspect. Inside, Johns has opened it up and cleared away most of the period décor, leaving a suite of sparsely furnished, uncluttered spaces, where he has placed works by artists he admires. In the living room, a small oil painting by Cézanne, a version of the famous male *Bather with Outstretched Arms,* hangs over the fireplace. Twelve framed Cézanne drawings rest on shelves in a nearby bookcase. A large freestanding sculpture made of bent and twisted auto body parts, by Johns's contemporary John Chamberlain, occupies one corner of the room, and a stack of Andy Warhol's Heinz cartons serves as a side table for one of the two pale-gray armchairs. On a long table against the far wall, five Jomon pots (rare, prehistoric

Japanese ceramics) group companionably at the far end. "I always wanted five of them," Johns says. "And now I have five."

Johns, at seventy-six, is an imposing presence. Just over six feet tall, with thinning white hair and considerable bulk through the chest and shoulders, he projects a concentrated self-assurance that is less armored than it used to be. Twice before, during the forty years we have known each other, I have proposed writing about him for *The New Yorker;* both times he said he would think about it, and then, a week or so later, he tactfully declined. Recently I asked him again, and this time he said that he was willing to try, with the understanding "that it might be a failure." I knew what he meant. Johns has never been an easy interview. Although he makes a serious effort to answer most questions about his work, attempts to probe into meaning or interpretation annoy him. He prefers to talk about how a work was made, not why, and his answers tend to be literal, succinct, and often opaque. This does not encourage personal revelations. As the art critic Vivien Raynor once wrote, in *Artnews,* "He has a remoteness that, while very amiable, makes all questions sound vaguely coarse and irrelevant."

Johns had suggested I meet him that morning in his painting studio, in a converted coach barn about a hundred yards from the house. The studio, which occupies half the ground floor, is a big, open room with a high ceiling and immense sliding doors at either end. There are several worktables, with paints and art supplies neatly laid out. On the wall just to the right of the entrance is a very small, very crude oil sketch by Cézanne of a reclining nude woman. To the left of this door, on the wall and clustered on two shelves, is a miscellany of disparate objects that Johns likes, or that people have sent him because they think he would like them: two versions of Marcel Duchamp's self-portrait in profile; a geode with water trapped inside it; a tiny Joseph Cornell box; four

shadow-box frames containing, respectively, a seahorse, a praying mantis, a large beetle, and a tarantula; some children's drawings; a micro-teapot made from a single penny; several novelty toys, two of which feature an outhouse with a small boy inside who pees on you when you open the door—Johns demonstrated one of them for me.

Four recent paintings hung on the back wall. All four were painted in a pattern of irregular abstract shapes that echoed the "flagstone" motif Johns had used extensively in the 1960s and 1970s. Three of them were in muted colors, and the fourth was predominantly gray, a color whose tonal complexities have figured prominently in Johns's work throughout his career. This one's title, he said, was *Beckett*. When I asked why, he told about working with Samuel Beckett on a book, in 1976, with writings by Beckett and images by Johns—flagstone images, and also the tight clusters of short, diagonal "cross-hatch" brushstrokes that he was using in many of his pictures then. "Sam was looking at some etchings I had made," Johns said. "He held them up very close to his face—he had bad eyesight—and then he said, 'I'll tell you what I see. Here'—pointing to the cross-hatching—'I see you try all these paths in different directions, but, no matter where you go, you come up against this wall.'" I asked him whether Beckett's remark, with its ring of comic futility, might have had to do more with Beckett than with Johns. "Don't you think that all of our interpretations of other people's work sound like us?" he said, laughing. "That's what's interesting—you get to see yourself another way."

Later, we walked over to the main house for lunch. On weekdays, Johns has lunch with his staff: his studio assistant, James Meyer; John Lund, who runs a fully equipped print studio that occupies the other half of the building's ground floor; Sarah Taggart, his

longtime secretary and personal assistant; and Taggart's aide, Lynn Kearcher. On this Sunday in May, the staff was absent, but Johns's chef had prepared lunch, which was precisely laid out on a side table, on antique Japanese plates—seafood salad, corn salad, asparagus, wild rice, fresh bread, and sautéed morels, gathered that morning from a spot that Johns pointed out to me, under an oak tree, where they appear at this time every year. There were three paintings in the dining room, each with a wall to itself. A small, metallic image of the American flag (the subject of Johns's 1954 breakthrough work) hung over the fireplace; it is actually a cast, in silver, of a collage that Johns made for Robert Rauschenberg in the early 1960s. One of Cy Twombly's large "blackboard" paintings, with white scribbled lines on a black background, occupied a side wall, and a 1963 silk-screen painting by Rauschenberg, called *Cove,* was on the wall facing the Johns flag.

During lunch, I started to ask him about what had struck me, in the studio, as a return to his abstract period of the 1970s, but he cut me short. "What are you talking about?" he said. I said I was referring to the flagstone and the cross-hatch motifs. "If you consider that abstraction," Johns said. "Those stupid marks." Most people do, I said. "Well, I don't know that I think of my other work as representational," he said. "This is an idea that isn't mine. If I meet someone I don't know, someone slightly naïve, and they ask me what I do, I say I'm a painter, and if they ask what kind of a painter, I say an abstract painter. It's a way to get out of saying anything else. Or I just say I'm a modern artist. But I don't know what kind of an artist I am."

JASPER JOHNS'S FIRST SOLO EXHIBITION, at the Leo Castelli Gallery in 1958, established him as an artist of great originality and singular importance. Alfred Barr, the Museum of

Modern Art's director, came in, stayed for an hour, and bought three paintings for the museum, a virtually unprecedented vote of confidence for a previously unknown painter who was still in his twenties.

Johns and Robert Rauschenberg, who had an intense personal and professional relationship from 1954 to 1961, are often said to have broken the dominance of the Abstract Expressionist style and opened up new approaches and new subject matter. These included, in Johns's case, figurative paintings of targets, flags, numerals, and letters of the alphabet. Johns's seductively painted renderings of these "things the mind already knows," as he put it, and Rauschenberg's wildly inventive collages and "combines" (part painting and part sculpture), which brought the whole, promiscuous image bank of contemporary American experience into art-making, set the stage for Pop art, Minimal art, and many subsequent developments. Although Rauschenberg's reputation has fluctuated widely, Johns's remained at an exalted level for three decades. (As late as 1988, the *Times* critic Michael Brenson cited his standing in Europe as "the greatest American artist since Jackson Pollock.") The first stirrings of discontent surfaced over *The Seasons,* a suite of four large paintings done in 1985 and 1986, in which autobiographical references and deliberate borrowings from Picasso made some critics suspect that the artist was losing his merciless originality. Critical dissent has slowly gathered momentum since then, fueled by Johns's increasing tendency to fill his paintings with cryptic, puzzle-like images, and with details taken from pictures by other artists, from Matthias Grünewald's Isenheim Altarpiece to the forgotten W. E. Hill's 1915 drawing of a woman's head which, depending on how you view it, can be either a pretty young Gibson girl or a forbidding hag in a head scarf. The complaints reached a fairly shrill pitch

during his show at the Matthew Marks Gallery last year, when several former enthusiasts attacked what Michael Kimmelman, in *The Times,* called Johns's "ever more preening and self-mythologizing brands of obscurity." Other critics had similar reactions. Peter Schjeldahl, in a review in *The New Yorker,* wrote that Johns had, in his new work, "attempted to retreat behind a curtain of hermetic, teasingly simple formats. The result is undernourished and overthought."

WHEN INTELLIGENT CRITICS dismiss the current work of an artist who has been as extravagantly admired as Johns has, it is often because the work does not coincide with their expectations. (For a while in the 1970s, the rap on Picasso was that he had done nothing major since *Guernica,* in 1937.) The recent Johns criticism has been consistent and troubling, nevertheless. I have had my own feelings of frustration with what has sometimes seemed like Johns's willful oscillation between pulling me in and shutting me out. The large painted maps of the United States that he did in the 1960s, one in bravura, Abstract Expressionist style and primary colors, another in subtly muted, mostly gray tones, struck me as the most beautiful works I had seen by a living artist, until the "Usuyuki" series of cross-hatch paintings that he did fifteen years later. (The Japanese word *usuyuki,* which refers to a light snow, was an apt verbal equivalent to these works, whose exquisite colors seemed to lie just beneath the surface.) The increasing complexity and the hidden references in his work of the 1980s and 1990s never made me think that the artist was playing trivial games, but some of the paintings did seem clotted and hermetic. Over time, though, I have come to think that Johns is following the only course available to him. He believes in Duchamp's theory that the artist sets in

motion a creative process that the spectators must complete, and the current disconnect may indeed turn out to be a failure on his part. My guess, though, is that the work will hold up and the criticism will not.

Again and again in his career, he has thwarted critical expectations by abruptly changing the way he paints. The first major shift occurred immediately following his début show at Leo Castelli's. Abandoning the deadpan reticence and muted palette of his targets and numbers, he began painting splashy, colorful, mostly abstract canvases that carried echoes of Willem de Kooning's loose-elbow style, canvases in which swatches of a bright primary color were identified, confusingly, by the stenciled name of another color. A very different sensibility marked the series of dark, somewhat morbid paintings and drawings that he did in 1961–63, soon after a bitter falling-out with Rauschenberg; their titles (*No, Liar, Fool's House, Painting Bitten by a Man, Diver*) suggested, to the multiplying herd of Johns's explicators, that personal emotions had invaded the work of an artist whose previous approach had rigorously ruled them out. After the predominantly abstract flagstone and hatch-mark paintings in the 1970s, recognizable images returned in 1979: real knives and forks attached to the picture frame in some paintings, three-dimensional plaster casts of body parts in others, painted images of skulls and male and female genitals in the "Tantric Detail" series. We also began to see more and more direct borrowings from older artists, borrowings that took on, in Johns's cerebral reworking, a strange duality. When Picasso reworked Velázquez, Delacroix, and other Old Masters, he seemed to be devouring them, appropriating and digesting for his own use their mysterious essence. Johns's motive is more like compulsive curiosity: Why does this image carry meaning, and would it still do so if I used it in this way?

Through all the stylistic variations in Johns's work over the decades, what didn't change was his painterly touch. In whatever medium he used—oil paint, encaustic (a nearly extinct technique, which Johns rediscovered in an art book, of mixing pigment with hot wax), charcoal, pencil, crayon, watercolor, lithography, etching, and so forth—the physical skill he brought to its application carried an almost erotic charge. "Looking closely helps," his friend John Cage, the composer, wrote in an early essay on Johns, "though the paint is applied so sensually that there is the danger of falling in love."

Even his detractors still pay perfunctory tribute to the way he handles paint. It's the subject matter that riles them. They want to know what, exactly, is the point of these bizarre and unrelated images in his work of the past two decades: the schematic floor plan of his grandfather's house in Allendale, South Carolina; the little stick figures wielding paintbrushes; the shadowy child with superimposed geometric forms; the spiral galaxy; the weirdly distorted female face from Picasso's *Straw Hat with Blue Leaf.* Aside from the skill involved, what do these images have to do with anything beyond Johns's all-too-private conceits and preoccupations? As Kimmelman wrote in 1991, "His current drawings and paintings seem increasingly based on a code that demands to be broken but to which he alone holds the key." But why should Johns be denied the use of unexplained images? The mysterious, unidentifiable shape near the center of Matisse's *The Moroccans* does not keep it from being considered one of the greatest pictures in the Museum of Modern Art.

Impatient with all the critical spadework that has gone into decoding his images, Johns unveiled a new puzzle in a 1990 painting called *Green Angel,* a roughly rectangular shape that has appeared in several subsequent works; when asked about it, he

said that he was not going to reveal the source. Baffled reviewers took to calling it "a buffalo in a blanket." This might suggest that the artist is indeed playing games with his viewers, but to think that, you would have to believe in the kind of intentional working process that he has always made clear he does not follow. For Johns, as for most of the great modern artists, a picture is not a statement, nor does it emerge from a preconceived plan. Every brushstroke, even the first, is a response to something that has occurred before, on the canvas or in the artist's mind or memory, and will influence what happens next. Johns would like viewers to construct their own meanings from his pictures. With *Green Angel*, as he explained to me during another visit to his Connecticut studio, "the idea was not to create a mystery about the derivation of an image but to free the image from that other thing," its previous association. "I was trying to find out something about how our minds and eyes work, and what creates a new or original image."

I asked him what had triggered his use of autobiographical references in *The Seasons* and later paintings. He was silent for some time, frowning slightly—enough to make me think he was irritated. "I don't know how to answer you," he said at length. "But I'll try. When you're painting, you have a central thought that pulls in various kinds of details, and that's the way you make the painting. You go in a direction, and you gather up whatever you need to move that way. It's not necessarily that you have planned to make a picture like this. It's not 'Well, now let's say something about myself.' You're saying, 'Now let me make another painting.'"

I reminded him of his early statements about not wanting his work to be about himself, his life, or his feelings. "Well," he replied, "one realizes that it's a failure, that effort. It produces

something, it's an attitude which allows you to filter certain things, and gives the work a direction, or the sense of a direction. As other things are filtered or allowed in, you get a different kind of image. One would like to control that, but it is more or less a hopeless procedure." In other words, I suggested, the autobiographical elements were not important in themselves; they just happened to be what he was working with at a certain point. "That's what I think," he said.

IN 2006 THE NATIONAL GALLERY organized an important exhibition called "Jasper Johns: An Allegory of Painting, 1955–1965." Before the opening, I asked Jeffrey Weiss, the show's curator, how he felt about the recent critical backlash against Johns. "That's a hard thing to account for," he said, "except to say that art has changed so much, and critical expectations have changed as well. His language is more closely attached to the distant past than to what's being done now." It is true that not many young artists today seem influenced by Johns, in the way that so many used to be in the 1960s, and so many are still influenced by Rauschenberg and Warhol. Johns has become like an Old Master—but one whose work continues to change, double back on itself, contradict expectations, and disturb. On my last visit to Connecticut, in October, Johns brought out a small flagstone painting that he had finished just the day before. About a quarter the size of *Beckett,* it was much more vivid: The flagstones were red, yellow, and blue, on a white ground. The interaction of color and shape was remarkably active. The little picture had a brilliance and clarity that I had not seen in Johns's work for a long time, or maybe ever.

Johns appears to be indifferent to the recent attacks. "Usually I have read what critics say," he told me last spring. "I always

find it interesting that they have anything to say, because I find it difficult to say much, and certainly not to sum things up. I don't hold on to what they've said, and more recently I pay less attention." He was silent for several moments, looking off into the distance, as though considering what he had just said. "Of course," he added, "artists can torture themselves over almost anything." I asked him what were some of the things he tortured himself about. "I don't think I want to tell you!" he said, with a burst of laughter.

Johns was not always so unmoved by criticism. Early in his career, he made a wicked little sculpture called *The Critic Sees II*. It consists of a pair of eyeglasses embedded in what looks like a block of lead. (The block is actually plaster, covered with a gray compound called Sculpmetal.) Behind each lens, instead of an eye, there is an open, speaking mouth.

ONE DAY IN THE 1970s, the art dealer Irving Blum invited Jasper Johns to lunch at an expensive uptown restaurant. During the meal, Johns asked what the lunch was about. Blum explained: He knew an important collector who wanted very much to buy Johns's *White Flag,* a 1955 painting that Johns still owned. The collector would pay big for it, Blum said—up to $2 million. Johns, whose prices were extremely high by then, but not that high, smiled and changed the subject. Dessert and coffee arrived. Blum called for the check. As they were saying goodbye, he ventured, "So, Jasper, what do you think of my proposal?" Smiling broadly this time, Johns said, "Irving, it's not worth it."

For a long time now, the prices paid for Johns's work have been the gold standard for contemporary art. His *False Start* broke the auction record for work by a living artist when

Sotheby's sold it for $17 million in 1988; last month, it brought $80 million in a private sale. Johns gets nothing from these secondary-market resales, but they help to boost the market for his new work, whose prices are unaffected by the critical backlash. Johns, who stayed with the Castelli Gallery until Leo Castelli's death in 1999, no longer needs a primary dealer. He produces very few paintings in any given year—rarely more than four or five, some years none at all—and he tries to hold on to at least one work from every show. Occasionally he sells something directly out of the studio, or through Matthew Marks or Barbara Castelli, Leo's widow, who has a small gallery on the Upper East Side. There is a long list of people waiting to buy anything he does, at several million dollars for a painting, upward of $500,000 for a new drawing, and up to $50,000 for a print. This enables him to live exceedingly comfortably. In addition to the property in Connecticut, he has a house on St. Martin, in the Caribbean, where he spends the winter, and he is thinking about renovating a space in a downtown Manhattan building that he co-owns with a friend. (Johns used to own Gypsy Rose Lee's former town house, on East Sixty-third Street, but he sold it several years ago; now he wants a place to stay when he is obliged to come in from the country for an opening or a dinner party.) Wherever he is, he lives in what I think of as a kind of monastic luxury. Johns's most visible extravagance, apart from his real estate holdings, is the work of other artists, which he buys at auction or through private sales or exchanges. In addition to the examples already mentioned, he owns works by Degas, Picasso, Matisse, Magritte, Picabia, Schwitters, Warhol, de Kooning, Juan Gris, Barnett Newman, Eric Fischl, Brice Marden, Frank Stella, as well as many more works by Rauschenberg. Unlike some of these artists, Johns has managed, through

rigorous refusals and the protective loyalty of a few close friends, to avoid becoming an art star. Outside the art world, few people know him by sight.

This is not to say that he doesn't appreciate his success. "I've been very fortunate to have a large enough number of people interested in my work over a long time," he said to me. "The generous reception it's had has allowed me to be much more"—a pause—"free in my decisions. More obstinate. I feel I have benefited from the kind of attention I've had, rather than being hampered by it." There was another long pause. Then he said, "In fact, I think I've been treated so well that I'm overly comfortable."

JASPER JOHNS, who was born in 1930, grew up in rural South Carolina. His parents divorced when he was two or three, and he was sent to live with his paternal grandfather, a well-to-do Baptist farmer, who had a much younger second wife and a large house in Allendale, in the southwestern part of the state. His grandfather died in 1939, and Johns spent the next year living with his mother and her second husband and their two children, in Columbia, the state capital. That summer, when he was ten, he was sent to visit his father's sister, Gladys, who lived on Lake Murray, about eighty miles north of Allendale. "It wasn't a town," Johns recalled, "it was an area that people called The Corner. At the end of the summer, I was informed that I was to stay there." He stayed six years. For the first three years, he went to a one-room schoolhouse, where his aunt Gladys taught all the grades. There were only two other children in Johns's class; he loved learning how to diagram sentences, which his aunt taught "with passion." When the time came to go to high school, he commuted by bus to the town of Batesburg. After tenth grade, he moved in again with his mother and stepfather, who had

relocated to Sumter, about forty miles east of Columbia. "Most of the time," he said, "wherever I lived, I felt like a guest."

Johns's paternal grandmother, who died before he was born, had been an amateur artist, and her paintings—scenes from nature, copied (he suspects) from other sources and hanging in the Allendale house where he grew up—were the first art works he saw. "I think I always wanted to make art, as far back as I can remember," he told me. "What I find curious is that I didn't train myself. It was simply a kind of blank ambition." Although he once said that he started drawing at the age of three "and never stopped," he also insists that he never really learned to draw, and still has no facility for it. In 1948, he entered the University of South Carolina, in Columbia. "I had no interest in most subjects," he recalled. "I had no sense of history, so I didn't do terribly well. But I found the art classes very interesting, and by the beginning of my second year, maybe the second half of the first year, I stopped studying and took only art classes." One of his teachers there, Catharine Phillips Rembert, who had studied with Hans Hofmann and knew the New York art scene, became a close friend and mentor. She invited him to dinner at her house almost every night. (Her dining table, which Johns bought from her a few years ago and enlarged, is now his dining table in Connecticut.) Rembert talked to him about contemporary art and artists, and told him that he should go to New York. In the winter of his second year of college, he did so, and enrolled at the Parsons School of Design. He soon ran out of money. He was offered a scholarship, but was told that he didn't deserve one: The Parsons administrator said she was only offering it because of her friendship with Catharine Rembert. In that case, Johns said, he couldn't accept it. He quit Parsons and got a job as a messenger. He took and passed the examination for the art school at Cooper Union, which was

free, but he did not enroll there. In the spring of 1951, he was drafted into the Army.

The Korean War was in its first year then, and Johns, who was trained as a heavy-weapons infantryman, expected to go to Korea, but after a year and a half of running an art exhibition program for soldiers at Fort Jackson, in South Carolina, he was assigned to a Special Services unit in Sendai, Japan, about two hundred miles north of Tokyo. His duties—printing movie schedules; designing posters on the perils of venereal disease— were not onerous, and during his time in Sendai he initiated what became a lifelong interest in Japanese culture. He visited Kyoto's temples and gardens, attended Kabuki performances, and went to a Surrealist-inspired exhibition in Tokyo where he remembers seeing an elephant's foot pinning a woman's glove to a pedestal. After his discharge from the Army, in 1953, he moved back to New York and spent one day at Hunter College, which he could attend on the GI Bill. He went to an English literature class on *Beowulf,* "where the teacher was talking about the mead hall"; a French class in which he couldn't understand a word anyone said; and an art class whose imposing, red-haired female teacher praised his "marvelous line quality." Returning to his railroad apartment on East Eighty-third Street that evening, he passed out on the street (the effects of a virus, he surmises), stayed in bed for several days, and decided that the Hunter experience was not worth pursuing.

Most of the work Johns had done up to this point no longer exists; he destroyed it in 1954. Some years ago, Johns told me that his work before then "was mainly negative, concerned with not doing anything that had been done before," but last summer he said he couldn't remember what it was like. He worked as a night clerk at the Marboro bookstore, on West Fifty-seventh

Street. Walking home after work in late 1953 or early 1954, he saw someone he knew, the writer Suzi Gablik, who was with two other people on the corner of Fifty-seventh and Madison. Gablik introduced him to her friends, one of whom was Robert Rauschenberg.

"BOB WAS THE FIRST real artist I had any contact with," Johns told me a couple of years ago. "You could say that I learned what an artist was from watching him, on the practical level." For seven years, beginning in the summer of 1954, when Johns moved to a downtown industrial-loft studio on Pearl Street, they saw each other's work almost every day. Rauschenberg was living a few blocks away, on Fulton Street; the following summer, he moved to the floor above Johns on Pearl. "For a number of years," Johns said, "we were the main audience for each other's work."

Rauschenberg, who was five years older than Johns, had grown up in Port Arthur, Texas. He'd had solo shows in New York and knew many of the city's artists, but his recent work—fetish-like objects made from scrap materials, collages whose elements included newspaper, mirrors, fabric, gold leaf, or things he picked up on the street—had found few buyers, and for several years after he met Johns, no gallery wanted to show it. He and Johns, who had quit his job at Marboro, supported themselves by designing window displays for Tiffany's and Bonwit's; Gene Moore, the display director for both stores, paid them his top fee of $500 a job, which they could live on for three months.

Johns's breakthrough had come when he dreamed that he was painting the American flag. The next day, he did paint it—not a painting of the flag but the flag itself, stars and stripes filling the canvas from edge to edge. This led to the targets, and the letters and the numbers, and the maps of the United States. The map

idea came from Rauschenberg, who one day brought home a cheap outline map of the states and gave it to Johns.

They traded ideas as well as pictures, and occasionally tried their hand at each other's work. "I did a couple of gold-leaf paintings," Johns once told me, when I was interviewing him for an article about Rauschenberg. "And I did one in the style of his painting *Rebus*. I thought I understood what went into his pictures, but my work wasn't convincing." Rauschenberg told me in 1963 that he had been "envious of Jasper's encaustic, but too respectful to touch it, except once. He was painting one of the large flags. It smelled so delicious, all those aromatic bubbling waxes. I begged him to let me do one stripe, and he finally said all right, one. I stared at the painting, savoring the moment, and then I dipped a brush in the red wax and made a stroke—in the middle of a white stripe! Oops! Needless to say, I didn't ask him again." A few years later, after hearing of de Kooning's crack about Leo Castelli's salesmanship ("That son-of-a-bitch; you could give him two beer cans and he could sell them"), Rauschenberg was trying to work two crumpled beer cans into one of his combines. "You should let me use that," Johns said to him, and Rauschenberg agreed. The result was Johns's *Painted Bronze*, a 1960 sculpture of two cast bronze, meticulously painted replicas of Ballantine Ale cans.

In those long-ago interviews, you get a sense of how the two artists felt about each other. "Jasper was soft, beautiful, lean, and poetic," Rauschenberg said in 1963. "He looked almost ill—I guess that's what I mean by poetic. . . . He read a lot, and he wrote poetry. Jasper would read Hart Crane to me in the studio. I loved it—I just didn't have the patience to read it myself." And Johns, around the same time: "I felt kin to him. He seemed amazingly naïve, but he functioned in ways that I couldn't. Bob

assumed that other people would support what he did. I assumed I would have to do it in spite of other people."

Their closest friends in those years were John Cage and Merce Cunningham, the modern-dance choreographer, both of whom Rauschenberg had studied with in 1952 at Black Mountain College. Rauschenberg and Johns became closely involved with the activities of Cunningham's dance company. They made sets and costumes, and Rauschenberg acted as the company's lighting designer and eventually as Cunningham's artistic adviser, a role Johns took over in the late 1960s. (The Foundation for Contemporary Arts, a private grant-making agency that Johns and Cage established in 1963, and that Johns still oversees, grew out of a fund-raising effort for the Cunningham company.) The four men shared certain ideas and ambitions which would soon become much more influential than they were then: ideas of an art based not on self-expression or heroic individualism or some concept of the sublime but on a field of aesthetic possibilities reachable through nontraditional means such as chance, experimentation, and the unapologetic embrace of everyday experience. Cage, who was a few years older than the others, had come to these notions intellectually, through his delvings into modern literature, Zen Buddhism, Hindu philosophy, and the work and thought of Duchamp. Each of the others had arrived on his own, by different routes, but they found reassurance in Cage, who was a natural teacher and a world-class optimist. "It had great meaning for me that John was so organized in his thinking," Johns recalled, in one of our conversations. "Although I was very attentive, I would say I was not a good student. John didn't like to argue. I like to argue, and that annoyed him tremendously."

A few years after Johns and Rauschenberg's unhappy parting in 1961, Cage talked to me about their relationship. "We called

them the Southern renaissance," he said. "Their personalities were so very different—Jasper was much quieter in those days—but often a kind of electricity seemed to pass between them, striking sparks that lit up any discussion. I remember thinking I didn't need to have any other friends. Their breakup seemed to me a very great deprivation."

ONE DAY LAST SPRING, I watched Jasper Johns carefully unwrap a large black-and-white lithograph. He had made it that week. Brushy abstract markings ran down one side of the sheet, opposite more or less untouched areas of white paper, and near the bottom was a narrow horizontal shape in a diamond pattern that suggested one of Picasso's Harlequin figures. The print was based on two large paintings, called *Pyre* and *Pyre 2,* which Johns had done in 2003, and which would shortly make their first public appearance in the "Picasso and American Art" exhibition at the Whitney Museum.

This is how Johns often works. He makes a painting, and afterward (rarely before) he may make any number of drawings and/or graphic works in which different aspects of the painting are added to, omitted, or altered. Prints are as important to his working process as drawings; they allow him to explore the endless possibilities he is able to find in any visual motif. "I prefer work that appears to come out of a changing focus," he said in a 1964 interview, "not just one relationship or even a number of them but constantly changing and shifting relationships to things in terms of focus." This sense of a shifting focus is one of the elements he responds to in the work of Cézanne, whose "synesthetic quality," as he once remarked, "makes looking equivalent to touching." I inquired about the title, *Pyre.* Did it imply a funeral? "I don't think so," he said.

Against my better judgment, I asked whether the thought of death had been on his mind when he made the paintings. "I don't mean to scorn what you're saying," Johns said carefully. "Such things do come into play, but I think to focus on them would be a mistake."

There is a common misperception about Johns that he is a secretive and melancholy person. He enjoys many things in his life—food, books, plants of all kinds, conversation, friendships. Although his work requires a certain degree of isolation and solitude, which he takes care to provide for himself, he can be extremely good company. He is witty, well-read, curious, and interested in what others think, although he doesn't hesitate to argue with it.

"Jasper is good for me," Susan Sontag wrote in her journal in 1966, when they were seeing a lot of each other. "He makes it feel natural + good + right to be crazy . . . to question everything." Johns told me that he had loved talking with Sontag. "She was certainly lively in her thought, and in her willingness to encounter things. I would go with her occasionally to literary gatherings, with people like Lionel Trilling. She seemed to think my presence would be interesting to everyone else, although I think they couldn't understand what they were supposed to find interesting about me." His friendship with Sontag may have had something to do with his agreeing to appear, last December, one year after Sontag died, in a *Vogue* fashion shoot by her longtime companion, the photographer Annie Leibovitz. The theme was *The Wizard of Oz,* with Keira Knightley as Dorothy (in frocks that L. Frank Baum could not have envisaged), and a gaggle of contemporary artists as the other characters. To the astonishment of much of the art world, Johns appeared as the Cowardly Lion, sitting on a large rock, wearing a heavy overcoat and looking

extremely dire. Some artists were upset by this. Johns had come to represent for them the incorruptible exception, "an example of how to lead your life without letting wealth and celebrity and fashion take over and subvert your work," as one of them said to me. This sort of reverence is probably quite boring to Johns, who sometimes goes out of his way not to be bored.

JOHNS BEGAN GOING to St. Martin in 1969. He bought a piece of land there in 1972, on the French side of the island, and had Philip Johnson, a friend, sketch out a house, which two younger architects then built. The house is a stucco rectangle with a bedroom, a bath, and Johns's studio at one end, coming off a forty-foot living room whose sliding glass doors overlook a wide lagoon. When my wife and I went down there last winter, Johns insisted on picking us up at our hotel in his tiny Renault Twingo: The roads, he indicated, were too hazardous for us to navigate on our own.

He also insisted on making dinner for us. While he busied himself in the kitchen, behind a counter at one end of the all-white living room with its cathedral ceiling, we took in the view from the covered veranda that runs the length of the house, listened to *The Magic Flute* on the stereo, and studied the room's single art work, a tall, relatively recent Johns canvas called *Bush-baby*. The painting, which looked to be about six feet high by four feet wide—Johns didn't know the exact dimensions—was divided lengthwise in three sections: Harlequin-patterned form on the right, gray encaustic brushwork in the center, and colored circles on the left. Attached to the frame were two tall wooden slats, upright and overlapping, with a length of string hanging down from one of them. The string moved gently in the breeze coming through the sliding doors. Like the series of

"catenary" paintings in his 2005 New York show—so called because each contains a length of string whose ends are attached loosely at two points, forming what mathematicians call a catenary curve—this one was empty of recognizable images. To me, it looked very quiet and meditative. I asked why it was called *Bushbaby*. Johns said that he thought bush babies were small nocturnal animals found in Africa, animals "with monkey-like features and very large eyes." He said that this painting was a new version of an earlier, smaller one with the same title. But why the title? "It's a personal association," he said.

The self-imposed solitude at the core of Johns's life is more apparent in St. Martin. James Meyer, his studio assistant in Connecticut, comes down at the start of Johns's stay each year, which usually lasts from just before Christmas to March; he helps Johns set up the studio, stretch canvases, and so forth, but then he leaves, and Johns is alone in the house. Friends come for brief visits—he has a guest house—but you sense that he is perfectly comfortable with no one around. Although he keeps to no regular schedule, he gets up early and usually works for several hours every day. For recreation, he swims in his pool, or he gardens. The round, slatted-wood table in the living room is piled with books that people have sent him: *Kafka on the Shore,* by Haruki Murakami; *The Liberal Imagination,* by Lionel Trilling; *The Complete Poems of Ted Berrigan; Cézanne and the Eternal Feminine,* by Wayne Anderson. He often wakes during the night and reads.

Dinner was fricassee of chicken and vegetables, served in its own broth, with couscous, red wine, and salad from the garden. Johns drank water. He hasn't touched alcohol for the last year. In November 2005, he was driving two other people home from a Thanksgiving dinner in Connecticut when his car skidded out

of control on an iced-over hill and hit a utility pole. The other people were not seriously hurt, but Johns broke several ribs.

I asked him if he had seen the recent show of Rauschenberg's work from 1954 to 1964, the influential combines, which opened last December at the Metropolitan Museum. (I knew that he had not been to the opening; although Rauschenberg and Johns can't help running into each other occasionally, they tend to avoid doing so.) Johns had gone before the show opened. "My first thought was that it was wonderful," he said. "Next thought was that the unfortunate thing about those early works is that they take on a quality of being relics. Originally, they were fresh, immediate, not precious—things apt to be overlooked, picked up here and there, like a minute ago. Maybe that's not important; maybe all work goes through this kind of thing."

Johns is somewhat more willing than Rauschenberg, these days, to discuss their early relationship, but the curtain lifts only so far. At dinner that night, when I mentioned Cage's comment about not needing any other friends, Johns nodded, and said, "Well, for a while the four of us were a very interesting group—at least, to ourselves—because there was complete and open communication, and different levels of experience and knowledge. I've certainly never experienced anything like that before or since."

I also brought up something Cage had written in his essay on Johns, that the atmosphere of his work was heavy rather than light, and that this was "something he knows and regrets." "I haven't read that piece in years," Johns said. "I'm not sure what he meant, but I think it's fair. There is a kind of . . . hesitation, or feedback, in my work that would give it the sense of heaviness rather than lightness. It doesn't just move forward gracefully." And would he prefer it if his work didn't have this heaviness? "Oh, I would. I

think anyone would prefer to move ahead in a cheerful way, without hesitation. One would like to have a life that caused no confusion." He glanced across at my wife and added, mischievously, "Not you, Dodie!" Starting to laugh, Johns said, "No, the basic question here is whether you think life is a wonderful condition, or not. I don't, particularly. Amazingly enough, it's not entirely to my liking."

THE NEXT DAY, we had lunch at the Claude Mini-Club in Marigot, a restaurant where Johns often goes by himself. He wore a white shirt, baggy white pants, and sandals. The Mini-Club is open on three sides, with terrible murals and a good view of the harbor. The waiters all knew him, but nobody else did. At lunch, I had hoped to get him talking about Duchamp. Of all the artists Johns has learned from or made use of over the years, Duchamp seems to be the closest to him in spirit. What Johns wrote in a brief memorial statement on Duchamp, in 1968, that he had moved his art "into a field where language, thought, and vision act upon one another," applies just as well to his own work, and clear references to Duchamp's ideas and images run like a leitmotif through Johns's paintings, drawings, and prints. On this occasion, I reminded him of something else he had written about Duchamp, that "it may be a great work of his to have brought doubt into the air that surrounds art." At first Johns said that he didn't remember what he had meant by that, but then he mentioned the readymades, common manufactured objects such as a snow shovel or a bottle-drying rack, which Duchamp had elevated to the status of art simply by choosing and signing them. "You don't know what they are," Johns said, "and I would say he didn't, either. He was not

concerned with knowing what they were. He did it out of good-will, and a feeling of wit and optimism, but basically they convey a kind of pessimism, or what I would call doubt. You could say they became expressions of a fact of life." Such as the fact that there can never be a valid definition of art, as Duchamp always maintained? "Well," Johns said, "there can't be a permanent definition of anything, it seems."

JOHNS AND RAUSCHENBERG met Duchamp in 1959. They both made paintings in homage to him soon afterward, but Johns has always made it clear that they saw Duchamp and his wife, Alexina (called Teeny), no more than a dozen times in all, and that he, Johns, would certainly never have presumed to talk about art or ideas with Duchamp. He particularly treasures a memory of the night in 1959 when he and Rauschenberg and Duchamp and Teeny had Christmas dinner together in Chinatown. During the meal, Duchamp said he was not happy with his own replies to a recent interviewer, who had asked him why he quit painting. (Duchamp's last painting on canvas was dated 1918.) As Johns remembers it, Duchamp had told the interviewer that it was "because of dealers and money and various reasons. Largely moralistic reasons. And then he looked up and said, 'But you know, it wasn't like that. It's like you break a leg—you didn't mean to do it.'" What Johns loved about this, I think, was Duchamp's denial of conscious intention as a ruling principle. It coincided with his own feeling that an artist does what he is helpless not to do.

Driving back from the restaurant, Johns wanted to get to a drawbridge before three o'clock, the hour when it's raised. A red light was flashing at the bridge entrance. The Twingo sailed

through it. A man in some sort of uniform yelled at us. Johns shouted out the car window, "Sorry, I didn't see it," and kept on going. Caribbean justice did not descend.

At the house, he showed us around the garden and gave us iced lemongrass tea under a tiled-roof shelter overlooking the swimming pool. I asked him whether, as he grew older, there had been any changes in the way he went about his work. He was silent for some time, looking away and chewing on some ice. "I don't feel overloaded with ideas that I have to express urgently," he said. "But I don't know that I've ever felt that way." Did he think that the impulse to keep on making new work might someday run out? "Not that it might run out. I just don't feel the pressure of it now. I feel more freedom to do anything I might think to do, but my range of choices may be more limited. I'm old enough that I can see in my work things other people might not see—limitations, repetitions, states of mind that seem limited—and sometimes I have a sense of those things before, or while I'm working."

There was another long pause, punctuated by sounds of vigorous ice-crunching. "Part of working, for me," he went on, "involves anxiety. A certain amount of anxiety, or hesitation, or boredom. Frequently, I think for a long time before I do something, even though I've decided over the years that this is absolutely pointless. Actually, when one works, one comes to a solution much more quickly than when one sits and thinks. But I can't avoid it. I just sit and wonder. I don't think that used to happen, but I'm not sure."

A brief rain shower sent us inside. Standing at the windows, looking out over the lagoon with its surrounding green hills, Johns spoke of how much he enjoys the rain here. "It's so beautiful,

like a curtain in front of the mountains," he said. "You see it coming, and you see it pass."

—*December 11, 2006*

The National Gallery show in 2006 and a more recent exhibition called "Jasper Johns: Gray," at the Art Institute of Chicago and the Metropolitan Museum of Art in New York, seem to have silenced, at least temporarily, the anti-Johns backlash. Writing in The Times *about the "Gray" show, which surveyed the artist's career through his obsessive, varied, and infinitely complex manipulations of that "shadow" color, Roberta Smith called it "a supremely clear account of Mr. Johns's maturation from brilliant, methodical young artist to a deeper, more lyrical, less predictable one." Being predictable, after all, has never been one of Johns's concerns.*

JEFF KOONS

If art is ever delivered from the grip of postmodern irony, a large share of the credit will go to Jeff Koons. You may think I'm joking. Jeff Koons? The artist whose industrial-scale replicas of balloon animals, gift-shop tchotchkes, and other commercial kitsch now sell for upward of $2 million? If there is irony here, it is lost on the artist. "In this century, there was Picasso and Duchamp," Koons announced in 1990. "Now I'm taking us out of the twentieth century."

In the Chelsea commercial building that he calls his studio, Koons currently employs more than eighty people. Six or seven of them were sitting before large-screen computers in the outer office when the artist met me there recently. Koons, who is fifty-two, looks very much the same as he did at thirty: trim and boyish, with neatly barbered brown hair and the unfinished features that seem to be peculiarly American. He was eager to show me around. In a large room behind the office, more than twenty new

paintings were in various stages of completion. They would be shown in June at the Gagosian Gallery in London, and the studio was on a tight schedule. Each canvas in progress had three people working on it. They concentrated on very small areas at a time, copying from digital printouts in which the colors were marked and identified by number.

Most of the new paintings, which were very large, displayed a kaleidoscopic mixture of computer-based images—inflatable toys, cartoon monkey heads, a freight train, a horse-drawn carriage, landscapes, steam whistles, naked girls—interlaced with abstract passages, and presented in a rollicking collage style that included overlays of stenciled dots. It was hard to make out what was going on in some of them, and Koons's running commentary, enthusiastic but disjointed, wasn't much help. "That's a 'Triple Elvis,'" he said, of a canvas with three nearly life-size images of a recent *Playboy* centerfold model, whose facial expression reminded Koons (somewhat miraculously, I thought) of Elvis Presley. "I liked Elvis," he said, "and I liked using the reference to Andy Warhol's Elvis paintings. And the lobster there"—a swimming-pool toy in the shape of a lobster—"that refers to Dali, and to Duchamp." Several paintings were dominated by menacing images of the Incredible Hulk, all green skin and purple tights. "The Hulk represents for me both Western and Eastern culture, and the sense of a guardian, a protector, and at the same time this sense of power," Koons said, quite seriously. "All these paintings are about power. I want to connect people to humanity, and hopefully the parameters of everyone's life can become larger."

Fine with me. While I tend to agree with the critics who say that Koons's best work is in three dimensions, I liked the bursting energy and declarative precision of these paintings. The colors

were hard and bright, with many subtle gradations. There was an impersonal intensity to the work, a flat, in-your-face authority that was nevertheless unmistakably Koonsian; it makes James Rosenquist, whose subject matter and collagist technique are somewhat similar, look by comparison like an intuitive artist of an earlier period. Koons himself rarely touches brush to canvas. His first idea for a painting may be a magazine photograph or one that he takes himself, scans into a computer, and manipulates or combines with other images; from there to the final sign-off, he controls every step in what is essentially an industrial process, prowling the studio with Argus-eyed attention to the exact carrying out of his most minute decisions. (There is no room for individual initiative in this shop.) I'm also okay with Koons's often perplexing references to other artists, having learned that, like many of the weird-sounding things he says, they usually have some basis in logic. There are no lobsters in Duchamp's work, so far as I know (there are in Dali's), but then, as Koons tells you, the arc formed by an inflatable lobster's tentacles can suggest a handlebar mustache, and one of Duchamp's famous actions was to draw a mustache on a reproduction of the *Mona Lisa*. Duchamp also invented the concept of the "readymade," a common object promoted to artistic status, and the readymade is the Rosetta stone of Koons's art.

The painting studio was only one of many in the House of Koons. He led me, through labyrinthine passages, on a tour of the others, seven in all, where squads of assistants polished and spray-painted, measured and calculated, made molds, removed imperfections, scanned dimensions into computers, and devoted other skills to the perfect replication of cheap plastic toys. The obvious analogy to Santa's workshop fades when you realize that months and sometimes years are needed to bring these objects

to the level of smoothly detailed perfection that Koons requires. In one area, there were several sculptures of a gaily painted caterpillar suspended from eight red-link chains; the model was clearly a child's pull toy, but Koons called it "an ecstasy piece," whose chains might suggest "the pain and passion of a martyred saint." Koons's references to the spiritual dimensions of his art take some getting used to. A few years ago, he told me, "I've always wanted the viewer to feel a sense of security in the work—a kind of spiritual trust in that image or object."

On the return trip through the labyrinth, he paused to demonstrate a small-scale model of his latest sculptural project, a full-size re-creation of a 1943 Baldwin locomotive, hanging nose down from an industrial crane. Koons plugged in an electrical cord, and the toy locomotive's wheels slowly began turning. "This is Wilshire Boulevard right here," Koons said, excitement quickening his voice. (The plan is to situate the suspended locomotive at the entrance plaza of the Los Angeles County Museum of Art, on Wilshire.) "And this is the big new contemporary-art building, designed by Renzo Piano. So, to get into the museum, you'll go under the train. It will operate three times a day—at noontime, and at three o'clock, and at six o'clock." The model locomotive's wheels were speeding up. Its brass bell tinkled, and a curl of smoke emerged from the smokestack while Koons continued to describe the future behemoth. "The locomotive is seventy feet long; it's the 2900 series, among the largest steam engines ever built. The wheels are eighty inches tall. The real thing weighs five hundred thousand pounds—ours will be lighter than that, but the outside will look absolutely identical to the original. Every rivet, every bit of texture will be authentic." The wheels were racing now. Smoke poured from the tiny smokestack, and the whistle sounded a mournful *whooo-whooo*. Almost

immediately, the locomotive began slowing down. "The running time is five minutes," Koons said. "Kids will want to lie down under it. Nothing has ever been more powerful than the image of a steam engine."

The train project could cost as much as $20 million. For an artist like Koons, whose vast ambition and ruinous needs have severely strained the resources of several dealers and nearly bankrupted him, this obstacle seemed surmountable. The train, he said, would be up and running in two and a half to three years.

ALTHOUGH I MET Jeff Koons in 1986, I didn't really get to know him until 1990, at the Venice Biennale, where he was showing the first fruits of his "Made in Heaven" series in the Biennale's *aperto* (or "open") exhibition. These sexually explicit, photo-based images of Koons, buck naked, in a variety of erotic embraces with the Italian porn star La Cicciolina, who wore white net stockings, a filmy bustier, and a floral headdress, attracted awed crowds. So did Koons and Cicciolina. Hordes of paparazzi followed them through the streets, begging for poses and autographs. In Italy at that time, Cicciolina was a much bigger attraction than Koons. She was serving as a deputy in the Italian parliament, but she also found time to continue the stage performances, some of them involving a compliant snake, that had made her Italy's top porn goddess.

Hungarian-born—her real name is Ilona Staller—she had white-blond hair, dark eyebrows, and pale, luminescent skin. There was an unexpected sweetness about her, a delicacy that Koons had responded to in the three paintings and one large, carved-wood sculpture on view at the Biennale, all of which seemed to be adrift in flowers, birds, butterflies, and rosy colors.

She had never heard of him before they met. After seeing her picture in two European magazines, he had flown to Rome, watched her perform, and gone backstage to suggest that they collaborate on what he then thought would be a movie. She agreed. A series of strenuous photographic sessions became the basis for the "Made in Heaven" paintings and sculptures, in various media. The movie never got made, but Koons and Staller fell in love, or anyway he did. He courted her through an interpreter: She spoke very little English, and Koons, who spoke about four words of Italian, kept trying to communicate directly by speaking English with an Italian accent. The interpreter had to be let go, because she fell in love with Koons. He proposed to Staller in Venice that spring, and they were married a year later.

When "Made in Heaven" was shown in New York, in 1991, at the Sonnabend Gallery, the reviews were venomous. Some of the post-Venice images were a lot more explicit than the earlier ones—the gallery posted a warning notice about the hard-core subject matter—but that wasn't what riled the New York critics. It was what they saw as the artist's lust for notoriety, and his loopy rhetoric; he kept saying that his goal was to remove fear and guilt and shame, so that when viewers saw these images they would be in "the realm of the Sacred Heart of Jesus."

"Just when it looked as if the '80s were finally over," Michael Kimmelman wrote, in *The Times*, "Jeff Koons has provided one last, pathetic gasp of the sort of self-promoting hype and sensationalism that characterized the worst of the decade." The show coincided with a sudden cooling in the overheated art market of the late 1980s. Sonnabend had trouble selling the works (no museum would go near them), but what bothered Koons most was the sense of being misunderstood. "Sex with love is a higher state," he told an interviewer. "It's an objective state, in which

one lives and enters the eternal, and I believe that's what I showed people. That's why it wasn't pornographic." Although the viewer might conceivably miss the higher state invoked here, the images were curiously non-arousing; they lacked the necessary artlessness of true porn. Koons, at any rate, was severely disheartened. "I'm always very upset if somebody doesn't like my work, because I never want to lose anyone," he told me. "I feel like I've failed if I do that."

He made up for the failure soon enough. A year later, in 1992, his *Puppy* made its début in the German town of Arolsen. A monumental, forty-foot-high topiary likeness of a West Highland Terrier, with thousands and thousands of blooming flowers blanketing the steel-and-wood structure, it has been re-created since then in Sydney and Bilbao and at Rockefeller Center, and in each place multitudes of viewers (and even art critics) have surrendered to its appeal. " 'Puppy' renders all who see it equal," Jerry Saltz wrote in *The Village Voice*. "It is the rare work of art that laymen can talk about with the same degree of confidence and authority that those in the art world bring to it." Koons, in full evangelical mode, said that he "wanted the piece to deal with the human condition, and this condition in relation to God. I wanted it to be a contemporary Sacred Heart of Jesus."

Aware that Koons's only brushes with religious observance had occurred during sporadic, seasonal visits to a Lutheran church in York, Pennsylvania, when he was growing up, I asked him what he meant by "the Sacred Heart of Jesus." "It doesn't come from any religious background," he conceded. "Just from sort of absorbing Baroque culture, Catholicism in church imagery." Some of the erotic poses that he and Staller assumed in "Made in Heaven" were based on European paintings of saints in ecstasy, as he pointed out, and in one of them he was channeling

Michelangelo's Adam. Whatever the Sacred Heart of Jesus meant to him (I never did get clear on that), Koons was quite serious about the shame-and-guilt thing. "When I look at a painting like *Ilona's Asshole,*" he said, referring to one of the raunchier examples in the series, "I'm very proud of it. I think it's a really wonderful painting. I like that it's close up, because guilt and shame about the body, especially when seen close up, have a certain intensity. If you look at Ilona's ass, there are pimples on it, and there's such a sense of humanity in that, and oneness with the world and with nature."

Jeffrey Deitch, a close friend who became Koons's dealer after Sonnabend, couldn't understand the marriage to Staller. Koons himself says that Ileana Sonnabend and his father had warned him against it, fearing the worst. "Jeff had confused fantasy with reality," Deitch said. "It was as though he felt the 'Made in Heaven' work wouldn't be authentic unless they were married. It was a moral issue for him." The marriage began to fall apart even before their child, Ludwig, was born, in 1992. Staller wanted to keep on performing. (She also offered, publicly, to have sex with Saddam Hussein in exchange for his releasing foreigners held in Iraq.) And then, after divorce proceedings had begun in New York, Staller spirited baby Ludwig out of the New York town house that Koons had rented for them and took him to Rome. Koons spent more than a decade and millions of dollars in legal battles over custody, which the court here had awarded him, but the Italian court eventually ruled in Staller's favor. For the past few years, Koons has been unable to see or talk to his son.

"When I look back," Koons told me recently, "I realize that I loved Ilona very much. And I was really embracing the philosophy of my work, which tries to tell the viewer that everybody's cultural history is perfect, and should be accepted

without embarrassment. Accepting Ilona's history was an example. But you can't change somebody who was involved in the profession she was involved in." Did you think you could? I asked him. "I didn't want to change her," he said quietly. "I thought she wanted to change."

IT TAKES THREE and a half hours to drive from Manhattan to Red Lion, Pennsylvania. Jeff Koons, his wife, Justine, whom he married five years ago, and their three young boys—Sean, who is five, Kurt, three, and Blake, eighteen months—make the trip nearly every weekend, winter and summer, to a hundred-and-seventy-acre farm that once belonged to Koons's maternal grandparents. Koons bought back the property two years ago, and he is restoring the houses, the barns, and the grounds to look (with a few additions) the way they did when he was a boy: the same bright-yellow exteriors, with red trim; the same low stone walls defining the fields and rolling hillsides. "It's really about letting my family bathe in a culture that's very different from what they experience in New York," he says, meaning the rural, middle-class culture that he bathed in so happily as a child.

Koons, who was born in 1955, spent his first years in York, an old industrial city a few miles north of Red Lion. His father, Henry J. Koons, was an interior decorator who had his own furniture store there. "My parents were very happily married," Koons recalled. "My father worked hard, and I always had the sense that we were thriving, enjoying social mobility." (Henry Koons's father had been a streetcar conductor; the covered-over tracks of his trolley line ran right past the suburban house that Jeff and his family moved to when he was four.) In Jeff's early memories, visits to the farm are still vivid. Ralph Sitler, his maternal grandfather, was a significant figure in York, a successful

merchant who got into real estate and politics and served as city treasurer. He kept ten or twelve show horses in the barn, and he also owned vintage carriages, which Jeff remembers riding in, all dressed up in a child-size tailcoat and top hat, during the Colonial Days parade. "I grew up feeling a bit like a young prince," he said.

He began drawing and painting when he was very young. "I always believed," he said, "that I got into art because my parents encouraged me to feel I had more skill in that area than my sister"—Karen, who is three years older. (She is now an environmental health-and-safety manager at a plastics company.) His father found him a teacher when he was eight, a woman in her eighties, and every Saturday he went to her basement studio. At the public school he attended, his main focus was art class. He never cared about sports. "At a certain age, I think in sixth grade, I began to feel that maybe all this art activity seemed effeminate," he said, "so I stopped taking lessons." He resumed them a few years later. His father hung Jeff's imitations of Old Master paintings in his store, and customers bought them, for several hundred dollars apiece. When it was time for college, Koons chose the Maryland Institute College of Art, in Baltimore, because "I didn't know anything else than art to do."

His first day there, in 1972, the whole class went to the Baltimore Museum of Art. Seeing paintings by Manet and other artists whom many of the students recognized right away, Koons realized that he knew nothing about art history. "I didn't know who Braque was," he said. "When I was younger, my dad never taught me football, so when I tried out for the football team the other kids all knew something about the game, but I didn't. This art experience could have been the same for me. I might have left art school. I thought about going back and raising

cattle—my girlfriend's father was a farmer. But I didn't. That was a defining moment. Somehow I was able to accept my own cultural history."

His youthful self-confidence restored, he contrived to meet Salvador Dalí. A coffee-table volume on Dalí was one of the only art books in his parents' house, and Koons, who'd spent hours looking at it, had asked his mother if she could possibly buy him a Dalí print. She discovered that Dalí spent part of the year at the St. Regis hotel, in New York, and so one day, early in his freshman year, the seventeen-year-old Koons called the St. Regis and was put through to Dalí. The upshot was that a week later Koons got on a bus to New York, to visit the artist. "He met me in the lobby," Koons recalled, "wearing that majestic fur coat and carrying a black cane with a silver handle. He said he had an exhibition at Knoedler"—his uptown gallery—"and would I like to see it? I told him I would love to. We went up separately to Knoedler. As I was looking at the work, he came over and asked if I wanted to photograph him, and I did; he stood in front of the painting that has a tiger and three heads of Lenin." (A year ago, Koons was able to buy a Dalí study for this painting.) "I just remember leaving New York that day feeling that this type of life was accessible."

Koons's student paintings and drawings, not surprisingly, were "mainly Surrealism, things I dreamed the night before." He was in love with his college girlfriend, and when she told him she was pregnant, he said that he wanted to marry her and rear the child. Her parents intervened, insisting that they put the baby up for adoption. Koons and the girl drifted apart. After three years in Baltimore, Koons took his last year at the School of the Art Institute of Chicago. Here, studying with the Chicago painter Ed Paschke, he realized that he was bored by subjective art. "I no

longer wanted to paint what I'd dreamed the night before," he said. "I wanted much more out of art than that."

A Patti Smith album that he heard on the radio (*Horses*) triggered the decision to move to New York. He settled there in early 1977 and got a job almost immediately, selling admission tickets at the Museum of Modern Art. "It was very low pay, but I had access to the collections, and I just met people all day long," he said. Seeing works by Duchamp, Matisse, Miró, and other modern masters was enthralling enough, but meeting people, talking to them, persuading them to take out or upgrade their museum memberships—this was something he could really do. Koons, like Warhol, is a gifted salesman, but in his case the gift is generic: the all-American boy pushing his product. As a pre-teen in York, he had earned pocket money by selling candy or wrapping paper or other items; one of his parents would drive him to a neighborhood and wait while he went door to door. "I always enjoyed that," he recalled. "I felt I was meeting people's needs." At MOMA, he attracted considerable attention by wearing polka-dot shirts, floral vests, big bow ties (sometimes two at once), and, occasionally, an inflatable plastic flower. Sometimes when an important personage was visiting the museum, Richard Oldenburg, the director, would come by and suggest, gently and somewhat apologetically, that Koons go out for an hour or so, but by and large the staff considered him a big asset. "People loved me," he told an interviewer, "and I doubled the membership rolls. The trick is to be outrageous but not offensive."

"WORKING AT THE MODERN, I knew that I wanted to try to add something to the Duchamp tradition," he said. His approach to this cheerfully immodest goal took the form, initially, of low-rent readymades: inflatable plastic toys or flowers (like

the ones he had worn to work at MOMA) resting on and backed by hardware-store mirrors. He progressed to small kitchen appliances affixed to fluorescent light tubes, and then to brand-new, top-of-the-line vacuum cleaners and rug shampooers encased in brightly lit clear plastic vitrines. His talent for self-promotion, which had blossomed at MOMA, helped him place a few of these objects in downtown group shows, and in 1980 Marcia Tucker, the director of the New Museum of Contemporary Art, did a small installation in the window of the museum's building, on Fifth Avenue.

By then, Koons had quit his job at the museum and was selling mutual funds. He got his broker's license and worked at First Investors Corporation, because he needed more money to make his art: a two- or four-vacuum-cleaner piece cost him up to $3,000. Koons spent his nights at Max's Kansas City and Fanelli's Café, and he knew a lot of artists and dealers. Julian Schnabel and David Salle, rising stars of the neo-expressionist generation, recommended him to their dealer, Mary Boone, who took him on provisionally, but when she didn't offer him a solo show soon enough he walked out. His next prospective dealer, Anina Nosei, sold a vacuum-cleaner piece for around $5,000 but then told him (as Koons recalls it) that she had lost interest in his work. Flat broke and about to be evicted from his apartment, Koons retreated in shame to the house his parents had moved to in Bradenton, Florida, when Henry Koons retired. (His mother, Gloria, now lives in Sarasota; Henry died in 1994.)

Six months later, he was back, selling commodities at the Siegel Trading Company and then at Clayton Brokerage. His sales pitch on the telephone was so vibrant that he often convinced himself, and bought, on his own account, shares in copper or other metals that ended up losing him large sums. "It was very,

very high pressure," according to Andy Moses, another young artist-trader, who sat next to Koons at both brokerage houses. "Everything was on a commission basis, so if you didn't perform you didn't earn a dime. Jeff was such an optimist—people just wanted to be part of that personality." Selling commodities earned him enough to finance his next series of works, basketballs submerged or partly submerged in tanks of water. (The Nobel Prize winner Richard Feynman was one of many physicists he consulted, by telephone, to arrive at the correct proportions of distilled water and saline water that would keep them stable.) What he called the "Equilibrium" series—basketballs in tanks, framed Nike posters featuring professional basketball stars, and flotation devices (an aqualung, a rubber dinghy) cast in non-floating bronze—was shown in the spring of 1985 at a new East Village gallery called International with Monument. It was Koons's first solo gallery show. Although the boundaries of sculpture had been expanding for decades, no art gallery had shown anything remotely like this, and quite a few people, artists especially, took notice. (Seven years later, Damien Hirst rose to fame with a tiger shark in a tank of formaldehyde.) Koons quit selling commodities to concentrate on art.

For a year or so, he worked mainly in stainless steel, a material whose impersonal, reflective brilliance he found "intoxicating." His second show at International with Monument, in 1986, featured stainless-steel casts of liquor paraphernalia, including a travel bar and a model train whose seven cars held a fifth of Jim Beam bourbon each. The "Statuary" works that came next were readymade novelty items, recast in stainless steel and related only by their kitsch origins: a dime-store bust of Louis XIV, a Bob Hope figurine, a lecherous doctor and his female patient, a refulgent stainless-steel bunny similar to a plastic one that he

had used in one of his early inflatables. All these items were issued in editions of three, plus one artist's proof. Charles Saatchi, the influential British collector, paid $75,000 for a cast of the bourbon train. The critics were fascinated. Reviewing the - eye-opening four-artist "Neo-Geo" show, at Sonnabend in 1986, in which the "Statuary" pieces made their début, the *Times*'s Roberta Smith praised Koons for "creating works of a strange, disembodied beauty that expand our notion of what sculpture is and means," and went on to cite his *Rabbit* as "a dazzling update on Brancusi's perfect forms."

Koons, whom I met around this time, struck me as an odd, amorphous presence, someone who was either amazingly naïve or slyly performative. In his soft-spoken way, he could sound like a motivational speaker; this made me (and a lot of other people) wonder whether I was talking to the real Jeff Koons, or whether there even was one. I decided that he was on the level, and that he had virtually no sense of humor, about his work or anything else. Nobody could figure out what he was up to. Was he satirizing the mass-market culture that produced these tawdry souvenir-shop items, or celebrating it? When the same question was asked about Pop art in the 1960s, there were similar uncertainties. Warhol said that Pop was about "liking things," but people tended to assume that everything Warhol did or said was in some sense a put-on. Pop harbored enough irony to give it the benefit of the doubt, at any rate, and only the mossback formalists condemned it as pandering to mass culture. Koons seemed to strive for art world approval while reaching beyond it, to a mass audience whose tastes he shared. The academic critics managed to avoid commenting on his work at all; to this day, it has been invisible to them. Yet there was no denying the fascination of his perfectly rendered objects. Casting

them in stainless steel seemed both to glamorize and to dignify them. The bright-silver bunny, with its evocative carrot, really did look like a Brancusi.

The next show, which Koons called "Banality," made him the art world's new superstar. Opening simultaneously at three galleries, in November 1988—Sonnabend, in New York; Max Hetzler, in Cologne; and Donald Young, in Chicago—it offered twenty fairly large sculptures in wood or porcelain, handmade by traditional craftsmen in Europe. Koons had spent many months tracking down the best wood-carvers in Germany and Italy. He had visited more than two hundred artisan workshops. And what had he inspired his master craftsmen to create? A pair of carved-wood, clothes-wearing "Winter Bears," grinning and waving their paws. A semi-nude girl embracing a somewhat uneasy-looking Pink Panther. A nearly life-size, gold-and-white ceramic likeness of Michael Jackson with his pet monkey. And, perhaps the key image, a wood carving of two cherubs and a human child (Koons himself) coaxing a very large pig to move forward. This one was entitled *Ushering in Banality.*

The critical reaction was mixed. Hedging his bets in *The Times,* Michael Brenson wrote that "the blend of sincerity and scheming, cleanness and crassness, chastity and corruption, presents an impossible contradiction." Klaus Kertess, in the art journal *Parkett,* hailed "the tonic innocence of pure tasteless-ness." Once again, many viewers couldn't decide whether Koons was serious or kidding, but by now that hardly mattered. What-ever you thought of it, the work registered in the public's con-sciousness, in some cases indelibly. A few critics and others saw the show as part of a new, object-oriented wave of Pop art and, as such, a bracing alternative to the turgidities and bombastitudes of neo-expressionism. "Banality" earned everyone a lot of money,

at any rate, and unleashed a flood of Koonsian rhetoric, recorded in countless interviews. He announced that everything in the show was a metaphor for the viewer's shame and guilt. The average person liked banal imagery, but art, "which can be a horrible discriminator," had made people ashamed of their tastes.

It is possible to argue that no real connection exists between Koons's work and what he says about it. I am not at all sure that the viewer Koons talks about feels guilty about his or her tastes, or that such a person looks at his work and feels better. I decided long ago that Koons believes what he says, though, and I suspect that his convincing (and obsessive) sincerity, with its roots in bourgeois middle-class values and its rejection of postmodern art theories, is a factor in the magnetic power that these absurd images—some of them, anyway—can exert over a wide gamut of viewers. Writing about *Rabbit* in 2003, Kirk Varnedoe, MOMA's chief curator of painting and sculpture, called it "one of those very rare hits at the exact center of the target." It was, he said, "a piece where a ton of contradictions (about the artist, about the time) are fused with shocking, deadpan economy into an unforgettable ingot."

AFTER "BANALITY," Koons's time of troubles set in. He weathered the storm over "Made in Heaven" and regained his balance with *Puppy*, but then virtually sank from sight during the disastrous, decadelong struggle to complete his next, far more ambitious series of works. Called "Celebration," to honor the ardently hoped-for return of Ludwig from Rome, the series grew to include twenty large sculptures and sixteen paintings, which the Guggenheim Museum offered to show in 1996 in its new SoHo space. The subject matter this time centered on children's delights: party hats and birthday cake, Easter eggs, kittens, flowers,

building blocks, a huge, lumpy, multicolored mound of Play-Doh, and a *Balloon Dog* like the ones magicians twist together at kids' parties, except that the Koons version was stainless steel and stood ten feet high. When he started work on "Celebration," in 1993, Koons had left the Sonnabend Gallery. He wasn't happy with the way Sonnabend had handled the production of his "Made in Heaven" works, and with his approval Jeffrey Deitch, who had recently started his own art advisory business after ten years as an art consultant at Citibank, put together a consortium of three dealers—Anthony d'Offay, in London; Max Hetzler, in Cologne; and himself—to finance the new venture. Koons had rented a commercial loft on lower Broadway and he had begun hiring a workforce that eventually numbered more than seventy people and cost him more than half a million dollars a year in salaries and overhead.

By 1995, problems were mounting. The Pennsylvania foundry that Koons had engaged to cast his stainless-steel sculptures couldn't do the job to his exacting specifications; when he brought suit against them, the foundry's managers declared bankruptcy. Two million dollars went down the drain right there. Deitch and the other backers, with their initial investment fast running out, decided to sell some of the sculptures in advance to major collectors. A fabricator in California said that he could make the *Balloon Dogs* for a quarter of a million dollars apiece. Eli Broad, the Los Angeles art patron, and Dakis Joannou, a Greek construction entrepreneur whose collection Deitch was helping to form, agreed to buy them, for a million dollars each, but the fabrication costs soon escalated beyond that. Nobody had ever tried to make stainless-steel sculptures this complicated, and the technical problems were heightened by Koons's demand for flawless execution. He wanted true reflectability,

with no visual distortions; he wanted every wrinkle and fold to look balloonlike. When promised delivery dates for the sculptures were postponed again and again, Broad grew restless. Lawsuits were bruited. Deitch, who was financially hard-pressed, sold a half interest in his gallery to Sotheby's. Koons sold most of the artist's proofs of his earlier sculptures, along with several treasured works by Roy Lichtenstein and other artists, but that money went to pay the legal costs in his custody battle for Ludwig. His frequent trips to Rome for court appearances also played havoc with production schedules. Koons was so angry with Staller that at one point he destroyed all the "Made in Heaven" work that remained in his collection.

In 1999, the IRS filed a $3 million lien for back income taxes: Koons had been using payroll tax money to cover his studio rent. When "Celebration" funding ran out, the staff was laid off, leaving a skeleton crew of two: Gary McCraw, Koons's studio manager, who had been with him since 1990, and Justine Wheeler, an artist from South Africa, who had arrived in 1995 and eventually took charge of the sculpture operation. The "Celebration" project came to a halt.

Throughout this long debacle, I never heard anyone run Koons down. There is no shortage of schadenfreude in the art world, but most artists, and most dealers and collectors and museum people, seem unable to resist liking Koons and wishing him well. No one was surprised by his comeback, which began in 1999—that year, his 1988 *Pink Panther* sculpture sold at auction for $8 million, and he returned to the Sonnabend Gallery. Well aware of Koons's bottomless needs and demands, Ileana Sonnabend and Antonio Homem, her gallery director and adopted son, nevertheless welcomed him back; in all likelihood they sensed (correctly, it turned out) that he was poised for

a glorious second act—something that only he, among his generation of overpublicized artists, has so far managed to pull off. Koons, however, no longer confines himself to a single gallery. Larry Gagosian, the colossus of New York dealers, eventually agreed to finance the completion of all the unfinished "Celebration" work, in exchange for exclusive rights to sell it. "I always said, Jeff is totally ready to ruin himself, ruin me, and ruin everyone in the world for the work to be perfect," Antonio Homem told me recently. "Every time I read how cynical Jeff is, I say, 'My God, I wish he would be a little more cynical.' He's much too romantic for comfort."

Koons's turnaround was buoyed by his marriage, in 2002, to Justine Wheeler, and by the rapid-fire arrivals of three sons. Having abandoned hope of getting Ludwig back by legal means, he still thinks the boy, who is fourteen, will one day come back on his own. Meanwhile, he delights in his new family, which now includes the daughter, Shannon Rodgers, who was put up for adoption. "One of the reasons I wanted to be famous was so that my daughter could find me," Koons has said, and, sure enough, when Shannon came of age, she tracked down both her birth parents, and came to stay with Koons during the worst period of his custody fight for Ludwig. Now thirty, married and with a child of her own, she lives in New York and sees both sets of parents often.

Three successful shows at Sonnabend (which included paintings and sculptures), plus substantial profits from sales of "Celebration" works, have enabled Koons to rebound financially and to set up the Chelsea studio, where his expenses now exceed several hundred thousand dollars a month. Koons travels regularly to California and Germany, to visit the fabrication facilities that oversee production of his large-scale sculptures, and sometimes

he brings the whole family along. Last January, I arranged to meet them in Los Angeles. While the rest of the family visited the La Brea tar pits, the aquarium, and other points of interest, Koons put in long days at Carlson & Co., a plant half an hour north of LA, which does work mainly for contemporary artists.

"This is the first time I'm seeing *Play-Doh* on this trip," Koons told me, as we trekked through the hangarlike workspace at Carlson to where a ten-foot-high Matterhorn of white plaster dominated lesser peaks. (It would be painted in a rich panoply of bright colors.) *Play-Doh,* Koons explained, is one of six "Celebration" sculptures that he is casting in polyethylene, a plastic material that is used a lot in the toy industry. "It's a very joyous, very pop material, and that's what I'm really excited about," he said. "I think that when somebody comes in contact with *Play-Doh* he's going to feel very good." After walking around the huge lump a few times, running his hand over its surface textures and commenting approvingly, Koons clambered halfway up it, trying to remove one of the twenty-five separate, interlocking forms to show me how they fit together; he couldn't quite budge the section, so one of the Carlson employees brought over a ladder and got it out. "I've always loved the smell of Play-Doh," Koons informed me. He said that the idea for the piece had come to him on a visit with Ludwig in Rome, a dozen years ago. He had brought along some Play-Doh as a present. "Ludwig made a mound just like this on the coffee table, and then, with his arms out, he said, 'Daddy, voilà!'"

A few unfinished sculptures by other artists could be seen here and there at Carlson, but Koons's "Celebration" pieces took up most of the space. Many of them were enormous. In *Bowl with Eggs,* which was being remade because it "wasn't round enough," there were eleven eggs, each larger than a beach ball.

Why eleven, and not a dozen? "Because of the loss of my son, it's not complete." Two versions of *Moon,* an exquisitely shaped stainless-steel orb ten feet in diameter, were at different stages of the polishing process. Like most of his stainless-steel pieces, each version would be painted a different color, making it unique; Koons had been studying color samples for the last three months. There were two new images in the room: a fourteen-foot-high rabbit and a small plaster model for an eleven-foot swan. As with *Balloon Dog,* the rabbit's intimidating scale and glittering surface gave it a strange aura that oscillated between cuteness and menace, a surreal territory that is unique to Koons. His work has always had its dark side, intentional or not, but then you could say the same thing about Walt Disney. "I think of this *Rabbit* almost like an Egyptian sun goddess," Koons said as we stood gazing up at the piece. "It's kind of vaginal."

THE DAY AFTER my visit to Carlson, I sat in on a meeting at the Los Angeles County Museum of Art between Koons and Michael Govan, the museum's new director. Govan is the man responsible for bringing the hanging-locomotive project to Los Angeles and, now, for finding the money to build it. He views the suspended train as both an emblem and a civic monument. "You'll be able to see the crane from the Number 10 freeway, from Hollywood, from downtown," he said. "The metaphor here is to create a town square. It's like a clock tower—you'll measure your distance by it. It makes sense not only for Los Angeles but for the way we visit museums today, all the families with kids. I've always had this dream of making a museum that kids drag their parents to."

"One of the main things will be to get right under the train,

so you sense the power of that engine," Koons said. "This will not be an amusement park spectacle; it will be a visceral, realistic experience. I also think the train has a tremendous sexual quality to it, but not just masculine—there's a feminine element. For the train, because it's so phallic, the whole world becomes feminine."

When Koons discusses his work these days, the sexual references seem to have eclipsed the oddball religious ones. This may reflect his life as a family man. While the new-model Jeff Koons is more relaxed and less deliberately "outrageous" than the old one, his underlying belief system is unchanged. Sitting in the bar of the Fairmont Miramar Hotel, in Santa Monica, after dinner that evening, Koons drank beer from a bottle and talked about two new sculptures he's working on in his New York studio: precise replicas of the Liberty Bell, in Philadelphia, and of the Dictator, a Civil War siege cannon with a two-and-a-half-mile range. This led, in a roundabout way, to his remembering his time at the Maryland Institute College of Art, when he had recognized and embraced his own ignorance of art history. "I realized you don't have to know anything," he said, "and I think my work always lets the viewer know that. I just try to do work that makes people feel good about themselves, their history, and their potential."

He told a story about a stainless-steel piece he had made in 1987, called *Kiepenkerl,* for an outdoor sculpture exhibition in the German city of Münster. When his piece was being pulled from the mold at a local foundry, the workers damaged it badly. "It was a complete fiasco," Koons recalled. "We gave it plastic surgery, but what I realized, going through this experience, was that I didn't really care about objects at all. The people were the

readymade I cared about, and that was where the art was, in the viewer. What I wanted was to help people accept their own cultural background."

Was this really how he went about leading us into the twenty-first century—by reconciling ordinary people to their tastes and preferences? His reply, an amalgam of earnest clichés, post-postmodern populism, and sincere reflection, struck me as vintage Koons. "Well," he said, "I think art takes you outside yourself, takes you past yourself. I believe that my journey has really been to remove my own anxiety. That's the key. The more anxiety you can remove, the more free you are to make that gesture, whatever the gesture is. The dialogue is first with the artist, but then it goes outward, and is shared with other people. And if the anxiety is removed everything is so close, everything is available, and it's just this little bit of confidence, or trust, that people have to delve into."

Marcel Duchamp, too, believed that the viewer was an essential part of the creative process. The artist initiated the creative act, he said, but it was up to the viewer to complete it, by interpreting its meaning and its place in art history. Although Koons's take on art, taste, and history is a long way from Duchamp's, he feels very close to what he calls "the Duchamp tradition" and, for that matter, feels connected to a great many artists, living and dead—"kind of in the sense of a family," as he puts it. Lately, he has been buying Old Master paintings, and rebuilding his collection of works by modern artists he admires, including Magritte, Dalí, Man Ray, and others. In the front room of his New York studio is an easel that belonged to Roy Lichtenstein; it was given to him by the artist's widow. Six or seven years ago, Koons told me that he hoped I would go and see a sculpture of his called *Split-Rocker,* which had just been installed at the

Palais des Papes, in Avignon. "It's beautiful," he said. "It's so good, I wish Picasso or Roy could see it. I know Picasso and Roy would give me a little pat on the shoulder, because both of them would really love it."

—*April 23, 2007*

Koons's market-tested brand of populist entertainment, high-quality fabrication, and conceptual genius keeps him at the top levels of art world success, along with Damien Hirst, Richard Prince, Takashi Murakami, and one or two others. They have obliterated the aesthetic boundaries that Duchamp undermined a century earlier. Until the current, ever-expanding art market succumbs to reversals, as the experts keep predicting, their position at its summit appears unassailable. Jeff and Justine, meanwhile, are celebrating the recent birth of their fourth child, Eric Dash Koons.

JOHN CURRIN

The painting shows three young women standing close together in a room. The woman in the middle faces us directly, head held high; her dress is falling open, and her bra has been pulled down to expose both breasts. On either side of her, the other two—one nude, one wearing a chic cocktail dress unzipped in back—touch her erotically. The canvas is eighty-eight inches high by sixty-eight wide. It has the scale and pyramidal structure of a Renaissance altarpiece, but, according to John Currin, who began work on it four days ago, the immediate source was an Internet porn site. What struck him about the image, he explains, was "this completely archaic pose, like the three witches or something. I think of them as Danish, because of the thinning blond hair and the gaps between the teeth. They're not pretty enough to be Swedes. Oh, and I want to do a still-life down there in the lower right corner. I don't really know where this picture is going yet, but I think it's going to work."

Eight or nine smaller canvases are hanging in Currin's studio, on the ground floor of a building in lower Manhattan; north light comes from a row of high windows on the street side. The other paintings are in various stages of completion, and all but one show naked or semi-naked people engaged in sex acts. (The exception is an exquisitely painted still-life of porcelain plates and cups.) Currin himself is somewhat conflicted about the persistence of these images in his work in the past two years. Paintings derived from porn sites, some of them decidedly hardcore, were prominent in his solo show at the Gagosian Gallery last winter, along with a pair of wonderfully sensitive portraits of his young son and a few other, non-erotic oils. "I'd like to get the sex thing over with, but I realized I'm not done with it," he tells me now. "You should never will a change in your work—you have to work an idea to death. I often find that the best things happen when you're near the end." The new paintings will be shown in March at the Sadie Coles gallery, in London. What strikes me about them now is their beauty. Most pornography today is photographic, and it has a coldness that suggests (to me, anyway) an underlying contempt for adult sexuality. Currin uses the motif, but by taking it into another medium he changes the temperature; the sensual pleasures of oil painting evoke what's absent in the photographs. "There's a kind of comedy in making paintings of this," he tells me. "Pornography is so associated with photography, and so dependent on the idea that the camera doesn't intercede between you and the subject. One motive of mine is to see if I could make this clearly debased and unbeautiful thing become beautiful in a painting."

More than any artist I know, John Currin exemplifies the productive struggle between self-confidence and self-doubt. Forty-five years old, tall (six feet three inches), and good-looking in the

open-faced American way, he currently rides a wave of success that has drowned out most (but not all) of his early detractors, and brought him international acclaim. His technical skills, which include elements of Old Master paint application and high-Mannerist composition, have been put to use on some of the most seductive and rivetingly weird figurative paintings of our era—an era when figurative painting has gradually returned from the periphery to the mainstream. Portraits, nudes, and genre scenes have occupied most of his attention so far, and several critics have noted Currin's increasing mastery of these antique forms. Arthur C. Danto, writing in *The Nation* in 2004, called him "a virtuoso of a style and manner that would have been admired in Ferrara or Parma in the 1550s," and went on to describe him as "one of the brightest art stars of the early twenty-first century." Not every critic would agree with this assessment, but few have been harder on Currin than he tends to be on himself. "I've always felt insecure about being a figurative artist, and about being an American painter," he told me last fall. "To me, oil painting is inherently European. My technique is in no way comparable with that of a mid-level European painter of the nineteenth century. They had way more ability and technical assurance. It's like learning to play tennis when you're four or five years old: you know things you don't even know you know. I suppose in the end what I do is my version of being progressive— that I thought my only chance was to regress in the face of everything. I wanted my paintings to be difficult; I just didn't think they'd be difficult in this way."

The basic design of the new painting, his largest to date, was sketched out first in a grisaille undercoat of white, raw umber, and a binding agent of sun-thickened linseed oil, and Currin has

just begun to build up the flesh tones. The faces of the women have very little detail as yet. To give me an idea of where he's going, he points to a small oil-on-canvas study that hangs just to the right of the new painting; although quite rough, it has more detail and hints of color. "Actually, I posed for the body," he says, indicating the left-hand figure in the painting. He often uses his own hands, arms, or face (viewed in a mirror) for the initial image, in preference to hiring live models. "When I get people to pose for me, it almost never works," he explains. (This does not apply to his wife, Rachel Feinstein, whose wide-set hazel eyes, pearly skin, and heart-shaped face he has used again and again in his paintings.) "Not many people are good at modeling, and I always change things around anyway. I made up the face on the right. The middle figure might become less realistic and more ideal, with wind blowing her hair." The central figure's face came from an advertisement for housecoats in a 1970s Montgomery Ward catalogue, which he has torn out and taped to the wall. "She shows up in other catalogues," he says. "She's got something special." In the Internet porn photograph, the middle figure is swooning in sexual transport, eyes closed and lips parted, but the model in the catalogue looks right at you and smiles broadly, and why not? Her housecoat is priced at $29.90, and never needs ironing. "At one point, I thought of using Rachel's face there, but I decided against it," Currin says. "The humiliation of the narrative is not something I want to put her face into. I'll keep myself the only person humiliated by this painting."

A FEW DAYS BEFORE this first studio visit, my wife and I had had dinner at an uptown restaurant with Currin and Feinstein, who is also an artist. Their marriage, which is now in its

tenth year, has been a dovetailing of contrary qualities whose symbiosis fascinates and occasionally irritates their less ecstatically married friends. Rachel's work—wildly fanciful laminated-plywood sculpture is her current focus—holds such compelling interest for John that last spring, when she was feeling overwhelmed by the demands of raising their two young boys (Francis is four, Hollis is two) and thought maybe she should take a year off from making art, he argued her out of it. "He said, 'I think you're a great artist, and it really means something to me that you make things,'" Rachel told me, a week or so later. (She shows at the Marianne Boesky Gallery in New York.) "One reason John chose me was because I'm a loudmouth," Rachel had also said, but at dinner that night she let John do most of the talking. Sitting on the banquette with my wife, she listened with amusement to his increasingly convoluted explanation of the origins of his porno paintings, and eventually deposited one of her long, bare legs in his lap, where he stroked it with unflagging ardor.

The origins were pretty complicated. Currin speaks rapidly and volubly, with a lot of self-corrections and asides, and sorting out the various elements took several subsequent interviews. But the gist that night seemed to be that he had gone through a long dry spell after his 2003 retrospective at the Whitney Museum, painting very few pictures and worrying about losing his way. One day in 2005, in the studio, he picked up a cartoon that a friend had torn out of a porn magazine and sent to him sometime earlier. "On the back of it, there was this faded-out picture of a woman in a corset, spreading her legs, and up in the corner was a crazy little text saying, 'I am a nuclear physicist,'" he said. Something about the image led him to start a painting based on it. "About ten minutes into that painting, I realized it was going to be good," he said. "It had no relation to my work at all.

I disliked that it was pornographic. I'd never done that, lifted the veil completely. It had been a vibe in my paintings, but never something explicit, and I worried that if I made it explicit I was going to kill the painting."

Pornography has a long history in art, from Greek vases and Pompeian wall paintings to Jeff Koons's 1990s evocations of his sex life with Ilona Staller, but for the most part, as Currin was well aware, the art it has inspired is bad art. "In art school, there's always a guy doing porno," he told me. "It's such an obvious idea, and that bothered me, but at the same time I kind of liked it, because this picture was going to be good. If there was a way to make good work out of something that's been responsible for a lot of surefire bad art, that was doubly appealing. People came into my studio and said, 'Wow, that's a beautiful painting.' It had a strange life I hadn't gotten before. But at first it didn't have much meaning for me. I liked it a lot, but I didn't know why I was making it."

A reason presented itself soon enough, in the headlines about riots in the Islamic world over twelve Danish newspaper cartoons of the Prophet Muhammad. "The response to that totally shocked me," Currin said at dinner that night. "That *The Times* decided that it was not going to show the cartoons—okay, they're terrible-ass cartoons from a quality standpoint, but the idea that those thugs get offended and we just acquiesce, that was the most astonishing display of cowardice. And also the killing of Theo van Gogh, the film director, by some jihadist in Amsterdam—all of a sudden, the most liberal societies in the world were having intimidation murders happen. That's when it occurred to me that we might lose this thing—not the Iraq war but the larger struggle." Currin had launched into one of his political rants, which sometimes make listeners think he is far more conservative than he is.

He went on at length about a book he had read called *Milestones,* by Sayyid Qutb, an Egyptian intellectual who was one of the prophets of the Muslim Brotherhood, and this led to a long riff on the powerful appeal of violence among Islamist fundamentalists, and the declining power of Western liberal values. When I asked how this tied into his making pornographic paintings, Currin talked about low birth rates in Europe, and people having sex without having babies, and pornography as a kind of elegy to liberal culture, at which point I lost the thread. "I know how rightwing this sounds," I recall him saying, "but I was thinking how pornography could be a superstitious offering to the gods of a dying race."

At any rate, as he told me in a later conversation, when the cartoon controversy was at its height he started a second painting derived from another Internet porn site. (He was still working on the one of the woman in the corset.) The new one showed a standing nude woman and a clothed woman kneeling beside her, and it occurred to him to call it *The Dane.* "Like, when they're not involved in cartoon controversies, this is what they're doing," he explained, with a laugh. "If all your freedoms are taken away, even sleazy porn becomes valuable. There are a lot of levels for me here: a parody of what I imagine Europe to be, a parody of my life before September 11, of my life before I had children, and also a picture of a sunset, this failing light of liberty. I know that seems like bullshit, but I've always liked to impose meanings on paintings that can't quite bear them. Anyway, calling that picture *The Dane* and linking it up with the Muhammad cartoon thing was very exciting for me. It gave me a direction."

When Currin's porn paintings went on view at the Gagosian Gallery, in November 2006, the reactions were surprisingly muted. It was as though nobody quite wanted to deal with the

subject matter, for fear of sounding prudish. The people whose reactions to the show Currin had worried about the most were his parents. James Currin, his father, is a retired physics professor whose dry wit and barbed, offbeat opinions have influenced John's own thinking on many subjects. A month or so before the opening of his show at Gagosian, he and Rachel had dinner at his parents' house, in Stamford, Connecticut, and when his mother was driving them to the train station afterward he finally got up the nerve to tell her that some of his new work was pornographic. Anita Currin, a gifted musician who teaches piano at her home, remembers saying, "Is it really bad?," and then thinking, when Rachel said that it showed penetration, "Oh, good grief." When she got home, Anita went into Jim's den and told him. "I always knew he'd do something like this" was Jim's response. They both went to the opening. Anita steered a quick course around the room, avoiding the worst examples. Jim headed for the gallery's terrace—it was a warm night for November—and shared nips of bourbon from his hip flask with Larry Gagosian until almost everyone else had left, before making his own tour. On his way out, he was overheard to say, "People who like this sort of thing will like this a lot." Recently, when I asked him about the show, Jim mentioned John's "screwy idea that he's backing up the people in Denmark who published those cartoons, but I think he did it because he could. I think he said, 'I can do this, and make people like it,' which is pretty much what happened. He made everybody but me like it."

THE HOUSE IN STAMFORD is where John spent his teenage years. After what he remembers as an idyllic California childhood, the family moved east in 1972, when his father switched from the Santa Cruz campus of the University of California to

the physics department at SUNY Purchase. John was ten at the time, the third of four siblings: Jeff, eight years his senior, who stayed behind in California to enter UC–Berkeley, and who is now a computer engineer in the Bay Area; Sarah, his older sister, who lives in Arizona; and Rachel, two years younger, who lives on the Upper West Side. John and Rachel were very close throughout their childhood. "John always made me laugh," Rachel remembered. "The strongest thing about John, for me, was his sense of humor."

Growing up in the Currin household was a rigorous experience. All four kids were expected to master a musical instrument. Sarah and Rachel chose the piano, and Rachel now teaches it professionally. "I took about five lessons on piano," John said, "but it was sort of hopeless in comparison with Rachel, who was playing adult stuff before her feet touched the pedals. My brother had taken violin, so I did that. I took it for years and years, but never got tremendously good." He studied with a Russian-born woman named Asya Meshberg, who lived in nearby Darien. Her husband, Lev, who came from Odessa, was an artist, a painter, whose studio upstairs John loved to visit. John had won prizes for art at the public schools he and Rachel went to, and eventually Anita Currin arranged for him to take painting lessons with Lev. He did so for three years, absorbing the nineteenth-century methods and techniques that Meshberg had learned in Odessa, and almost immediately he knew that this was what he wanted to do. "Lev told me he thought I was going to be a good artist, a famous artist," he recalled. "At that time, I thought art was something that had sort of petered out. I knew about de Kooning and Pollock, but it seemed like after that it was all performance art and things like the *Spiral Jetty,* and that completely didn't interest me. It was the romantic thing with Lev that appealed, the

studio with oil paints and birds in cages and old books and blotted still-lifes. The idea that you would be yearning to cast all that off, the shackles of ossified European culture, never took with me."

John's wanting to be an artist was all right with his parents, as long as it didn't interfere with schoolwork, but dating was something else. "Our kids were popular," his mother recalled. "Girls were calling John all the time, and nobody would have got anything done." Most nights, instead of going out, John would watch late-night movies on TV with his father. "My father didn't have buddies, and my mother worked until ten o'clock at night, teaching piano," he said. "I think I was the person he talked to the most." Jim Currin was an old-style political liberal ("Nixon was the enemy in our house," John said), but he liked to challenge received opinion, and John picked up on this. "I didn't rebel," he told me. "I think this has echoes in my artistic career—that my supposed conservatism as an artist was a carryover of my consciously not rebelling against my parents."

At Carnegie Mellon University, in Pittsburgh, which he attended from 1980 to 1984, he took a few general, parent-pleasing courses while majoring in fine arts. It was here that he found out what David Salle, Julian Schnabel, and the other hot young 1980s artists were doing—"I ripped off both Salle and Schnabel," he said—but his idol then was Willem de Kooning. Currin made "fake de Koonings to get into Yale," whose graduate art school was the best in the country. He kept on doing de Kooningesque paintings at Yale, with turbulent abstract brushwork, and overlaying them with angry-looking slashes of black paint. "I remember him telling me he wanted to do something beautiful and ugly in the same painting," his mother recalled, "but I didn't understand the anger in them. We never saw that

here." John burst out laughing when I relayed this to him. According to his sister Rachel, the backlash from all that nonrebellion continued for several years after he left college. She remembers calling him on the phone once, when he was about twenty-five, and saying he just had to stop being so angry.

One of his best friends at Yale was his classmate Lisa Yuskavage, an earthy, fearless young painter whose work even then was largely figurative. "If I didn't paint the figure, I'd probably become a nurse," she told him one day, shocking him to the bone. Even though Abstract Expressionism was the default direction at Yale, as it was at most other art schools around the country, painting the figure was an acceptable thing to do. Currin took several drawing classes with live models, and he'd secretly begun filling sketchbooks with quick drawings of idealized pretty girls. He continued to do this after graduation, as a kind of escape from his turgid abstractions. He stayed on in New Haven for another year, doing odd jobs, then moved into a loft in Hoboken with Yuskavage and her husband, Matvey Levenstein, and supported himself by working construction and housepainting jobs. His own painting wasn't going well, and he says that he felt like "a loser."

"That's when I broke away from what I was doing at Yale," he said. "I read *The Horse's Mouth,* by Joyce Cary, which had a big effect on me—also Kenneth Clark's book *The Nude,* and William Blake's poems. Those poems, together with Cary's descriptions of an artist painting figuratively, just made me think, God, I want to do that." He spent several weeks painting a large canvas of a female nude, which he claims was terrible. Soon after that, he answered an ad in *The Village Voice* and sublet space in a storefront on Ludlow Street, on the Lower East Side of Manhattan, which happened to be across the street from where two of his

Yale classmates, Sean Landers and Richard Phillips, were living. "I hadn't stopped being a loser, but I had company," he said.

In 1989, he and Landers took a studio together on Houston Street, and it was there that Currin started painting a series of portrait heads of young girls, derived from photographs in a high school yearbook. "They were naïve images," he said. "I didn't know how to paint figuratively." Centered on canvas against monochrome backgrounds, Currin's bland, character-less head-and-shoulders portraits somehow turned the insipid yearbook cliché into something arrestingly strange. White Columns, a nonprofit downtown gallery, showed five of these in December 1989—Currin's first solo show—and they sold well. "All of a sudden, I had seven thousand dollars, which repre-sented half a year of housepainting," Currin said. The bottom fell out of the art market at this moment, though, and none of the commercial galleries took him on, so he continued to paint apartments and do construction work.

In 1991, he began a series of much less ingratiating pictures, of middle-aged, upper-middle-class women whose drab clothes and ravaged features gave grim notice of what the yearbook damsels could look forward to. When they were shown, at the Andrea Rosen Gallery in 1992, the new pictures struck many observers as sexist and mean-spirited. Kim Levin, in *The Voice,* called them "awful paintings," and advised her readers to "boy-cott this show." Currin himself once described his subjects as "old women at the end of the cycle of sexual potential, between the object of desire and the object of loathing," but to him they also mirrored his own situation as a figurative painter whose work lacked validity in the market of ideas. "I was a pretty de-pressed person," he told me. "Not about the paintings, because I thought they were good. I don't know what I was depressed

about." He was dating Andrea Rosen, who had opened her gallery in 1990. Currin was reluctant to join his girlfriend's gallery, but Rosen put him in group exhibitions in 1990 and 1991, and early in 1992 she did the solo show of his middle-aged women. (Their romantic relationship had ended by then, but they remained friends, and he continued to show at her galley for ten years.) The show sold out. "I only made about nine thousand dollars," Currin said, "but thank God there was that really bad review in *The Village Voice*"—Kim Levin's diatribe—"which got me some attention."

Although Levin eventually changed her mind about Currin ("I was wrong, of course," she wrote in 2003. "Currin's subsequent oeuvre reveals an artist whose work is something other than merely misogynist, sexist, and ageist"), his subject matter continued to be a problem for critics. It included innumerable images of young women weighed down by basketball-size breasts; of very young women with much older men whose ridiculous beards and absurd clothing nudged them over the line into caricature; of two gay men in their kitchen extruding homemade pasta; of voluptuously painted female nudes whose elongated hands, necks, and legs channeled Lucas Cranach and Hans Baldung; of three young suburban housewives on a sofa drinking martinis and smoking cigars. "Mr. Currin mixes leering, lightheaded kitsch with old-masterish weight as if there were no distinction," Michael Kimmelman wrote in *The Times* in 1999, "a dizzying feat that makes every picture seem wholesome and evil at the same time."

The artist's technical ambitions since then have provoked furious disdain (his "mousy imitations of old-master portrait styles would not earn him a freelance gig as a magazine illustrator": Jed Perl, in *The New Republic*) and helpless admiration

("Currin's skills, now enhanced with positively Venetian color, insure that if it's too late in your life to stop liking painting you're sunk; he has you": Peter Schjeldahl, in *The New Yorker*). His offbeat but highly recognizable subjects and the increasing skill with which he painted them set his work apart from the contemporary art scene, with its glut of video and performance art, random scatter, sculptural megaliths, and homeless abstraction, and also from the new wave of figurative painting that emerged in the 1990s. The Museum of Modern Art put him in one of its Projects (new talent) shows in 1997, along with two other figurative artists (Luc Tuymans and Elizabeth Peyton), and from then on he had no trouble selling his work. Currin's prices rose rapidly in the boom market of the mid-to-late 1990s. By 2003, when his first major career retrospective went from the Museum of Contemporary Art in Chicago to the Serpentine, in London, and the Whitney Museum, in New York, collectors were lining up to pay $300,000 or $400,000 for one of his new paintings. That same year, in a move that prompted feature stories in *The Times* and elsewhere, he left the Andrea Rosen Gallery, which had introduced and nurtured him, for the big-time operation of Larry Gagosian, who felt that his prices were "ridiculously low" and boosted them accordingly. Currin thinks that his move to Gagosian might have helped defuse the potential controversy over the porno paintings, but it could just as easily have done the opposite. His work had not been seen in New York since the Whitney retrospective in 2003, a lot was riding on his Gagosian début, and his reputation seemed ripe for bashing. Instead, the critical consensus was cautious. *The Times*'s Roberta Smith discerned "a kind of innocent lightness and ease that is open and vulnerable, even joyful, but also a little too easily pleased." Eleanor Heartney, in *Art in America,* compared Currin to John Singer

Sargent in his "remarkable virtuosity in technique" and his "un-flagging ability to produce imagery that generates comment and publicity." All twenty paintings in the show sold on or before the opening, several of them to important collectors, for prices in the high six figures.

THE NEW PAINTING, which Currin has decided, somewhat apologetically, to call *The Women of Franklin Street,* in homage to Picasso's *Les Demoiselles d'Avignon,* looks slightly more advanced on my next visit to Currin's studio, two weeks after the first one. The middle figure's features are clearly defined, and her reddish-blond hair flows down and back in undulant waves. Her companion on the left (our left, her right) has platinum-blond hair, carefully coiffed, which stays in place as she bends to lick one of the succulently exposed breasts. She is more dynamic than the other two; she has one knee on what seems to be a bed, and she touches the central figure's vagina with her slender, manneristically elongated hand. Is there an echo here of art-historical sources? "I've always liked that thing of a figure coming in from the side who doesn't quite obey the spatial rules of the rest of the painting," Currin tells me. "The thing with angels and Annunciations."

Currin has been building up the central figure's face with white paint. "The goal is to get the white up pretty high," he explains. "Then, when it's time for color, you can paint more transparently. White is by far the most important color. It's what oil painting is about." Until a year ago, Currin worried that the lead white he uses would soon be unavailable. It wasn't being made anymore, and he had heard rumors (unfounded) that they were banning it in some art schools. "The idea that artists' materials should be banned for environmental reasons is completely crazy,"

he says. "I was told that most of the new stuff comes from China, and the quality is very different. I used to get so furious about this." Then, he says, he "found out that this guy in Brooklyn, Robert Doak, probably the best color guy in the world, had discovered a cache of the really good lead white. I bought enough from him to last me a lifetime."

Currin's methods ensure that he works slowly. He completes no more than ten pictures in a good year, and some years it's more like two or three. Today, he takes me up the stairs to the platform he uses as an office and storage space—it was his and Rachel's bedroom during the eight years they lived here—and pulls out a large unfinished painting of two women against a yellow background, a picture he worked on for seven months in 2004 and finally abandoned. This was during the bad period after his Whitney retrospective, when he felt upended by events: fatherhood, leaving Andrea Rosen's gallery for Gagosian's, giving up the studio he had shared for ten years with Sean Landers, losing his momentum as a painter. "The worst thing was not feeling any joy coming from the brush," he says now. For the first time since he met Rachel Feinstein, he had slipped into one of his low-grade depressions.

Currin's artist friends all agree that meeting Rachel was the answer to his unformulated prayers. "Rachel brings him out into the world in a way he can't do for himself," Lisa Yuskavage said. "I think he always wanted to be exactly who he is now." Someone who was not even a close friend told him, one day in 1994, that he should go to Exit Art, the alternative art space, to see the girl who was doing a performance piece there; he said she looked just like the girls in some of Currin's recent paintings. Currin, who had had a succession of unsatisfactory relationships since his amicable breakup with Andrea Rosen, went to Exit Art the

same day and knew almost instantly that this was it. Rachel's performance involved her sleeping for several hours a day in a sort of mock gingerbread house that she had built in the gallery. When he arrived, she had just woken up. Currin introduced himself, and Rachel asked if he wanted to go out with her that night.

"He was sort of taken aback, and said no," she remembers. "We ended up going out a week later. I went to see him in his studio first. He had placed two chairs so we could look at his paintings, but I turned mine around so it was facing his. 'I'm not interested in the paintings,' I said, 'I'm interested in you.'" A week later, he invited her to Paris, where he was having a show, and they've been together ever since.

"Meeting Rachel changed everything," Currin told me. "I came to the conclusion that there is no misery in art. All art is about saying yes, and all art is about its own making. I just became overwhelmingly happy."

Their backgrounds could hardly have been more different. The daughter of a Miami dermatologist, Rachel grew up in a boisterous Jewish household where she and her younger sister were allowed to do whatever they liked. "For a while, being with John was hard for me," Rachel confided, "because he sees women as different beings, some kind of embodiment of creativity, of life and beauty, all these strange emotions. The male-female issue is a constant battle for John and me." As battles go, this one seems to have been unusually stimulating for both parties, and it certainly changed the direction of Currin's work.

His palette got brighter. He did paintings of wavy-haired blond girls (like Rachel) on grassy hillsides, the landscapes he remembered from his California childhood. "With Rachel, I realized I could be different from everyone else just by being cheerful

in my work," he said. "In art school, I wanted to be intense, like Francis Bacon, but I'm not; I'm better when I'm jokey and cheerful."

What surfaced was the absurdist, ironic humor that his younger sister had found so endearing, and which the other Rachel (Feinstein) helped to release. It cropped up aggressively in his paintings of huge-breasted women, which were parodies of sexism, and of provocative painting in general. "I liked the idea of a beautiful painting that has this big problem," as he put it, "like a lead ball chained to its ankle. A heavy weight that keeps it from ever being good"—something beautiful and ugly at the same time. He was experimenting with different techniques, such as using the palette knife to rough up the faces of his big-breasted women; this idea came from Courbet, who liked to impose jarring contrasts between smoothly painted figures and crusty landscapes. Courbet, no slouch in the depiction of erotica, had replaced late Picabia as Currin's aesthetic guide. "Picabia couldn't get rid of his European elegance, the way I can't get rid of my vulgarity," he said. "With Courbet, there's no glamour to the style. He's what saves me when I get fussy about ways of making color."

Currin spent many hours at the Metropolitan Museum, and he read a lot of art history, but for years he resisted trying Old Master techniques. "It was like those dragon caves with old bones lying around the entrance—you don't go in there," he said. After he met Rachel, though, the inhibition lost its hold. "I went to the Met one day in 1997," he said, "and I was looking at that painting by Velázquez, of the little girl with the butterfly things in her hair"—a portrait of the Infanta María Teresa. "I thought, That's an odd color on the forehead, and I realized there was an underpainting, with a vermillion glaze over it. You

could see the two layers, and it was magical. The skin color was not like paint, not an exact color, but a combination of layers that formed in your eye."

This separation of form and color went out of fashion in the nineteenth century, when European artists began to paint *alla prima*, without glazes or underpainting, and only the most conservative art schools still offer instruction in the older techniques. Currin certainly hadn't heard about them at Yale, but now, studying the Velázquez, he was tempted. He tried underpainting for the first time in a 1997 painting, called *Heartless*, of a girl with Rachel's features, wearing a dress that has a heart-shaped cutout in front. "I painted her flesh in blue-black and white, which looked very weird," he said. "When it was dry, I painted an orangey flesh tone over it, and thought, Oh, my God, it works! The color was different from anything in my paintings before. I remember thinking, This is a really big deal."

He and Rachel got married soon after that; he had wanted to do so two years earlier, but she was in no hurry. The ceremony took place at the Parrot Jungle in Miami (Rachel's choice) on Valentine's Day, 1998, and afterward the newlyweds flew straight to Florence, where neither of them had been before. "It was a fantastic trip," Currin said. "I was looking for underpainting in every picture in the Uffizi, but it was in Venice that I really saw it. The Accademia puts paintings out on easels, under natural light, and you can get right up close to them and see how some parts were glazed and other parts were not." When they got home, what he had learned went into an unprecedented (for him) outpouring of technically ambitious paintings—voluptuous nudes, genre scenes, Mannerist compositions echoing Old Masters from Baldung to Parmigianino, and over-the-top inventions like his 2003 *Thanksgiving*, a virtuoso rendering of three Rachels

in a Gothic interior, presiding over the largest and sexiest un-
cooked turkey in Western art. (The Whitney should have bought
this picture, which was finished just in time for his three-museum
retrospective; the Tate Gallery got there first, and it went to Lon-
don instead.) He was teaching himself painting techniques that
had been out of fashion for more than a hundred and fifty years.
Currin is probably right when he says that his skill level doesn't
match that of a mid-level nineteenth-century painter, but he was
improving all the time, and this put him ahead of just about every
American painter in sight. The two-year dry period stopped him
in his tracks in 2003. What got him out of it was the birth of
Hollis, their second son, who arrived in 2005. "I suddenly felt
better," he said. "It made having kids feel normal. Being with
Larry Gagosian also meant that we had more money, so we could
have help." He started a bunch of new paintings, among them
the nude torso and *The Dane.*

THE DANE HANGS in the living room of John and Rachel's
spacious loft apartment in SoHo, which they moved into in
2004. They debated for some time before hanging it, because of
the boys, but the picture isn't all that racy (two women, one of
them clothed), and it marked a new direction in Currin's work.
When three-year-old Francis saw it, he said, "What's that?"
Rachel, who believes in being direct with children, said it was a
vagina, and Francis went, "Ewww," and hasn't paid any atten-
tion to it since.

These days, the Currins try to go out no more than three
evenings a week. This isn't always possible, because they are ex-
tremely popular, and the art world is ruthlessly demanding.
Both of them get up at eight each morning and walk the chil-
dren to their preschool. Rachel's studio is in the same building

as John's, on the eighth floor, which means that she uses a different entrance and takes the elevator; this makes for what John calls a "prophylactic" separation, but they share a studio assistant and tend to drop in on each other frequently. At the forty-fifth-birthday party that Rachel threw for John in his studio last fall, the guests included Mick Jagger, Larry Gagosian, and most of the couple's artist friends, who pitched in after dinner to sketch the nude odalisque that their hostess had thoughtfully provided.

In November, they took the boys on a four-day trip to Disney World, in Orlando, and got back in time to spend Thanksgiving, as usual, with John's parents in Stamford. The elder Currins had also invited my wife and me. We got there around five in the afternoon. The Currin boys ran in and out of the cozy, low-ceilinged living room, with its two grand pianos and comfortable 1950s-era furniture. (One of the pianos and the picture window turned up in Currin's painting of the three suburban housewives smoking cigars.) John's father, who wore dark brown corduroys and a tweed jacket, played Mozart and Haydn on the hi-fi until Rachel Currin, who was in charge of cooking the turkey, made him switch to Rachmaninoff. When we went in to dinner, Anita Currin announced that John would carve the turkey. Jim Currin, in a dry aside to my wife, said that, although he doesn't like to carve, he would do it better than John. There was a lot of contentious but good-humored talk and banter at the table, WASP style, with frequent interruptions. Rachel Feinstein, who loves to cook and does it so robustly that John has to work out at the gym every day to stay in shape, had brought the dessert, three pies from the Balthazar bakery.

During dessert, Rachel Currin went to one of the pianos and played, from memory, a Chopin mazurka that their mother used

to practice late at night, when she and John were upstairs in bed. John remembered it vividly, but what really set him off was the ballade she played next, another familiar piece, whose general mood of depression is interrupted by a sudden hopeful chord. "It's, it's like the Chinese are not going to stop supporting the dollar after all," John called out, to much laughter. "But then the mood of depression returns. The candles are lit, the family is drinking champagne, but in the morning they're coming to take the furniture away."

"I told you," his sister Rachel said. "He always cracks me up."

THROUGHOUT THE FALL, I visited Currin's studio nearly every week to see how the big painting was progressing. Sometimes I would see no change, but then I'd notice that he had redrawn the position of a leg or put down a grid of lines in the foreground, where he planned to paint a tile floor, "maybe delft blue-and-white tile, with the kind of tilted perspective that you see in Quentin Massys or Rogier van der Weyden." One day, the face of the middle figure sang out to me from across the room: He'd painted in the flesh tones. "When you put the color on, things become less realistic but more alive," he said. This time, it hadn't worked. He hadn't built up the white underpainting enough, he said, so the color made her face look masklike and artificial. He would have to redo it, building up the yellow and white undercoat, and, when that dried, going back in with red and gray. A week later, this had been done, and he had changed the background, reverting to a reddish-gray undercoat. "It doesn't look good now," he said, "but a big part of painting is getting used to things not looking good while you work on them."

"I've been pulling away from transparency lately, and trying to paint more directly," he said on another occasion. A few minutes

later, though, he was disparaging the "nineteenth-century bias, where color and form are one, and painting becomes a kind of performance." This was fine if you're a good enough painter, he said, "but I'm not good enough to do that, and I don't know anybody else who is, either." When I asked which nineteenth-century artist had achieved the best results with direct painting, he said van Gogh, without question. "Van Gogh had absolute pitch in color, to a degree I've never seen in another artist. He could work in a key of green and find the full spectrum in that color. Nobody painting today has anything like it. In Vermeer, you feel light coming out of the dark parts, which is something you don't see in other artists. The angels of painting—Titian, and the Venetians, and especially Velázquez—always painted with a wonderful combination of opacity and transparency. I'm lucky if I can get some transparency in my paintings, but if I try to get too much of that it becomes sentimental—I really mean effeminate."

By early December, the interaction of the figures and their setting in *The Women of Franklin Street* painting was much more defined. The background had gone dark, with a red curtain sweeping across most of it. The face of the middle figure looked finished to me, and full of life. "Midway through the process, I decided she would be sort of an idealized figure, like a goddess," Currin said. "I find myself, with some of these new paintings, trying to move out of the porn thing. I know my dealers would like that; there's a limited market for this stuff. And it bothers me that I can't let the children come in here." He described a terrifying dream he'd had, about deformed people having sex, and his children being somehow involved or endangered by it. "But it's not so big a problem that I want to stop doing it," he added. I asked him whether his parents knew he was still doing pornographic paintings. "They must know, because they haven't

asked me about it," he said, and laughed. "Everybody's going to breathe a sigh of relief when I move on."

A week before Christmas, the painting suddenly came together. The body of the right-hand figure, indistinct until now, looked fully three-dimensional, with luscious flesh tones and a sensuous play of light and shadow on her belly. Currin had sketched in grisaille a still-life of bone china cups and plates at the lower right, and he had turned the bed behind the three figures into a distinct presence, with a rumpled sheet and a curvy leg copied from his and Rachel's flamboyantly rococo bed at home. Right now, he planned to concentrate on the three figures. "There's not enough depth in them," he said. The painting, he said, would not be in his upcoming show in London. Larry Gagosian had told me earlier that he would like to have this one himself—something dealers are inclined to say when they want to establish a record price.

CURRIN HAD AGREED sometime earlier, rather reluctantly, to let me watch him paint, but somehow this had not happened. Today it did. He set up a palette, choosing three tubes of Robert Doak oil paint from a worktable piled high with several dozen others, and squeezing out small dollops from each. The colors were yellow ocher, vermillion, and Turkey umber, which registers as blackish green. From a lineup of liquid mediums in glass bottles, each of which had a different consistency and drying time, he selected a mixture of stand oil and balsam and poured a little of it into a small cup that was affixed to the palette. "And here's the white I'm so excited about," he said, squeezing from a larger tube of lead white. He went to work right away, dabbing a rather large bristle brush first into the white, and then the umber and the other two colors, mixing them quickly with a little

of the oil medium on the palette, remixing until he had the brownish tone he was after, and then applying it to the leg of the central figure with quick, deft strokes. He walked back ten or twelve paces, looking, then added more vermillion and went over the section again, making it darker at the outside edge of the leg and lighter toward the middle.

I was surprised to see how fast he worked. After about ten minutes, the brownish pigment, applied over the white ground, had made its magical transition into live flesh. "I have about an hour before it gets sticky and becomes unworkable," he explained. Now and then, he used his index finger to blur or blend the paint. "Say I want a sort of purply knee, slightly bruised or something," he said. "I go in with black and red, maybe a little yellow." He did so. He switched to a sable brush, much softer than the one he had been using, to work around the knee. "It starts to multiply, the grading of tones, until it becomes thousands of tones," he reflected. "Some are accidental and some are intentional. It's great when the accidental becomes indistinguishable from the intentional. That's when it begins to seem like a living thing." Watching him, it occurred to me that every brushstroke, every gradation in tone reflected a body of knowledge and a capacity for intuitive decisions that reached backward and forward in time. Also, that the art of figurative painting, which has been around for twenty thousand years, retains enough challenges to keep us enthralled for another millennium or two.

Currin stood back to look at what he'd done, then picked up a soft cloth and began wiping it off. The central figure's legs, he said, would eventually be sheathed in green stockings. He had just been showing me how he worked.

The demonstration made me think of three other things he had said during our talks:

"The meaning of the painting is what you do with your hands."

"The way things are painted trumps everything else."

"So much art now doesn't want to look like art, but painting can't help it."

—*January 28, 2008*

Currin put The Women of Franklin Street *aside in the early spring of 2008, so he could finish the ten paintings he was sending to London for his show at the Sadie Coles gallery. When I visited his studio in May, the big painting was back on the wall. He had repainted the central figure, heightening her flesh tones, and he was thinking about changing the background again. "It's kind of ambiguous to me, what's happening to the picture," he said. "But it's almost done." There was no longer a question about its future: Larry Gagosian had bought it for himself, to join the other trophies (by Picasso, Johns, Warhol, and others) in his Manhattan townhouse. Two new canvases, done since Currin's return from London, made it clear that the artist was still involved with the porn theme. "That horse," as he put it, "is still twitching."*

ACKNOWLEDGMENTS

I would like to thank all the artists whose time and patience I have encroached on since 1961, when I first began to write about their doings. Each of them has taught me things I would not have known otherwise, and kept me from mistakenly assuming that I know what art is, was, or could be. My thanks also to *The New Yorker*, which has published my writings for more than four decades; to the magazine's current editor in chief, David Remnick, and to my implacably clear-eyed editor there, Jeffrey Frank; to Jack Macrae, who guided this and several other books of mine into print; and to Dodie Kazanjian, my first reader, best critic, and captive audience. Writing is a solitary but also a collaborative project, and for a long time I have enjoyed both sides of this curious contradiction.

INDEX

ABOUT THE AUTHOR

CALVIN TOMKINS has written more than a dozen books, including the bestseller *Living Well Is the Best Revenge; Merchants and Masterpieces: The Story of the Metropolitan Museum of Art;* and the critically acclaimed biography *Duchamp.* He lives in New York City with his wife, Dodie Kazanjian.